Within the Landscape

D0862645

Within the Landscape

Essays on Nineteenth-Century American Art and Culture

Edited by Phillip Earenfight and Nancy Siegel

The Trout Gallery, Dickinson College, Carlisle, Pennsylvania

Distributed by The Pennsylvania State University Press
University Park, Pennsylvania

This publication was produced in part through the generous support of the Helen E. Trout Memorial Fund and the Ruth Trout Endowment at Dickinson College, and the Juniata College Museum of Art.

Published by The Trout Gallery, Dickinson College,
Carlisle, Pennsylvania, 17013
Distributed by The Pennsylvania State University Press,
University Park, Pennsylvania, 16802

First published 2005 by The Trout Gallery, Dickinson College

Design: Dorothy G. Reed
Production Editors: Phillip Earenfight and Nancy Siegel
Printing: Triangle Printing, York, Pennsylvania

Library of Congress Cataloging-in-Publication Data

Within the landscape : essays on nineteenth-century American art and culture / edited by Phillip Earenfight and Nancy Siegel.
 p. cm.
Collection of papers presented at a symposium organized by The Trout Gallery and presented in conjunction with the touring exhibition Along the Juniata: Thomas Cole and the Dissemination of American Landscape Imagery.
 Includes bibliographical references and index.
 ISBN 0-9768488-0-5 (alk. paper)
1. Landscape in art—Congresses. 2. Landscape in literature—Congresses. 3. Northeastern states—In art—Congresses. 4. Arts, American—19th century—Congresses. I. Earenfight, Phillip. II. Siegel, Nancy. III. Trout Gallery.
 NX650.L34W58 2005
 700'.4273097309034—dc22

 2005026397

Front Cover: Detail of Sanford R. Gifford, *A Gorge in the Mountains (Kauterskill Clove)*, 1862. Oil on canvas, 48 x 39 ⅞ in. The Metropolitan Museum of Art, New York. Bequest of Maria DeWitt Jesup, from the collection of her husband, Morris K. Jesup, 1914 (15.30.62). Photograph: © 1987 The Metropolitan Museum of Art.

Back Cover: Thomas Cole, *A View of the Two Lakes and Mountain House, Catskill Mountains, Morning*, 1844. Oil on canvas, 35 ⅞ x 53 ⅞ in. Brooklyn Museum. Dick S. Ramsay Fund (52.16).

In Memory

RUTH A. TROUT
1914–2004

Contents

List of Illustrations

PLATES (pages 79-96)

I. Thomas Cole, *Falls of Kaaterskill*, 1826. Oil on canvas, 43 x 36 in. From The Warner Collection of Gulf States Paper Corporation on view at The Westervelt-Warner Museum of Art, Tuscaloosa, AL.

II. Fenner Sears & Co. after Thomas Cole, *Head Waters of the Juniata Alleghany Mountains, Pen[n]sylvania*, 1831. Hand-colored engraving. John Howard Hinton, *The History and Topography of the United States*, 2 vols. (London: I. T. Hinton & Simpkin & Marshall, 1830–1832), 2: pl. 20. Juniata College Museum of Art, Huntingdon, PA.

III. William Adams & Sons, Staffordshire, England, after Thomas Cole, *Head Waters of the Juniata, U.S.*, c. 1831–1845. Ceramic soup plate, 10 ½ in. dia. Private collection.

IV. William Adams & Sons, Staffordshire, England, after Thomas Cole, *Monte Video, Connecticut, U.S.*, c. 1831–1845. Ceramic plate, 6 ¾ in. dia. Private collection.

V. Thomas Cole, *Distant View of Niagara Falls*, 1830. Oil on panel, 18 ⅞ x 23 ⅞. The Art Institute of Chicago. Friends of American Art Collection (1946.396). Photograph: © The Art Institute of Chicago.

VI. Thomas Cole, *View from Mount Holyoke, Northampton, Massachusetts, after a Thunderstorm—The Oxbow*, 1836. Oil on canvas, 51 ½ x 76 in. The Metropolitan Museum of Art, New York. Gift of Mrs. Russell Sage, 1908 (08.228). Photograph: © 1995 The Metropolitan Museum of Art.

VII. Thomas Cole, *River in the Catskills*, 1843. Oil on canvas, 27 ½ x 40 ⅜ in. Museum of Fine Arts, Boston. Gift of Martha C. Karolik for the M. and M. Karolik Collection of American Paintings, 1815–1865 (47.1201). Photograph: © 2005 Museum of Fine Arts, Boston.

VIII. Thomas Cole, *A View of the Two Lakes and Mountain House, Catskill Mountains, Morning*, 1844. Oil on canvas, 35 ⅞ x 53 ⅞ in. Brooklyn Museum. Dick S. Ramsay Fund (52.16).

IX. Asher B. Durand, *Sunday Morning*, 1839. Oil on canvas, 25 ¼ x 36 ¼ in. The New-York Historical Society, New York (1903.3). Photograph: Collection of The New-York Historical Society.

X. Asher B. Durand, *Sunday Morning*, 1860. Oil on canvas on wood paneled stretcher, 28 ⅛ x 42 ⅛ in. New Britain Museum of American Art, New Britain, CT. Charles F. Smith Fund (1963.4). Photograph: E. Irving Blomstrann.

XI. Asher B. Durand, *Early Morning at Cold Spring*, 1850. Oil on canvas, 59 x 47 ½ in. Montclair Art Museum, Montclair, NJ. Museum Purchase, Lang Acquisition Fund (1945.8).

XII. Frederic E. Church, *West Rock, New Haven,* 1849. Oil on canvas, 27⅛ x 40 ⅛ in. New Britain Museum of American Art, New Britain, CT. John Butler Talcott Fund (1950.10). Photograph: Michael Agee.

XIII. Frederic E. Church, *Niagara*, 1857. Oil on canvas, 42 ½ x 90 ½ in. Corcoran Gallery of Art, Washington, DC. Museum Purchase, Gallery Fund (1976.15).

XIV. Sanford R. Gifford, *Mansfield Mountain,* 1859. Oil on canvas, 30 x 60 in. Manoogian Collection.

XV. Sanford R. Gifford, *A Gorge in the Mountains (Kauterskill Clove)*, 1862. Oil on canvas, 48 x 39 ⅞ in. The Metropolitan Museum of Art, New York. Bequest of Maria DeWitt Jesup, from the collection of her husband, Morris K. Jesup, 1914 (15.30.62). Photograph: © 1987 The Metropolitan Museum of Art.

XVI. Sanford R. Gifford, *The Catskill Mountain House,* 1862. Oil on canvas, 9 ⁵⁄₁₆ x 18 ½ in. Private collection.

XVII. Sanford R. Gifford, *A Twilight in the Catskills,* 1861. Oil on canvas, 25 x 54 in. Private collection.

XVIII. Sanford R. Gifford, *Hunter Mountain, Twilight,* 1866. Oil on canvas, 30 ⅝ x 54 ⅛ in. Daniel J. Terra Collection (1999.57). Photograph: Terra Foundation for American Art, Chicago / Art Resource, NY.

FIGURES

Fig. 1. W. Hughes, *North Eastern Part of the United States.* Engraving. Nathaniel Parker Willis, *American Scenery; Or, Land, Lake, and River Illustrations of Transatlantic Nature,* 2 vols. (London: George Virtue,

American Scenery; Or, Land, Lake, and River Illustrations of Transatlantic Nature, 2 vols. (London: George Virtue, 1840), 2: pl. 52. Photograph: Archives and Special Collections, Dickinson College.

Fig. 10. J. C. Bentley, *The Two Lakes and the Mountain House on the Catskills.* Engraving after a drawing by William Henry Bartlett. Nathaniel Parker Willis, *American Scenery; Or, Land, Lake, and River Illustrations of Transatlantic Nature*, 2 vols. (London: George Virtue, 1840), 1: pl. 50. Photograph: Archives and Special Collections, Dickinson College.

Fig. 11. Sanford R. Gifford, *Hunter Mountain, Twilight,* 1866. Oil on canvas, 30 ⅝ x 54 ⅛ in. Daniel J. Terra Collection (1999.57). Photograph: Terra Foundation for American Art, Chicago / Art Resource, NY.

Fig. 12. J. T. Willmore, *The Caaterskill Falls (from above the Ravine).* Engraving after a drawing by William Henry Bartlett. Nathaniel Parker Willis, *American Scenery; Or, Land, Lake, and River Illustrations of Transatlantic Nature*, 2 vols. (London: George Virtue, 1840), 2: pl. 3. Photograph: Archives and Special Collections, Dickinson College.

Fig. 13. Thomas Cole, *Falls of Kaaterskill,* 1826. Oil on canvas, 43 x 36 in. From The Warner Collection of Gulf States Paper Corporation on view at The Westervelt-Warner Museum of Art, Tuscaloosa, AL.

Fig. 14. Thomas Cole, *River in the Catskills,* 1843. Oil on canvas, 27 ½ x 40 ⅜ in. Museum of Fine Arts, Boston. Gift of Martha C. Karolik for the M. and M. Karolik Collection of American Paintings, 1815–1865 (47.1201). Photograph: © 2005 Museum of Fine Arts, Boston.

Fig. 15. *Sunnyside—On the Hudson,* c. 1850. Published by Currier & Ives. Hand-colored lithograph, 8 x 12 ½ in. Private collection.

Fig. 16. Thomas Cole, *Scene in the Alleghany Mountains,* c. 1827. Black ink on paper, 6 ¼ x 9 ½ in. Juniata College Museum of Art, Huntingdon, PA.

Fig. 17. Fenner Sears & Co. after Thomas Cole, *Head Waters of the Juniata Alleghany Mountains, Pen[n]sylvania,* 1831. Hand-colored engraving. John Howard Hinton, *The History and Topography of the United States,* 2 vols. (London: I. T. Hinton & Simpkin & Marshall, 1830-1832), 2: pl. 20. Juniata College Museum of Art, Huntingdon, PA.

Fig. 18. William Adams & Sons, Staffordshire, England, after Thomas Cole, *Head Waters of the Juniata, U.S.,* c. 1831–1845. Ceramic soup plate, 10 ½ in. dia. Private collection.

Fig. 26. Fenner Sears & Co. after Thomas Cole, *The Falls of Cattskill, New York*, 1831. Engraving. John Howard Hinton, *The History and Topography of the United States*, 2 vols. (London: Simpkin & Marshall, and Philadelphia: Thomas Wardle, 1832), 2: pl. 44. Photograph: Courtesy of Archives and Special Collections, Franklin and Marshall College, Lancaster, PA.

Fig. 27. Fenner Sears & Co. after Thomas Cole, *Hartford, Connecticut*, 1831. Engraving. John Howard Hinton, *The History and Topography of the United States*, 2 vols. (London: Simpkin & Marshall, and Philadelphia: Thomas Wardle, 1832), 2: pl. 51. Photograph: Courtesy of Archives and Special Collections, Franklin and Marshall College, Lancaster, PA.

Fig. 28. Fenner Sears & Co. after Thomas Cole, *Timber Raft on Lake Champlain*, 1831. Engraving. John Howard Hinton, *The History and Topography of the United States*, 2 vols. (London: Simpkin & Marshall, and Philadelphia: Thomas Wardle, 1832), 2: pl. 55. Photograph: Courtesy of Archives and Special Collections, Franklin and Marshall College, Lancaster, PA.

Fig. 29. Fenner Sears & Co. after Thomas Cole, *View of the Cattskill Mountain House, N.Y.*, 1831. Engraving. John Howard Hinton, *The History and Topography of the United States*, 2 vols. (London: Simpkin & Marshall, and Philadelphia: Thomas Wardle, 1832), 2: pl. 59. Photograph: Courtesy of Archives and Special Collections, Franklin and Marshall College, Lancaster, PA.

Fig. 30. Fenner Sears & Co. after Thomas Cole, *View from Mount Washington*, 1831. Engraving. John Howard Hinton, *The History and Topography of the United States*, 2 vols. (London: Simpkin & Marshall, and Philadelphia: Thomas Wardle, 1832), 2: pl. 68. Photograph: Courtesy of Archives and Special Collections, Franklin and Marshall College, Lancaster, PA.

Fig. 31. Thomas Cole, *Distant View of Niagara Falls*, 1830. Oil on panel, 18 ⅞ x 23 ⅞ in. The Art Institute of Chicago. Friends of American Art Collection (1946.396). Photograph: © The Art Institute of Chicago.

Fig. 32. William Adams & Sons, Staffordshire, England, after Thomas Cole, *Monte Video, Connecticut, U.S.*, c. 1831–1845. Ceramic plate, 6 ¾ in. dia. Private collection.

Fig. 33. Engraver unknown, *Trout-fishing in Wyoming* [PA], 1852. Wood

Fig. 43. Thomas Cole, *View on the Catskill, Early Autumn,* 1836–1837 Oil on canvas, 39 x 63 in. The Metropolitan Museum of Art, New York. Gift in memory of Jonathan Sturges by his children, 1895 (95.13.3). Photograph: all rights reserved, The Metropolitan Museum of Art.

Fig. 44. Thomas Cole, *Landscape,* 1828. Oil on canvas, 26 x 32 ¼ in. Museum of Art, Rhode Island School of Design, Providence, RI. Walter H. Kimball Fund (30.063).

Fig. 45. John W. Hill, *View of the Palisades.* Hand-colored aquatint after a watercolor by William G. Wall. *Hudson River Port Folio* (New York: H. I. Megarey & W. B. Gilley; and Charleston: John Mill, 1821–1825), pl. XIX. Photograph: Courtesy, The Winterthur Library: Printed Book and Periodical Collection.

Fig. 46. J. C. Bentley, *The Two Lakes and the Mountain House on the Catskills.* Engraving after a drawing by William Henry Bartlett. Nathaniel Parker Willis, *American Scenery; Or, Land, Lake, and River Illustrations of Transatlantic Nature,* 2 vols. (London: George Virtue, 1840), 1: pl. 50. Photograph: Archives and Special Collections, Dickinson College.

Fig. 47. R. Brandard, *The Horse Shoe Fall, at Niagara.—With the Tower.* Engraving after a drawing by William Henry Bartlett. Nathaniel Parker Willis, *American Scenery; Or, Land, Lake, and River Illustrations of Transatlantic Nature,* 2 vols. (London: George Virtue, 1840), 1: pl. 16. Photograph: Archives and Special Collections, Dickinson College.

Fig. 48. Nathaniel and Simeon Smith Jocelyn, *View of Monte Video Approach to the House.* Engraving after a drawing by Daniel Wadsworth. Benjamin Silliman, *Remarks Made, On a Short Tour, Between Hartford and Quebec in the Autumn of 1819* (New Haven: S. Converse, 1820), pl. 2. Photograph: Courtesy, The Winterthur Library: Printed Book and Periodical Collection.

Fig. 49. View from the Site of Catskill Mountain House. Photograph: author.

Fig. 50. Thomas Cole, *View of the Bay of Naples,* 1832. Brown ink over graphite on paper, each sheet 8 ⅞ x 13 ⅜ in. The Detroit Institute of Arts. Founders Society Purchase, William H. Murphy Fund (39.566.6; 39.566.7). Photograph: © 1990 The Detroit Institute of Arts.

Fig. 51. Thomas Cole, *View of the Oxbow on the Connecticut River, As Seen From Mount Holyoke,* 1833. Graphite on paper, each sheet 8 ⅞ x 13 ⅜

in. The Detroit Institute of Arts. Founders Society Purchase, William H. Murphy Fund (39.566.66; 39.566.67). Photograph: © 1990 The Detroit Institute of Arts.

Fig. 52. R. Wallis, *Lake Winnipisseogee, From Red Hill.* Engraving after a drawing by William Henry Bartlett. Nathaniel Parker Willis, *American Scenery; Or, Land, Lake, and River Illustrations of Transatlantic Nature,* 2 vols. (London: George Virtue, 1840), 1: pl. 14. Photograph: Archives and Special Collections, Dickinson College.

Fig. 53. S. Bradshaw, *View from Mount Washington.* Engraving after a drawing by William Henry Bartlett. Nathaniel Parker Willis, *American Scenery; Or, Land, Lake, and River Illustrations of Transatlantic Nature,* 2 vols. (London: George Virtue, 1840), 1: pl. 47. Photograph: Archives and Special Collections, Dickinson College.

Fig. 54. Frederic E. Church, *Morning, Looking East Over the Hudson Valley from the Catskill Mountains,* 1848. Oil on canvas, 18 ¼ x 24 in. Albany Institute of History & Art. Gift of Catherine Gansevoort (Mrs. Abraham) Lansing (x1940.606.7).

Fig. 55. Frederic E. Church, *Above the Clouds at Sunrise,* 1849. Oil on canvas, 27 ¼ x 48 ¼ in. From The Warner Collection of Gulf States Paper Corporation on view at The Westervelt-Warner Museum of Art, Tuscaloosa, AL.

Fig. 56. Frederic E. Church, *West Rock, New Haven,* 1849. Oil on canvas, 27 ⅛ x 40 ⅛ in. New Britain Museum of American Art, New Britain, CT. John Butler Talcott Fund (1950.10). Photograph: Michael Agee.

Fig. 57. Frederic E. Church, *Heart of the Andes,* 1859. Oil on canvas, 66 ⅛ x 119 ¼ in. The Metropolitan Museum of Art, New York. Bequest of Margaret E. Dows, 1909 (09.95). Photograph: all rights reserved, The Metropolitan Museum of Art.

Fig. 58. Frederic E. Church, *Horseshoe Falls, December 1856–January 1857.* Oil sketch on two pieces of paper joined together, mounted on canvas, 11 ½ x 35 ⅝ in. Olana State Historical Site, New York State Office of Parks, Recreation and Historic Preservation (OL.1981.15).

Fig. 59. Sanford R. Gifford, *Mansfield Mountain,* 1859. Oil on canvas, 30 x 60 in. Manoogian Collection.

Fig. 60. Asher B. Durand, *Sunday Morning,* 1860. Oil on canvas on wood paneled stretcher, 28 ⅛ x 42 ⅛ in. New Britain Museum of American Art,

New Britain, CT. Charles F. Smith Fund (1963.4). Photograph: F. Irving Blomstrann.

Fig. 61. Asher B. Durand, *Sunday Morning*, 1839. Oil on canvas, 25 ¼ x 36 ¼ in. The New-York Historical Society, New York (1903.3). Photograph: Collection of The New-York Historical Society.

Fig. 62. John F. Kensett, *View of the Shrewsbury River New Jersey*, 1859. Oil on canvas, 12 x 20 in. Jane Voorhees Zimmerli Art Museum, Rutgers, The State University of New Jersey, New Brunswick. Gift of the Interfraternity Alumni, 1952. Photograph: Jack Abraham.

Fig. 63. Asher B. Durand, *Early Morning at Cold Spring*, 1850. Oil on canvas, 59 x 47 ½ in. Montclair Art Museum, Montclair, NJ. Museum Purchase: Lang Acquisition Fund (1945.8).

Fig. 64. Asher B. Durand, *Kaaterskill Clove*, 1866. Oil on canvas, 39 x 60 in. The Century Association, New York. Photograph: Frick Art Reference Library.

Fig. 65. Thomas Cole, *The Cross in the Wilderness*, c. 1844. Graphite with white, gray-green, and green-brown chalks on gray paper, 7 ⁵⁄₁₆ in dia. National Gallery of Art, Washington, DC. John Davis Hatch Collection, Avalon Fund (1983.2.2). Image © 2004 Board of Trustees, National Gallery of Art.

Fig. 66. Frederic E. Church, *Twilight in the Wilderness*, 1860. Oil on canvas, 40 x 64 in. The Cleveland Museum of Art. Mr. and Mrs. William H. Marlatt Fund (1965.233). Photograph: © The Cleveland Museum of Art.

Fig. 67. Sanford R. Gifford, *Mount Merino and the City of Hudson, in Autumn*, c. 1851–1852. Oil on canvas, 18 ½ x 26 ½ in. Albany Institute of History & Art. Purchase, gift by exchange, Governor and Mrs. W. Averell Harriman (1998.2).

Fig. 68. Thomas Cole, *A View of the Two Lakes and Mountain House, Catskill Mountains, Morning*, 1844. Oil on canvas, 35 ⅞ x 53 ⅞ in. Brooklyn Museum. Dick S. Ramsay Fund (52.16).

Fig. 69. Sanford R. Gifford, *The Catskill Mountain House,* 1862. Oil on canvas, 9 ⁵⁄₁₆ x 18 ½ in. Private collection.

Fig. 70. View of the site of the former Catskill Mountain House, with North and South Lakes, from Sunset Rock, 2003. Photograph: author.

Fig. 83. Julia Margaret Cameron, *Alfred, Lord Tennyson,* 1866. Albumen silver print from glass negative, 13 ¾ x 10 ⅝ in., printed 1905. The Metropolitan Museum of Art, New York. The Rubel Collection, Purchase, Lila Acheson Wallace, Michael and Jane Wilson, and Harry Kahn Gifts, 1997 (1997.382.36). Photograph: all rights reserved, The Metropolitan Museum of Art.

Fig. 84. Thomas Hicks, *Bayard Taylor,* 1855. Oil on canvas, 24 ½ x 29 ¾ in. National Portrait Gallery, Smithsonian Institution, Washington, DC (NPG.76.6).

Fig. 85. J. W. Orr after John F. Kensett, *The Cliff Walk, Newport.* Wood engraving. George William Curtis, *Lotus-Eating: A Summer Book* (New York: Harper and Brothers, 1852), 192. Photograph: General Research Division, The New York Public Library, Astor, Lenox and Tilden Foundations.

Fig. 86. John F. Kensett, *Beacon Rock, Newport Harbor,* 1857. Oil on canvas, 22 ½ x 36 in. National Gallery of Art, Washington, DC. Gift of Frederick Sturges, Jr. (1953.1.1). Image © 2005 Board of Trustees, National Gallery of Art, Washington, DC.

Fig. 87. Engraver unknown, after Winslow Homer, *The Bathe at Newport,* 1858. Wood engraving. *Harper's Weekly,* September 4, 1858, 568. Photograph: The Metropolitan Museum of Art, New York. The Irene Lewisohn Costume Reference Library.

Fig. 88. Sanford R. Gifford, *A Twilight in the Catskills,* 1861. Oil on canvas, 25 x 54 in. Private collection.

Fig. 89. Frederic E. Church, *Twilight in the Wilderness,* 1860. Oil on canvas, 40 x 64 in. The Cleveland Museum of Art. Purchase, Mr. and Mrs. William H. Marlatt Fund (1965.233). Photograph: © The Cleveland Museum of Art.

Fig. 90. Sanford R. Gifford, *Hunter Mountain, Twilight,* 1866. Oil on canvas, 30 ⅝ x 54 ⅛ in. Daniel J. Terra Collection (1999.57). Photograph: Terra Foundation for American Art, Chicago / Art Resource, NY.

Fig. 91. Photographer unknown, *Sanford R. Gifford on National Guard duty at Camp Cameron, Washington, D.C., summer 1861.* Albumen silver print, 7 ¼ x 5 ⅛ in. Archives of American Art, Smithsonian Institution, Washington, DC.

Acknowledgments

This book is a collection of essays that originated from papers presented at the symposium "Within the Landscape: Perspectives on Nineteenth-Century American Scenery" held at The Trout Gallery, Dickinson College, March 27, 2004. The symposium was held in conjunction with the exhibition *Along the Juniata: Thomas Cole and the Dissemination of American Landscape Imagery*, on loan from the Juniata College Museum of Art. The exhibition, symposium, and this publication are the result of collaborative efforts and support from a multitude of people and institutions. Without their assistance these projects could not have come to fruition.

At The Trout Gallery, we extend our sincere appreciation to Stephanie Keifer, the museum's administrative assistant, who not only oversaw countless details regarding the exhibition, symposium, and publication, but also served as one of the book's copyeditors. James Bowman, the museum's registrar and preparator, created the perfect installation of *Along the Juniata* for its venue at The Trout Gallery, while Wendy Pires, Curator of Education, and Dorothy Reed, Publications Coordinator, translated the exhibition into programs for area school groups. We would also like to thank the museum's attendants, Sue Curzi, Sylvia Kauffman, and Rosalie Lehman for assisting with visitors and helping with the educational programs. Special assistance with exhibition and symposium materials was provided by Robert Cavenagh, Tom Smith, and Jean Weaver. Audio visual assistance for the symposium was provided by Gary Greyhosky. Promotional materials for the exhibition and symposium were designed by Kimberley Nichols and Pat Pohlman. Publicity for The Trout Gallery was handled in part by Heidi Hormel.

At Juniata College, encouragement from President Thomas Kepple and Provost James Lakso has been appreciated greatly. At Dickinson College, President William Durden, Provost Neil Weissman, and the college community continue to foster a supportive and challenging intellectual environment where significant scholarly contributions are fundamental to teaching and learning. To the members of the Dickinson Department of Art and Art History—Robert Cavenagh, Ward Davenny, Barbara Diduk, Karen Glick, Sharon Hirsh, Joan Miller, Susan Nichols, Walter Nichols, Caroline Savage, Melinda Schlitt, and Brooke Wiley—we

are grateful for your friendship, encouragement, and boundless support of The Trout Gallery and its activities.

The Friends of The Trout Gallery provide valuable assistance to the museum and its programs. In particular, we wish to thank its board members past and present, who, in addition to several members from the Department of Art and Art History, include: Walter E. Beach, Donna Clarke, Carolyn W. Cleveland, Eric Denker, Christine Drake, Rosalyn J. Evans, Karen Faryniak, Melissa A. Gallagher, Susan H. Goldberg, Paul M. Kanev, Maureen Reed, Wilford W. Scott, Ruth Trout, Elliot Vesell, and Tamar Weiss. We thank members from the Office of Development at Dickinson College, particularly Christina Van Buskirk and Carolyn Yeager, their colleagues in Financial Operations, Annette Parker, David Walker, and Dickinson's General Counsel, Dana Scaduto.

We would also like to recognize the institutions that provided photographs of works from their collections and permission to reproduce them in this book. Thank you to the curators, registrars, and photographic rights coordinators at the following institutions who kindly responded to our countless requests, often under short notice and rapidly approaching deadlines: The Albany Institute of History and Art; The Art Institute of Chicago; Art Resource, New York; Archives of American Art, Smithsonian Institution; The Brooklyn Museum; The Century Association, New York; The Cleveland Museum of Art; The Corcoran Gallery of Art, Washington, DC; The Detroit Institute of Arts; Archives and Special Collections, Dickinson College; Fine Arts Center, Colorado Springs; Archives and Special Collections, Franklin and Marshall College; Frick Art Reference Library; Hughes Photographics, State College, PA; The Juniata College Museum of Art; The Metropolitan Museum of Art; Montclair Art Museum, Montclair, NJ; The National Gallery of Art, Washington, DC; The National Portrait Gallery, Smithsonian Institution; The New Britain Museum of American Art; The New-York Historical Society; The New York Public Library; Peter and Juliana Terian Collection of American Art; Terra Foundation for American Art, Chicago; The Manoogian Collection; Museum of Fine Arts, Boston; Museum of Art, Rhode Island School of Design; Olana, New York State Office of Parks, Recreation and Historic Preservation, Bureau of Historic Sites; St. Johnsbury Athenaeum; Thomas Cole National Historical Site, Cedar Grove, Catskill, NY; Westervelt-Warner Museum of American Art, Tuscaloosa, AL; Winterthur Library; and Jane Voorhees Zimmerli Art Museum, Rutgers, The State University of New Jersey. We also thank the various private collectors who provided photographs for this project.

Jim Gerencser, archivist, in Special Collections at Dickinson College Library, was particularly helpful in his tireless quest for identifying and obtaining the sources we needed as well as his assistance in obtaining photographs of plates from N. P. Willis's *American Scenery*. Likewise, we wish to thank Christopher M. Rabb, archivist, at the Archives and Special Collections, Franklin & Marshall College, who generously permitted us to photograph plates from its copy of John Howard Hinton's *The History and Topography of the United States*.

Special thanks to Kathleen Parvin, our copyeditor, for providing polish and precision of detail; Dorothy Reed, the book's designer, for creating a publication that gave vision to our concept; Deb Strausbaugh, of Triangle Printing, for her assistance with all matters regarding the printing of this book; and Gloria Kury at The Pennsylvania State University Press for her editorial expertise. We extend our deepest appreciation to the scholars who shared their research at the symposium and who contributed their essays to this volume.

Lastly, the support from colleagues, friends, and family has been instrumental throughout this project.

Principal funding for this publication was provided by the Ruth Trout Endowment and the Helen E. Trout Memorial Fund. Additional funding was provided by the Juniata College Museum of Art. This book is dedicated to the memory of Ruth A. Trout, who enjoyed the landscape and pictures of it.

Phillip Earenfight
DIRECTOR, THE TROUT GALLERY
DICKINSON COLLEGE

Nancy Siegel
DIRECTOR, JUNIATA COLLEGE
MUSEUM OF ART

Introduction:

Mapping the Image of the American Landscape

Phillip Earenfight

To compare the sublime of the Western Continent with the sublime of Switzerland—the vales and rivers, lakes and waterfalls, of the New World with those of the Old—to note their differences, and admire or appreciate each by contrast with the other, was a privilege hitherto confined to the far-wandering traveller. In the class of works, of which this is a specimen, however, that enviable enjoyment is brought to the fire-side of the home-keeping and secluded as well; and, sitting by the social hearth, those whose lot is domestic and retired, can, with small cost, lay side by side upon the evening table the wild scenery of America, and the bold passes of the Alps—the leafy Susquehanna with its rude raft, and the palace-gemmed Bosphorus with its slender caïque. So great a gratification is seldom enjoyed at so little cost and pains.

N. P. Willis, preface to *American Scenery*, 1840[1]

Nathanial Parker Willis's *American Scenery* was one in a variety of mid-nineteenth-century publications designed for sale to the increasing number of would-be travelers—both the "far-wandering" and the "fire-side" varieties—who sought to experience the sublime and poetic beauty of the American landscape in person or through text and images. The deluxe two-volume set provided readers with physical descriptions, lively historic anecdotes, legends, and accounts of 117 sites in the Mid-Atlantic and New England states, each accompanied by a finely engraved print, almost all of which were based on a series of drawings by one of England's leading topographical artists, W. H. Bartlett.[2] In addition to the scenic views, the second volume included a map entitled *North Eastern Part of the United States. Engraved for N. P.*

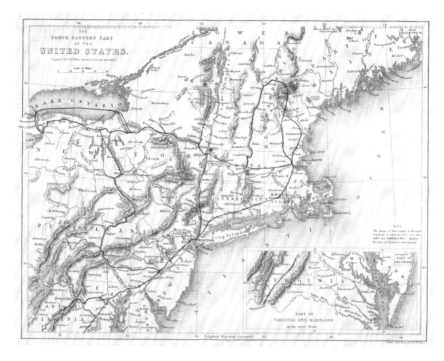

Fig. 1. W. Hughes, *North Eastern Part of the United States*. Engraving. Nathaniel Parker Willis, *American Scenery; Or, Land, Lake, and River Illustrations of Transatlantic Nature*, 2 vols. (London: George Virtue, 1840), 2: unnumbered page. Photograph: Archives and Special Collections, Dickinson College.

Willis's "American Scenery Illustrated" (Fig. 1). Drawn and engraved by W. Hughes, the map delineates the region from Maine to Northern Virginia, Cape Cod to Buffalo. Through a series of carefully engraved parallel lines, Hughes described the ragged Atlantic shoreline with its countless inlets, bays, and estuaries, the most important of which connect to major rivers that twist and climb inland to their source at a lake, valley pool, or distant mountain spring. From ocean to headwaters, the rivers are punctuated by towns and cities that trace civilization's penetration into the wilderness. The rivers, together with the canals and rails, cut through a region rich in scenic wonder and endless variety from Niagara Falls to the Palisades and from Mount Washington to the Natural Bridge. During the early decades of the nineteenth century, a variety of economic, cultural, nationalistic, and social factors combined to make this scenic region the focus and inspiration for generations of writers, painters, philosophers, tourists, publishers, and travelers. Willis's book capitalized on the region's popularity and appealed to the comfortable, fire-side reader. More than a century-and-a-

half later, the region and its cultural legacy continue to inspire interest and study. *Within the Landscape: Essays on Nineteenth-Century American Art and Culture* responds to this continuing interest by analyzing aspects of the region—its sites, artists, and writers, through a variety of perspectives. *Within the Landscape* includes essays by specialists from the academic and the museum professions as well as a combination of the two. The authors' research reevaluates previous assumptions, presents recent discoveries, and charts directions for future investigation regarding the image of the American landscape.

This volume brings together a collection of papers that was presented at *Within the Landscape: Perspectives on Nineteenth-Century American Scenery,* a symposium organized by The Trout Gallery and presented in conjunction with the touring exhibition *Along the Juniata: Thomas Cole and the Dissemination of American Landscape Imagery,* which was curated by Nancy Siegel.[3] The papers address a group of artists and writers associated with American scenery during the early to mid-nineteenth century and focus on the Mid-Atlantic and New England region. The principal artists and writers considered in this volume—Thomas Cole, Asher B. Durand, Frederic E. Church, Sanford R. Gifford, James Fenimore Cooper, Washington Irving, Ralph Waldo Emerson, and George William Curtis—are connected by their ties to the scenery of the Northeast and played leading roles in shaping visions of the American landscape that endured throughout much of the nineteenth century.

The popularity of this region, with its distinctive landscape and historic sites, was due in part to an increasing identification with the landscape as representatively "American." Consequently, sites within the White Mountains, the Catskill Mountains, the Connecticut and Hudson River Valleys, the Niagara Falls/Erie Canal region, and the Susquehanna River Valley/Allegheny Mountains, emerged as popular destinations for travelers, writers, and artists who wished to experience the scenic and the picturesque. As the essays in this book concentrate on a limited geographic region during a relatively short chronological span, they complement each other well and in several instances analyze the same subject from different perspectives and methodological frameworks. To cite two examples, the Catskill Mountain House, a large, well-appointed resort that offered a commanding view of the region, is considered in all of the essays (fig. 2). In David Schuyler's study, the Catskill Mountain House figures as a key tourist site along the American Grand Tour; in Nancy Siegel's essay it represents an image for mass production on ceramic plates; for Alan Wallach's paper, the site provides an important view for the development of the

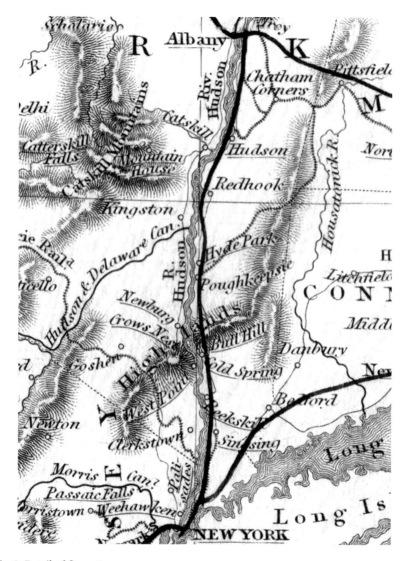

Fig. 2. Detail of figure 1.

panoramic mode; Matthew Baigell's essay considers how the view from the site suggested God's handiwork; while Kevin Avery's analysis examines Sanford Gifford's paintings of the Catskill Mountain House within the context of the exotic, as the "fifth pipe of opium." Likewise, while Schuyler and Baigell both cite James Fenimore Cooper's *Pioneers* in their respective papers, for Schuyler, the character of Natty Bumppo voices an anti-indus-

trial, preservationist sentiment, while Baigell examines the same character for his views on religion and nature. Such common points of contact bring the essays together in a textured and rewarding manner.

Within the Landscape: Essays on Nineteenth-Century American Art and Culture opens with David Schuyler's essay "The Mid-Hudson Valley as Iconic Landscape: Tourism, Economic Development, and the Beginnings of a Preservationist Impulse." This study considers factors that led to the rise of landscape tourism in the region and how sites along the Hudson River emerged as key stops along a grand tour of American scenery. Schuyler shows how the economic forces that made landscape tourism in the area possible were also the same factors that led to the region's rapid industrial development and transformation, which threatened to destroy that which made it a tourist site in the first place. Schuyler demonstrates how such developments caused several writers to examine the impact of man on the landscape, laying the foundation for what becomes the modern preservationist movement. In considering the various factors that led to the region's emergence as a popular tourist destination, Schuyler examines essential matters such as transportation to the region, adequate accommodations, and the writings of James Fenimore Cooper and Washington Irving, as well as various travel and gift books made during the 1830s and 1840s, including John Hill's *Hudson River Port Folio* (1821–1825) and Willis's *American Scenery*. Indeed many of the images reproduced in Schuyler's essay are drawn from Willis's generously illustrated volumes. Through these and similar writings, Schuyler reveals how civilization quickly encroached upon the American wilderness, eliciting a response from authors and artists such as Cooper, Irving, and Cole. As part of this analysis, Schuyler refers to George P. Morris's poem "Woodman, Spare That Tree," which was set to music by Henry Russell in 1837 and reprinted by Willis.[4] Although the pledge that the woodman's "axe shall harm it not" failed to change attitudes among the industrialists, it signaled the emergence of an environmentalist ethic. Indeed, Schuyler demonstrates how this sentiment emerged in the lands where Cooper, Irving, and Cole expressed their misgivings about the industrialization of the region and traces this dissenting voice into the twentieth century, when it ultimately gives rise to the modern preservationist movement.

Nancy Siegel's essay, "Decorative Nature: The Emblematic Imagery of Thomas Cole," shifts the geographic focus from the Catskills and the Hudson River Valley south and west, to the Allegheny Mountains of Pennsylvania and the Juniata River. Her study brings the reader to the western edge of the region to consider how a drawing by Thomas Cole,

Scene in the Alleghany Mountains (c. 1827), was the starting point for the dissemination of imagery that was widely reproduced and mass-marketed to the American public. Her analysis begins with the scene represented in the drawing which she locates along a southern branch of the Juniata River in southwestern Pennsylvania. Siegel demonstrates how Cole utilized this drawing and several others, primarily scenes in New York and New England, as the basis for finished compositions which in turn formed the basis for engravings that illustrated John Howard Hinton's ambitious and deluxe compendium *The History and Topography of the United States* (1830–1832). She follows the subsequent dissemination and copying of Cole's imagery, first through various reprintings of Hinton's book in England and the United States, and second through the production of ceramic dinnerware, where the imagery was used as transfer ware designs by the William Adams & Sons firm in the Staffordshire district of England. Siegel's study shows how, through mass production, images of the American landscape made their way from "high" art to middle-class consumer items and became emblematic of American scenery. She also examines how changes in dining practices among the middle class led to the demand for a wide variety of dinnerware, which, when combined with a rising sense of nationalism, led consumers to purchase plates and bowls decorated with scenes that extolled the beauty and bounty of the American landscape. Although the images that were reproduced as prints or on ceramic ware were several steps removed from Cole's original compositions, they reflect an awareness of and appreciation for scenery associated with the American landscape. Similarly, these objects were purchased by those with the means and opportunity to visit popular resorts like the Catskill Mountain House and to adorn their homes with handsomely illustrated books and ceramics.

Alan Wallach's essay, "Some Further Thoughts On The Panoramic Mode In Hudson River School Landscape Painting," considers an important development in the format of nineteenth-century landscape painting—the panorama. This study takes the reader away from matters of tourism, material culture, production, and dissemination, to matters of artistic form and development. Wallach examines the emergence of the panorama format, one that is proportionately much wider than it is tall, and one in which the painting's point of view is situated high above the scene, as if from a tree top, where there are no framing devices, no repoussoir elements, and no foreground between the viewer and the scene. While this powerful, at times overwhelming, effect is most readily recognized in paintings such as Church's *Niagara* (1857), Wallach identifies the early use

of the panoramic mode in works such as Thomas Cole's *Oxbow* (1836) and shows how it emerged among other, older landscape conventions: the pastoral, the prospect, the sublime prospect, and the view. He notes how artists typically used the first three modes, while the view was favored by topographical draftsmen. Wallach seizes on this point and argues that this utilitarian mode provided Cole with the means to organize a composition from a high vantage point, a view that he and his contemporaries had hitherto regarded as unpaintable. While Wallach shows that Cole's *Oxbow* represents an important step towards defining the panoramic mode in a finished painting, he demonstrates how the format was readily employed by topographical artists such as William H. Bartlett, who produced a number of panoramic views for Willis's *American Scenery*. According to Wallach, *American Scenery* contains the most important series of panoramic views of the period and that Bartlett's compositions influenced Cole's student Frederic Church, who in the 1840s experimented with the panoramic mode that led ultimately to his *Niagara* of 1857. Thus, in Wallach's study, it is not the landscape or the site that is in question but the means of representing it from an elevated viewpoint in a way that, according to Wallach, conveys the empowering effect of this commanding perspective.

Matthew Baigell's essay, "Getting a Grip on God: Painting the Christianized Landscape," moves the reader into the territory of meaning and iconography relative to nineteenth-century associations of nature with the divine. While it is well understood that many in the nineteenth century believed that "[nature] *was* God,"[5] Baigell aims to refine this generalization by sharpening the equation, noting that many viewers rejected it in part if not altogether, and creates a framework to consider these issues more subtly. To this end, Baigell lays out three primary ways by which God was understood in this period: "through scripture, through nature, and through a sense of God's immanence in the physical world." Baigell defines and provides examples for each. He then turns to several works by Asher B. Durand, an artist whose religious attitudes are well articulated through his writings, and considers them in light of these distinctions to reveal how Durand's attitudes regarding God and nature evolved over the course of the painter's lifetime. While not wanting to create strict criteria by which artists or works are pigeonholed into one of three categories, Baigell argues fundamentally for a more precise reading of texts and images. By extension, he argues for a more precise interpretation of the artist's intent in a given work, not just the work by itself, but rather, as part of a particular artist's religious and artistic journey, one that can, as in the case of Durand, occasionally turn back on itself. Baigell's essay represents a recalibration

of our scholarly compass, a sharpening of our position on the intellectual map. While Baigell does not question the basic ideas introduced decades ago about the important relationship of nature to religion in nineteenth-century America, he argues for a more accurate and precise assessment of where scholarship is and where it may go in the future.

In the volume's final essay, "Gifford and the Catskills: Resort and Refuge," Kevin J. Avery returns the reader to the Catskills and the tourist site of the Catskill Mountain House. His work on Sanford R. Gifford moves the discussion from the antebellum period up through the Civil War era. Avery compares Cole's and Gifford's approach to painting near-identical views from the Catskill Mountain House in light of critical attention to Gifford's paintings. Avery focuses on commentaries, including Eugene Benson's description of the tactile light and atmosphere that fill such signature works as Gifford's *A Gorge in the Mountains (Kauterskill Clove)* (1862). Avery traces such references to the writing of Alfred Tennyson, specifically his *Lotos-Eaters* (1832), and its influence on American authors, in particular, George William Curtis, whose *Lotus-Eating: A Summer Book* (1852) describes key sites along the American Grand Tour and portrays the American landscape in exotic hues, comparable to those used to describe the Orient. Avery extends the boundaries of the discussion from America to Europe, the East, and beyond, into the heavy haze of the opium-laden imagination. He reveals the anti-utilitarian, self-indulgent character of Curtis's book, which depends on Tennyson's example. He also connects Gifford to Curtis on various levels, including their contact with the painter John F. Kensett, who provided designs for the engravings that illustrated *Lotus-Eating*. Avery examines the relationship between the style of Gifford's painting and the tactile language of Curtis and Tennyson and positions his discussion at the advent of the Civil War. Avery argues that patrons drawn to Gifford's canvases responded to the concept of a refuge or a respite from the city in favor of the slow and languid pace that a hot summer's day at the Catskills Mountain House could provide.

As these essays demonstrate, the scenery of the Mid-Atlantic and New England states played an important role in the image of nineteenth-century America. They show how the landscape was regarded as a source of poetic and philosophical inspiration, a place of refuge and repose, a tourist site "to do," a commodity, a place of worship, a widely disseminated symbol of the young Republic, a living panorama, and a rapidly vanishing Garden of Eden. In bringing these essays together, "It is confidently hoped," to quote Willis, "that the attempt to assemble a mass of interesting

matter under this design, has not failed; and that, in the value of the intellectual portion, as well as in the beauty and finish of the embellishments, the Work will be thought worthy of the patronage of the public."[6]

Notes
1. N[athanial]. P[arker]. Willis, *American Scenery; Or, Land, Lake, and River Illustrations of Transatlantic Nature,* 2 vols. (London: George Virtue, 1840).
2. The book's frontispiece reads, "...121 steelplate engravings from drawings by W. H. Bartlett." However, the text that accompanies two of the engravings indicates that they are based on paintings by Thomas Doughty (*Silver Cascade, in the Notch of the White Mountains* and *Desert Rock Light-House, and Mountain*). Thus, the 121 plates include 117 text illustrations (115 after Bartlett, two after Doughty), one after a portrait of W. H. Bartlett, two frontispieces after Bartlett (one for each volume), and the map by W. Hughes.
3. The symposium took place on March 27, 2004; the exhibition was on view at The Trout Gallery from March 10–April 17, 2004. Nancy Siegel is also the author of the accompanying exhibition catalogue, *Along the Juniata: Thomas Cole and the Dissemination of American Landscape Imagery* (Huntingdon, PA: Juniata College Museum of Art, in association with the University of Washington Press, 2004).
4. Willis, *American Scenery,* 2: 2.
5. Barbara Novak, "Introduction: The Nationalist Garden and the Holy Book," *American Art* 60 (January–February 1972): 46–57, reprinted in *Nature and Culture: American Landscape and Painting, 1825–1875* (New York: Oxford University Press, 1980), 3.
6. Willis, *American Scenery,* 1: iv.

The Mid-Hudson Valley as Iconic Landscape:

Tourism, Economic Development, and the Beginnings of a Preservationist Impulse

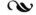

DAVID SCHUYLER

*I*n *The Pioneers* (1823), the first of James Fenimore Cooper's Leatherstocking novels, Natty Bumppo told his young friend Oliver Edwards that in all his travels he had found only one place more beautiful than the vicinity of Lake Otsego: the Catskill Mountains. These were the mountains Edwards had seen on his journey up the Hudson, which Natty described as "looking as blue as a piece of clear sky, and holding the clouds on their tops, as the smoke curls over the head of an Indian chief at the council fire." Standing at the edge of the escarpment, a thousand feet above the valley floor, Natty looked out upon "all creation." Leatherstocking explained that the river, eight miles to the east, was in sight from the Highlands at the south to Albany at the north, a distance of more than seventy miles. From the height and distance of the escarpment, he added, the river seemed as inconsequential as "a curled shaving, under my feet." Natty also described a second site, which, he conceded, in later years he had come to appreciate even more than the sublime prospect from the escarpment: "there's a fall in the hills, where the water of two little ponds that lie near each other breaks out of their bounds, and runs over the rocks into the valley." Cooper was so taken with the scenery that he gave the unlettered Natty a vernacular aesthetic vocabulary:

> There the water comes crooking and winding among the rocks, first so slow that a trout could swim in it, and then starting and running like a creater [sic] that wanted to make a far spring, till it gets to where the mountain divides, like the cleft hoof of a deer, leaving a deep hollow for the brook to tumble into. The

first pitch is nigh two hundred feet, and the water looks like flakes of driven snow, afore it touches the bottom; and there the stream gathers together again for a new start, and maybe flutters over fifty feet of flat rock, before it falls for another hundred, when it jumps about from shelf to shelf, first turning this-away and then turning that-away, striving to get out of the hollow, till it finally comes to the plain.

Natty speculated that no more than a dozen white men had gazed upon Kaaterskill Falls, which he considered "the best piece of work that I've met with in the woods" and evidence of the "hand of God . . . in the wilderness."[1]

If only a few white men had gazed upon Kaaterskill Falls at the time of Natty's fictional visit, almost overnight the eastern part of the Catskills became one of the most explored, and revered, American landscapes. In 1823, the year Cooper published *The Pioneers*, a group of merchants from Catskill, New York, obtained a charter of incorporation, acquired several hundred acres of land known as Pine Orchard, and began erecting a "large and commodious hotel." That frame building, known as the Catskill Mountain House, stood on table rock close to the edge of the escarpment, overlooking the Hudson. Historian John Sears has demonstrated that there were three prerequisites to the emergence of tourism in nineteenth-century America: the development of an urban class that had the money and leisure to begin exploring the countryside; an adequate transportation system; and an infrastructure to provide safe, comfortable accommodations for travelers. The emergence of a number of steamboat lines in the aftermath of the Supreme Court decision *Gibbons v. Ogden* (1824), which declared the Livingston monopoly on the river unconstitutional, and the resulting increased efficiency and reduced cost of travel, made the Hudson Valley and the Catskills popular destinations for tourists. The emergence and public embrace of landscape painting as a particularly appropriate form of American expression in the arts was another important development in promoting landscape tourism. So was the publication of books such as Timothy Dwight's *Travels in New England and New York* (1821–1822), the William Cullen Bryant-Asher B. Durand collaboration *The American Landscape* (1830), and guidebooks such as *Sketches of the North River* (1838) and *The New York State Tourist* (1842), all of which acquainted readers with the Hudson Highlands and the Catskill escarpment, which quickly became favorite haunts for painters, poets, and tourists seeking to experience the American landscape.[2]

In addition to these prerequisites, Kenneth Myers has pointed out the importance of the development of a way of seeing and thinking about

scenery, which resulted both from the "importation of contemporary landscape art and literature from abroad" and from American artistic and literary efforts, which "represented landscape appreciation as a natural or intuitive ability." Landscape tourism emerged in the early nineteenth century as a key to the development of an American national identity. To be sure, the United States lacked the monuments, ruins, and centuries of tradition that provided Europeans with a sense of identity in place and time, and Sidney Smith's biting remark, in an 1820 essay in the *Edinburgh Review*, wondering if anyone ever read an American book or looked at an American painting, was a devastating blow to cultural nationalists. But if the United States could not compete with centuries of European achievement in the arts, it had Nature in abundance—Nature, always with a capital N and always in the feminine, Nature as the source of America's distinctiveness as a culture. Moreover, the American landscape was older than all the institutions of European civilization. In *Home as Found* (1838), Cooper's fictional Eve Effingham, who had spent virtually her entire life in Europe, was amazed by the eloquent if misnamed Silent Pine that stood on the bank of Lake Otsego and equated it with all the institutions of European civilization: "When [William] the Conqueror first landed in England this tree stood on the spot where it now stands! Here, then, is at last an American antiquity!"[3]

With the development of an infrastructure for tourism—the steamboat lines, carriage services, and hotels to accommodate visitors—as well as the publication of promotional pamphlets and other publicity heralding the attractions of mountain scenery, upper- and middle-class Americans, especially from large cities, began to take tours in search of the picturesque. Most tourists, whom Andrew Jackson Downing described as the "travelling class," were not seeking a wilderness experience but one that provided reasonably comfortable accommodations and the opportunity to visit well-known places. They were first-generation consumers of the American landscape, both in the sense that building the facilities for tourists transformed that landscape and because many tourists undoubtedly perceived of scenery as a commodity to be experienced.[4]

Until the construction of railroads, river transportation provided the most comfortable access to the interior of the continent. As steamboats plied the Hudson, the first tourist destination was the Highlands, roughly forty miles north of Manhattan, where the river passes through a series of mountains. The distance from Dunderberg, at the southern gate to the Highlands (fig. 3), to Breakneck Ridge and Storm King Mountain at the north, is approximately fifteen miles of the most dramatic scenery in the

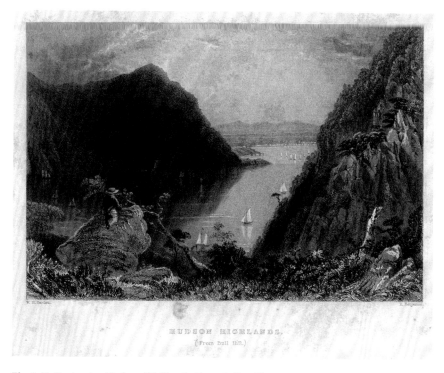

HUDSON HIGHLANDS.
(From Bull Hill.)

Fig. 3. E. Benjamin, *Hudson Highlands (from Bull Hill)*. Engraving after a drawing by William Henry Bartlett. Nathaniel Parker Willis, *American Scenery; Or, Land, Lake, and River Illustrations of Transatlantic Nature*, 2 vols. (London: George Virtue, 1840), 1: pl. 58. Photograph: Archives and Special Collections, Dickinson College.

eastern United States. Auguste Levasseur, secretary and companion to the Marquis de Lafayette during his 1824–1825 visit to the United States, was especially struck by the scenery of the Highlands, a place "where nature only shows herself under strange forms, and in sombre colours," and which evoked "phantoms" and "sinister sighings." Although someone who cherished the remnants of feudalism and the castles of the middle ages might favor the scenery of the Rhine, Levasseur wrote, "for one who prefers nature still virgin and wild, there is nothing so beautiful as the banks of the Hudson." John Fowler, an Englishman who sailed north on the Hudson aboard the steamboat *Albany* in 1830, marveled at the varied landscapes he passed: "I was so hurried on from the sublime to the beautiful, that before the image of one had impressed itself upon the mind, the other appeared to take possession, and every successive change but deepened the thrill of admiration and rapture."[5]

Washington Irving, whose fertile imagination invented much of the folklore of river and region, explained in Diedrich Knickerbocker's *A History of New York* (1809) that the Hudson was once an enormous lake extending from the Highlands some forty miles to the north. The mountains were "one vast prison, within whose rocky bosom the omnipotent Manetho confined the rebellious spirits who repined at his control." There, "bound in adamantine chains, or jammed in rifted pines, or crushed by ponderous rocks, they groaned for many an age. At length the conquering Hudson, in its career towards the ocean, broke open their prison-house, rolling its tide triumphantly through the stupendous ruins." Those newly freed spirits continue to inhabit the Highlands and cry out in haunting voices which reverberate throughout that stretch of the river.[6]

Sloops and steamboats sailing north on the river passed Dunderberg, or Thunder Hill, which the English traveler James Silk Buckingham described as "strikingly picturesque." The entrance to the Highlands struck him as romantic and wildly beautiful. From this point the river curves sharply to the northwest, a passage nineteenth-century navigators called the Horse Race, toward Bear Mountain and Anthony's Nose. Gustave de Beaumont, Alexis de Tocqueville's traveling companion, described Anthony's Nose (fig. 4) as epitomizing "all that is most picturesque." Venerable Diedrich Knickerbocker attributed its name to Antony Van Corlear, a trumpeter whose nose was "a very lusty size." During Peter Stuyvesant's journey up the Hudson, Antony, having finished his morning ablutions, was leaning over the quarter-railing, staring at his reflection in the water below. "Just at this moment the illustrious sun, breaking in all its splendor from behind a high bluff in the highlands, did dart one of his most potent beams full upon the refulgent nose of the sounder of brass— the reflection of which shot straightaway down, hissing-hot, into the water, and killed a mighty sturgeon that was sporting beside the vessel!" The crew cooked the sturgeon and found it to be excellent. Then, when Peter Stuyvesant tasted the fish and learned its history, he "marveled exceedingly; and as a monument thereof, he gave the name of *Antony's Nose* to a stout promontory in the neighborhood."[7]

Washington Irving was, together with the landscape painter Thomas Cole, central to the emergence of a widely-shared belief that the Hudson River Valley was a special place. Some historians and folklorists have claimed that, in "Rip Van Winkle" and "The Legend of Sleepy Hollow," Irving was simply repeating well-known European folk tales, but such criticism misses the most important point. What Irving accomplished was to give his tales a specificity of place and time in the Hudson Valley. In doing

this he both captured contemporary attitudes toward landscape and shaped how present and future generations would think about the Hudson Valley. Yale president Timothy Dwight, who was a keen observer of the American scene, repeated Irving's account of the ill-fated Antony Van Corlear, and also the story that the river was once a lake dammed by the Highlands, when he visited the Hudson Valley two years after the publication of the Knickerbocker *History*. In the decades since the publication of the Knickerbocker *History* (1809) and the *Sketch-Book* (1819–1820), which included "Rip Van Winkle" and "The Legend of Sleepy Hollow" and which gained its author international acclaim, Irving's tales have become inseparable from the popular perception of the Hudson Valley's history and folklore and, as part of a vernacular tradition, have been transformed by other storytellers.[8]

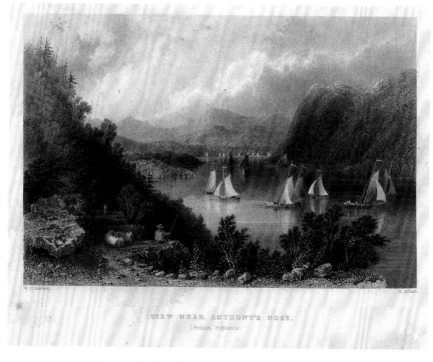

Fig. 4. H. Adlard, *View near Anthony's Nose (Hudson Highlands)*. Engraving after a drawing by William Henry Bartlett. Nathaniel Parker Willis, *American Scenery; Or, Land, Lake, and River Illustrations of Transatlantic Nature,* 2 vols. (London: George Virtue, 1840), 2: pl. 46. Photograph: Archives and Special Collections, Dickinson College.

THE HUDSON AT "COZZENS'S."

Fig. 5.
Artist unknown, *The Hudson at "Cozzens's."* Engraving. William Cullen Bryant, ed., *Picturesque America; Or, The Land We Live In. A Delineation by Pen and Pencil of the Mountains, Rivers, Lakes, Forests, Water-Falls, Shores, Cañons, Cities, and other Picturesque Features of Our Country* (New York: D. Appleton, 1872), 2: 10. Photograph: Courtesy, The Winterthur Library: Printed Book and Periodical Collection.

From Anthony's Nose the river changes direction again, toward the northeast and West Point, one of the first stops on the American Grand Tour. At the steamboat dock at Cozzens Landing a mile south of the academy grounds, visitors could take a carriage up the steep hillside to Cozzens Hotel (fig. 5). The original hotel had been at West Point, but in the 1840s it was relocated to a bluff above the Hudson at Highland Falls. A large structure set near a precipice overlooking the Highlands, Cozzens could accommodate more than 500 guests who came to take advantage of the hotel's extensive pleasure grounds, walk along paths to spectacular overlooks or streams cascading through ravines, or enjoy elite society. A. J. Downing attested to the popularity of the original hotel in 1835: "none of the fashionables," he wrote, "think their summer's tour complete until they have loitered away a day or two at 'Cozzens,' falling in raptures with the captivating, though (at that place) stern and majestick beauty of the Highlands." Hudson chronicler Wallace Bruce described the second Cozzens as "one of the best appointed summer hotels of the country." The

hotel was "one of the finest landmarks on the river" and possessed a majestic view from the veranda Bruce found to be charming. Other hotels and boarding houses were constructed nearby to provide additional accommodations for the increasing number of tourists.[9]

Alternatively, passengers could steam to the dock at West Point and stay at a smaller hotel on the academy grounds, established at the behest of Commandant Sylvanus Thayer, that welcomed official visitors as well as prominent tourists. West Point was the American shrine, the sacred place where American independence hung in precarious balance during the dark days of the Revolution. Fowler, for example, was charmed by sites important in the "glorious struggle for independence" and took pleasure in "beholding the hallowed grounds where the great and the brave had fought and fallen." The very topography that made the Highlands an advantageous location for the river's defense also made it a spectacularly scenic landscape. Almost every author of travel accounts was effusive in describing the landscape of West Point and vicinity. Frances Trollope, for example, judged the scenery "magnificent"; Gustave de Beaumont found the Highlands to be "one of the most beautiful spectacles and one of the most imposing tableaus" along the length of the Hudson; and James Silk Buckingham reported that "few prospects can be imagined more romantic, more stirring, or more beautiful." In the text accompanying John Hill's engravings in *Hudson River Port Folio* (1821–1825), John Agg similarly waxed poetic over the history as well as the setting of West Point: "every spot is rendered sacred by association with times and circumstances which 'tried men's souls,' and which now live only in memory, or rather, in history."[10]

Agg was wrong about one thing: that history was not a dim memory but was alive to Americans in the first half of the nineteenth century. Although Thomas Cole was born and educated in England, he appreciated the intersections of history and landscape in the Highlands: in his "Essay on American Scenery" he observed that the Hudson Valley was full of "historical and legendary associations" because "the great struggle for freedom has sanctified many a spot." Similarly, Benson J. Lossing described the mid-Hudson Valley as possessing "some of the finest scenery in the world," which was "enhanced in interest to the student of history by the associations which hallow it." O. L. Holley, author of *The Picturesque Tourist* (1844), a popular guidebook, described the Highlands as "classic ground, as many of the points or eminences in view from the river are celebrated in history for being the scene of stirring events during the struggle for American independence." An advertisement in yet another guidebook noted that the "historic associations of these mountain summits

with the early struggle of the Fathers of Liberty, combine, with the beauty of river and mountains, to render this vicinity peculiarly interesting and attractive." American schoolchildren learned the events of the Revolution, and particularly the battlegrounds of New York State. Hill's *Hudson River Port Folio*, Nathaniel Parker Willis's *American Scenery* (1840), Lossing's *Pictorial Field-Book of the American Revolution* (1850), and numerous guidebooks all described British General Sir Henry Clinton's foray into the Highlands in October 1777, when his troops captured forts Clinton and Montgomery. Part of Clinton's army reached as far north as Esopus (the modern Kingston), which the British burned, an event which was familiar enough to American readers that Cooper could assume they would understand Natty Bumppo's account of watching the fire from the Catskill escarpment.[11]

When Clinton learned of the British defeat at Saratoga and decided to return to New York City, American revolutionaries, who knew the strategic importance of the Highlands, quickly rebuilt the fortifications in the mountains under direction of the Polish volunteer Thaddeus Kosciusko and Colonel Rufus Putnam. Fort Putnam, which stood on a promontory west of the military academy, protected the rebuilt forts Clinton and Montgomery. In the early nineteenth century nearby residents began removing stone from Fort Putnam to reuse in building. Although the government eventually acted to preserve the site, it was so compromised that it stood as a majestic ruin. As tourism became a national pastime, Fort Putnam became a favorite destination, cherished by nineteenth-century Americans as a sacred place in the struggle for independence. The young landscape painter Thomas Cole made several sketches of the ruins of Fort Putnam during his 1825 journey up the Hudson and painted *A View of Fort Putnam* shortly after he returned to New York City, and Willis published an engraving of the fort in *American Scenery* (fig. 6). From West Point Washington's engineers extended a great chain and boom across the river to Constitution Island, which throughout the remainder of the war prevented British ships from passing through the Highlands. As the war dragged on, a disgruntled Benedict Arnold conspired with Major John Andre to surrender the fortifications at West Point to the British, and only Andre's capture by three militiamen in Westchester County prevented the British from regaining control of the Highlands and perhaps changing the outcome of the war.[12]

Timothy Dwight, who as a chaplain during the Revolutionary War had been stationed at West Point, returned to the Hudson Highlands in the fall of 1811. From West Point he crossed to the east bank and hiked north

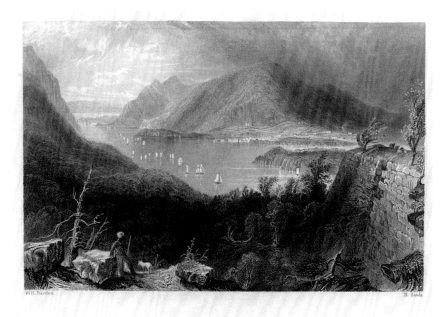

Fig. 6. R. Sandis, *View from P[F]ort Putnam (Hudson River)*. Engraving after a drawing by William Henry Bartlett. Nathaniel Parker Willis, *American Scenery; Or, Land, Lake, and River Illustrations of Transatlantic Nature*, 2 vols. (London: George Virtue, 1840), 1: pl. 20. Photograph: Archives and Special Collections, Dickinson College.

to Sugarloaf Mountain. Dwight described the view in rhapsodic terms: "Directly north, the Hudson, here a mile in breadth, and twice as wide higher up, is seen descending from a great distance, and making its way between the magnificent cliffs of the two great mountains, Butter Hill [now known as Storm King] and Breakneck. The grandeur of this scene defies description." The Highlands simply captivated the Puritan divine, who struggled to find a vocabulary adequate to the landscape: "It is difficult to conceive of anything more solemn or more wild than the appearance of these mountains," he wrote. After describing the immense forest whose deep brown color he likened to "that of universal death," and clouds at sunset that "imparted a kind of funereal aspect to every object within our horizon," Dwight concluded by observing:

> There is a grandeur in the passage of this river through the Highlands, unrivaled by anything of the same nature within my

Fig. 7. John W. Hill, *View from Fishkill looking to West Point.* Hand-colored aquatint after a watercolor by William G. Wall. *Hudson River Port Folio* (New York: H. I. Megarey & W. B. Gilley; and Charleston: John Mill, 1821–1825), pl. XV. Photograph: Courtesy, The Winterthur Library: Printed Book and Periodical Collection.

knowledge. At its entrance particularly and its exit, the mountains ascend with stupendous precipices immediately from the margin of its waters, appearing as if the chasm between them had been produced by the irresistible force of this mighty current, and the intervening barrier at each place had been broken down and finally carried away to the ocean. These cliffs hang over the river, especially at its exit from the mountains, with a wild and awful sublimity, suited to the grandeur of the river itself.[13]

Dwight was an astute chronicler of the American landscape, but he was essentially seeking evidence of the progress of civilization in the United States. He measured the transition from barbarism to a higher form of life by the neatness and industry of residents and by the settling of Protestant churches in small towns and villages. In words that anticipated, and undoubtedly influenced, Andrew Jackson Downing's writings a generation later, this conservative social critic judged the state of society by the buildings, fields, and streetscapes settlers had imposed on the landscape. Dwight was convinced that "Uncouth, mean, ragged, dirty houses consti-

tuting the body of any town will regularly be accompanied by coarse, grov-
eling manners. The dress, the furniture, the mode of living, and the man-
ners will all correspond with the appearance of the building and will uni-
versally be in every such case of a vulgar and debased nature." At stake in
the physical transformation of the landscape was the fate of social order,
of culture, in the new nation.[14]

John Agg echoed Dwight in perceiving the landscape in terms of the
progress of civilization. In the text of *Hudson River Port Folio* he too sought
evidence of neatness and cultivation, and expressed surprise that many
parts of the Hudson Valley were still untamed. Describing the view from
Fishkill Landing (the modern Beacon) south toward West Point (fig. 7), he
found little evidence of the civilizing process. There were few dwellings of
any sort throughout the Highlands, let alone ones that testified to the good
taste of occupants. What buildings he observed were "thinly scattered over
the landscape, and appear rather to add to the solitariness of the scene
than to lend animation." The Highlands represented, to Agg, "a wide field
for the industry and enterprise of the pioneer." He was certain that readers
would be surprised to learn that "immediately on the verge of a noble
stream, communicating with the most populous and commercial city of
the Union, such extensive tracts of land should yet be found, which have
never known the touch of the ploughshare, nor yielded any growth but the
forest oak and mountain pine."[15]

Neither Agg nor most other popular writers describing the Hudson
Highlands in the 1820s and 1830s apparently realized the extent to which
the mountains had been reforested in recent years—how much logging
had occurred to provide fuel for the foundry at Cold Spring and the
steamboats that traveled up and down the Hudson. He nevertheless
expressed approbation for what he termed "a spirit of enterprise [that was]
traversing this great State, out of which continual changes start forth to
astonish and delight the traveler." Only the poetic verse of the Old
Testament prophet Isaiah seemed adequate to describe this transforma-
tion: "Here is a voice in the wilderness—here the crooked places have been
made straight, and the rough places plain; the valleys exalted, and the
mountains leveled; here, as with the rod of Moses, the rock which has been
stricken has poured forth waters in the desert; and where loneliness and
sterility reigned, are now to be found the blessings of a fertile soil and an
opulent population."[16]

This was a vision of prosperity that would result from the transfor-
mation of the landscape, from the labors of residents following the Old
Testament injunction to take possession of and subdue the earth. A decade

after the publication of *Hudson River Port Folio*, Andrew Jackson Downing published two essays in the *New-York Mirror* that likewise proclaimed the superiority of cultivated nature over the sublime, of pastoral landscape over wilderness. The first led visitors to the summit of Mount Beacon, on the east bank of the river just above the Highlands. Named for the signal fires that alerted Washington's troops to the movements of the British army during the waning months of the Revolution, Mount Beacon was, to Downing's untraveled eye, one of nature's "most majestick thrones." Comparing the view favorably to better-known prospects in the Catskills, including Pine Orchard, the site of the Catskill Mountain House, he added that from Mount Beacon, "In every direction the country is full of beauty, and presents a luxuriant and cultivated appearance." The second essay was a reverie at Dans Kamer, a flat rock that projected into the Hudson north of Newburgh. The northernmost point of Newburgh Bay, this was a locale celebrated by Washington Irving as a ceremonial pow-wow ground for Native Americans. Downing, who admired Irving greatly and praised Knickerbocker for preserving the "rich old legends and antiquarian scraps" of the river's history, expressed sadness at the "extinction of the thousand tribes of our fellow-beings." Nevertheless, he celebrated the progress, the improvement, that had taken place in recent years. The age of the canoe had given way to the tall sloop and the steamboat, the "wild yell of the savage" had been replaced by the ringing of the church bell, and where wigwams once stood were "a thousand cheerful homes gleaming in the sunshine." What best characterized the changes wrought by civilization, Downing implied, was the domestication of the landscape, the establishment of homes, farms, and villages: the "once dense wilderness," he wrote approvingly, "has disappeared under the hands of civilized man." The author of *The Hudson Illustrated with Pen and Pencil* (1852) similarly measured progress through economic development: "Instead of the wild desolation of the savage, the eye is now greeted on every side by the indications of happy industry and civilization."[17]

N. P. Willis, who wrote the text to accompany William H. Bartlett's illustrations for *American Scenery*, was similarly captivated by the Hudson Highlands. He described the landscape at West Point as "doubtless the boldest and most beautiful" river scenery in the United States and wrote evocatively of the mountains that rose so precipitously on its banks. Nevertheless, drawing upon Cole's assertion that American associations were those of the present and future, Willis contrasted European and American scenery in terms of what was and what would be. If what best characterized the Old World landscape was its history, the distinguishing

VIEW FROM HYDE PARK.
(Hudson River.)

Fig. 8. G. K. Richardson, *View from Hyde Park (Hudson River)*. Engraving after a drawing by William Henry Bartlett. Nathaniel Parker Willis, *American Scenery; Or, Land, Lake, and River Illustrations of Transatlantic Nature,* 2 vols. (London: George Virtue, 1840), 1: pl. 23. Photograph: Archives and Special Collections, Dickinson College.

feature of the New World was its potential for development, a transformation, ironically, antithetical to the very scenery he was describing in the text accompanying Bartlett's handsome images. Gazing upon an "untrodden and luxuriant" valley, he wrote, the archetypal American would see not natural beauty but the "villages that will soon sparkle on the hill-sides, the axes that will ring from the woodlands, and the mills, bridges, canals, and railroads, that will span and border the stream that now runs through sedge and wild-flowers."[18]

Evidence of the civilizing process these authors celebrated abounded as steamboats passed through the northern gate of the Highlands. The topography along the river became rolling countryside, a rich agricultural landscape dotted every few miles by a village or thriving town. John Agg described Newburgh as "a very conspicuous figure in the scenery of this celebrated river," a community of approximately five hundred houses that

was a prosperous seat of commerce. "In point of scenery," Willis added, "Newburgh is as felicitously placed, perhaps, as any other spot in the world." A major tourist destination there was the Hasbrouck house, a simple vernacular fieldstone dwelling where George Washington had lived during the long months between military victory at Yorktown and the Treaty of Paris, which in 1850 became the first building in the United States preserved for its historic significance. Travelers passed Fishkill Landing and the spine of the Appalachians on the east bank, opposite Newburgh, which was dominated by Mount Beacon. The anonymous author of an early guidebook celebrating the Hudson River and its new east bank railroad described the view from Mount Beacon, with the Highlands to the south, the Shawangunk range to the west, and the Catskills to the north: "Within this circle the materials of the beautiful and the picturesque are arranged with all the grandeur, the softness, the beauty of detail, that the most fastidious connoisseur of fine scenery can desire." A dozen miles to the north the traveler reached Poughkeepsie, on the east bank, and shortly thereafter Hyde Park, with its famous view northwest across the "broad, tranquil, and noble river" toward the Catskill Mountains (fig. 8). With the mountains looming in the distance, the traveler approached Catskill, which Willis found to be a "thrifty little village, in which the most prosperous vocations are those of inn-keeper and stage-proprietor." Catskill was part of the tourist economy of the mountain region, which was epitomized by the Catskill Mountain House.[19]

Timothy Dwight was one of the earliest writers to describe the site of the Mountain House. Visiting the site in 1815, he first walked around the two lakes to Kaaterskill Clove, which he described as "a ravine, extending several miles in length, and in different places from a thousand to fifteen hundred feet in depth. The mountains on either side were steep, wild, and shaggy, covered almost everywhere with a dark forest." Dwight characterized the precipice at the end of the clove in terms of "stupendous and awful grandeur." Only later did he reach the escarpment, where he looked out over western Massachusetts and Connecticut as well as the Hudson Valley and recorded in his journal, a "more distinct and perfect view of a landscape cannot be imagined." The prolific writer Wallace Bruce, who characterized the Highlands in terms of sublimity and the rolling countryside north of Newburgh as picturesque, chose the word beauty to describe the Catskills.[20]

Construction of the Catskill Mountain House (fig. 9) in 1823–1824 commenced the resort era in the eastern Catskills. From the landing in the village of Catskill it was a four-hour carriage drive, on a bone-jarring road

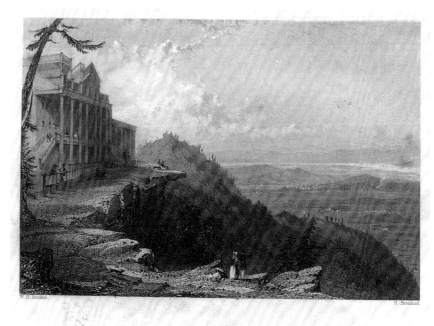

VIEW FROM THE MOUNTAIN HOUSE, CATSKILL.

Fig. 9. R. Brandard, *View from the Mountain House, Catskill.* Engraving after a drawing by
William Henry Bartlett. Nathaniel Parker Willis, *American Scenery; Or, Land, Lake,
and River Illustrations of Transatlantic Nature,* 2 vols. (London: George Virtue,
1840), 2: pl. 52. Photograph: Archives and Special Collections, Dickinson College.

over precipitous hills, to the hotel. About halfway up the mountain the
coaches passed a small dwelling reputed to be Rip Van Winkle's shanty and
the hollow where he imbibed the drink of the old Dutchmen playing
ninepins. Many travelers from abroad, including Harriet Martineau, John
Fowler, and James Silk Buckingham, described the journey as well as the
spectacular site that awaited them. Arriving by coach one July evening,
Martineau described the Mountain House as "an illumined fairy palace
perched among clouds in opera scenery" and found the views from the
escarpment more moving even than Niagara Falls. Fowler found the view
to be "altogether so beautiful, so boundless, so all-attractive," that he expe-
rienced increasing rapture the longer he stood at the edge of the escarp-
ment. Buckingham had an all-too-frequent experience. At the time he vis-
ited the Mountain House clouds had drifted over the valley floor, com-
pletely obscuring the view from the escarpment. The Mountain House
seemed, to him, an "aerial mansion suspended among the clouds," which

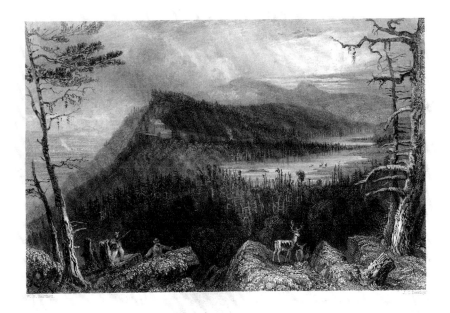

Fig. 10. J. C. Bentley, *The Two Lakes and the Mountain House on the Catskills*. Engraving after a drawing by William Henry Bartlett. Nathaniel Parker Willis, *American Scenery; Or, Land, Lake, and River Illustrations of Transatlantic Nature*, 2 vols. (London: George Virtue, 1840), 1: pl. 50. Photograph: Archives and Special Collections, Dickinson College.

existed in "complete isolation from the world." The following day the clouds started breaking up in mid-morning, and by noon the view to the east was "almost boundless." Altogether, Buckingham conceded, "the prospect was enchanting, and worth going a hundred miles to see."[21]

N. P. Willis described the Mountain House as a "luxurious hotel," with a broad, Greek Revival veranda affording spectacular views of the Hudson Valley. Willis Gaylord Clark found the Mountain House to be "earth's one sanctuary" and the view from the escarpment "a vast and changeful, a majestic, an *interminable* landscape." Elizabeth Fries Ellett, the author of important books on domestic economy, described the hotel's drawing rooms as spacious and the dining room as being "large enough for a feudal banqueting hall." Guests slept in three rows of comfortably furnished rooms of substantial size. As was true of most commentators, Mrs. Ellett judged the food to be excellent.[22]

From the hotel the visitors could hike around South Mountain to an observation point looking southeast over the Hudson Valley; another trail led around North and South lakes to Kaaterskill Creek and followed the watercourse to the top of Kaaterskill Falls and the clove; still another led north along the edge of the escarpment to destinations such as Artist's Rock, Sunset Rock, and Newman's Ledge. Willis particularly favored the view from the escarpment trail at Sunset Rock, looking southwest toward the Mountain House and the two lakes, which numerous artists painted. In a drawing for the engraving *The Two Lakes and the Mountain House* (1840), William H. Bartlett changed the outline of the mountains to make the setting more dramatic, but the rocky foreground, the shoreline of the lakes, and the site of the Mountain House all confirm that this was the vantage from which he sketched (fig. 10). "From the Mountain-House," Willis wrote, "the busy and all-glorious Hudson is seen winding half its silver length—towns, villas, and white spires, sparkling on the shores, and snowy sails and gaily-painted steamers, specking its bosom. It is a constant diorama of the most lively beauty."[23]

One of the earliest visitors to the site of the completed Mountain House was Thomas Cole, who first encountered the Catskills during his 1825 sketching tour of the Hudson Valley. According to his first biographer, Louis Legrand Noble, "From the moment when his eye first caught the rural beauties clustering round the cliffs of Wehawken, and glanced up the distance of the Palisades, Cole's heart had been wandering in the Highlands, and nestling in the bosom of the Catskills." The "romantic scenery" of the Hudson Valley and the Catskills, Noble wrote, "charmed his eye, and took his soul captive." Nature, to Cole and other cultural nationalists of the second quarter of the nineteenth century, would be the source of America's distinctiveness as a culture. "The painter of American scenery," Cole noted in his journal, "has, indeed, privileges superior to any other. All nature here is new to art." Two of the three paintings that launched his career were *Lake with Dead Trees (Catskill)* (1825), a view of South Lake, and *The Falls of the Kaaterskill* (1826), a place Natty Bumppo had described two years before the artist's first visit to the mountains, where Kaaterskill Creek falls sequentially over several levels of rock. Then, Cole wrote with more sophistication than the unlettered frontiersman, "struggling and foaming through the shattered fragments of the mountains, and shadowed by fantastic trees, it plunges into the gloomy depths of the valley below." The overall effect was "savage and silent grandeur." Kaaterskill Falls was, and remains, a place of striking beauty and surely is one of the most frequently painted and illustrated sites in nineteenth-century American art.[24]

Cole loved the Catskill Mountains, and in 1827 he began summering in the village of Catskill, today a sleepy Hudson Valley town but then a rapidly growing community that he soon made his permanent home. Just to the west of the village the mountains rise to majestic heights and present a spectacular view of the river. From Cedar Grove, his Catskill home, Cole made frequent sketching trips to nearby mountains as well as more extended tours in search of picturesque beauty. He represented the annual prospect of returning to New York City for the winter season as wearisome, professing to be happiest in the country and perceiving the city with a "presentiment something like of evil." To friend and fellow painter Asher B. Durand Cole prescribed an existence similar to his own: "You must come & live in the country," he advised, as "Nature is a sovereign remedy" and "in the country we labour under more healthy influences" than in the city.[25]

Years earlier Washington Irving had described the Catskills in terms of "mighty forests that have never been invaded by the axe; deep umbrageous valleys where the virgin soil has never been outraged by the plough; [and] bright streams flowing in untasked idleness, unburdened by commerce, unchecked by the mill-dam." But the impact of tourism and other forms of economic development on the Hudson Valley landscape became a source of great concern to Cole and Irving. They recognized, as did James Fenimore Cooper and a number of their contemporaries, that the march of time and the march of progress made it imperative that antebellum Americans preserve the landscape that was so much a part of their collective heritage. In *The Pioneers*, Cooper's fictional Elizabeth Temple expressed regret that her father's enterprise was "taming the very forests" and lamented, "How rapidly is civilization treading on the footsteps of nature!" In two of the most memorable chapters in the book, accounts of a pigeon shoot and fish seining on Lake Otsego, Natty Bumppo articulated a conservation ethic: "Put an ind, Judge, to your clearings. Ain't the woods his work as well as the pigeons? Use, but don't waste. Wasn't the woods made for the beasts and birds to harbour in?"[26]

The same pattern of exploitation and development Leatherstocking decried on the banks of Lake Otsego was evident in the Hudson Valley. Stands of hemlock on hillsides near the Catskill Mountain House were cut to provide the bark essential to the tanning process; indeed, the name of a nearby town, Tannersville, is a telling reminder that it was more economical to bring hides to tanneries in the forest than to bring the trees to urban centers. Like the farmer whose dwelling Sanford R. Gifford depicted in *Hunter Mountain, Twilight* (1866) (fig. 11; pl. XVIII), who had trans-

Fig. 11. Sanford R. Gifford, *Hunter Mountain, Twilight,* 1866. Oil on canvas, 30 ⅝ x 54 ⅛ in. Daniel J. Terra Collection (1999.57). Photograph: Terra Foundation for American Art, Chicago / Art Resource, NY.

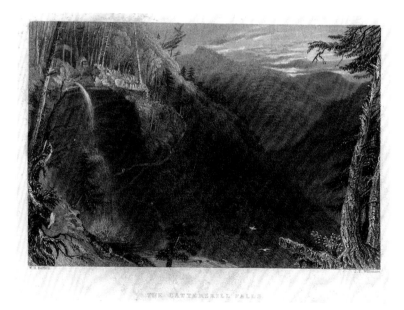

Fig. 12. J. T. Willmore, *The Caaterskill Falls (from above the Ravine).* Engraving after a drawing by William Henry Bartlett. Nathaniel Parker Willis, *American Scenery; Or, Land, Lake, and River Illustrations of Transatlantic Nature,* 2 vols. (London: George Virtue, 1840), 2: pl. 3. Photograph: Archives and Special Collections, Dickinson College.

formed a hemlock forest into a stump-strewn pasture, settlers on the frontier ravaged the environment: they cut trees with the enthusiasm of Cooper's fictional Billy Kirby, whose heroic efforts cleared forests with such efficiency that Natty Bumppo fled west to escape the settlers' axe. There was an observation platform at the top of Kaaterskill Falls, which Bartlett drew for the engraving published in *American Scenery* (fig. 12). Cole included the structure in his 1825 drawings of the falls but chose not to incorporate it in the painting of the scene he completed the following year (fig. 13; pl. I). A sawmill at Parmenter's Pond, which produced the lumber used in building the Catskill Mountain House, impounded the once-free flowing water of Kaaterskill Creek, and during dry summers no water cascaded over the falls. Mrs. Ellett described how, when she walked down to the shelf where the upper falls reached a pool, the amount of water cascading over the falls was "suddenly increased by opening the dam above, so that its roar fills the gorge." When she reached the base of the falls the dam once again opened "and the clouds of sunny spray rise and fill the amphitheatre; then melt away as before, while the fall assumes its former thread-like appearance." George William Curtis, who described a visit to the falls in 1852, was surprised to learn that the owners of the Mountain House had erected a pavilion near the top of the falls, and when visitors arrived the dam was opened and the water "*turned on* to accommodate poets and parties of pleasure." The human presence in the landscape had altered, and commercialized, what Natty Bumppo considered the best evidence of the divine in the wilderness.[27]

Moreover, tourism was transforming the landscape experience in the Catskills. As early as 1835 Thomas Cole recorded in his journal his distaste for the visitors to the Mountain House, who were more interested in indoor games and dancing than in the "magnificence that nature [has] spread around them." The artist dismissed such behavior as a "desecration of the place where nature offers a feast of higher holier enjoyment!" The dramatic enlargement of the Catskill Mountain House Charles L. Beach undertook in the mid-1840s, as well as the construction of numerous other hotels, including the Laurel House at the very top of Kaaterskill Falls, made a visit to the escarpment less a retreat from urban civilization than a social event. Wholesale deforestation had transformed the very scenery visitors to the Catskills encountered, while the tanning process also resulted in the pollution of the streams descending from the mountains through the cloves to the Hudson. The Clove Road was built not to give tourists yet another landscape experience but to provide access to a deposit of iron oxide essential in making the red paint used on barns and often on three

Fig. 13. Thomas Cole, *Falls of Kaaterskill*, 1826. Oil on canvas, 43 x 36 in. From The Warner Collection of Gulf States Paper Corporation on view at The Westervelt-Warner Museum of Art, Tuscaloosa, AL.

sides of rural houses. The mountains, in short, were losing the very qualities that had made them appealing to artists, writers, and those individuals making tours in search of the picturesque.[28]

In his "Essay on American Scenery" Cole was surely referring to places near the village of Catskill when he lamented that the "beauty of such landscapes are quickly passing away—the ravages of the axe are daily increasing—the most noble scenes are made desolate, and oftentimes with a wantonness and barbarism scarcely credible in a civilized nation." Then Cole ominously added, "The way-side is becoming shadeless, and another generation will behold spots, now rife with beauty, desecrated by what is called improvement; which, as yet, generally destroys Nature's beauty without substituting that of Art." While working on *The Course of Empire* (1833–1836), Cole wrote to his patron Luman Reed and observed bitterly: "the copper-hearted barbarians are cutting down all the trees in the beautiful valley on which I have looked so often with a loving eye." Two weeks later Cole penned a second letter to Reed, a prominent New York City merchant, on one level apologizing that "what I said about the tree-destroyers

might be understood in a more serious light than I intended." He expressed relief that "some of the trees will be saved yet." With more than a touch of sarcasm he returned to the condemnation of the improvers: "If I live to be *old enough*, I may sit down under some bush[,]the last left in the utilitarian world[,]and feel thankful that Intellect in its march has spared one vestige of the Ancient Forest for me to die by."[29]

What is so striking about the essay and the letters to Reed is that Cole was reversing the usual progression from barbarism to civilization that an earlier generation, including Timothy Dwight and John Agg, as well as contemporaries such as Andrew Jackson Downing, N. P. Willis, and a host of others, had celebrated. As economic development was transforming the landscape of the Hudson Valley, Cole realized that the civilizers were those who cut down the forests to bring fields into cultivation, who were destroying scenes of natural beauty out of greed or ignorance or philistinism. The civilizers, whom he characterized as "dollar-godded utilitarians," had become the modern barbarians.[30]

Historian Alan Wallach has demonstrated convincingly that Cole's painting *River in the Catskills* (1843) is an antipastoral, "a deliberate attack on the conventions of pastoral landscape painting and consequently on a pervasive, if often contested, ideology that lauded improvement and mate-

Fig. 14. Thomas Cole, *River in the Catskills*, 1843. Oil on canvas, 27 ½ x 40 ⅜ in. Museum of Fine Arts, Boston. Gift of Martha C. Karolik for the M. and M. Karolik Collection of American Paintings, 1815–1865 (47.1201). Photograph: © 2005 Museum of Fine Arts, Boston.

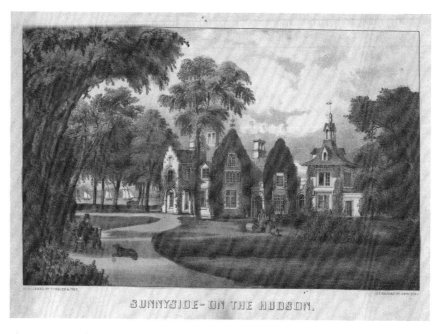

SUNNYSIDE- ON THE HUDSON.

Fig. 15. *Sunnyside—On the Hudson,* c. 1850. Published by Currier & Ives. Hand-colored lithograph, 8 x 12 ½ in. Private collection.

rial progress." Specifically, the painting conveys Cole's anger at the construction of the Canajoharie and Catskill Railroad alongside the Catskill River (fig. 14; pl.VII). On August 1, 1836 Cole wrote in his journal, "I took a walk last evening, up the valley of the Catskill, where they are now constructing the railroad. This was once my favorite walk; but now the charm of solitude and quietness is gone." Five years later, when delivering a "Lecture on American Scenery" to the Catskill Lyceum, he repeated the substance of his earlier "Essay on American Scenery" but added a long passage that denounced the destruction of landscape near the village: "within the last ten years, the beauty of its environs has been shorn away; year by year the groves that adorned the banks of the Catskill wasted away." Cole heaped scorn on the railroad builders and profiteers who sacrificed natural beauty in the name of improvement:

> This is a spot that in Europe would be considered as one of the gems of the earth; it would be sought for by the lovers of the beautiful, and protected by law from desecration. But its beauty is gone, and that which a century cannot restore is cut down; what remains? Steep, arid banks, incapable of cultivation, and

seamed by unsightly gullies, formed by the waters which find no resistance in the loamy soil. Where once was beauty, there is now barrenness.

If to many Americans the railroad represented progress, to Cole it was an unsettling, destabilizing force at odds with nature.[31]

Washington Irving's experience with the railroad paralleled Cole's. The veranda of his beloved Sunnyside faces west, toward Tappan Zee, where the Hudson River is more than three miles wide and where, according to Diedrich Knickerbocker, Dutch sailors "always prudently shortened sail, and implored the protection of St. Nicholas when they crossed." The Palisades, a vertical wall of rock opposite Manhattan and the Bronx, is visible on the west bank to the south, and High Tor and the Hudson Highlands loom over the river to the north. Irving, who loved the secluded location, acquired the former Van Tassel cottage in 1835 and transformed it into a "little nookery somewhat in the Dutch style, quaint, but unpretending." Irving described the cottage as "made up of gable-ends, and full of angles and corners as an old cocked hat." Almost immediately Sunnyside became an iconic building, a physical extension of the creator of Hudson Valley folklore and history, which was engraved and illustrated in A. J. Downing's *Treatise on the Theory and Practice of Landscape Architecture* (1841), published as a lithograph by Nathaniel Currier and James Ives (fig. 15), and the subject of a handsomely-illustrated article in *Harper's Monthly*.[32]

Sunnyside stands approximately twenty feet from an embankment. Today, and for more than a century and a half, railroad tracks separate Irving's cottage from his beloved Hudson River. To the south of the house the lawn curves gently to the east, and rushes wave in a gentle breeze where once there was a cove in the river. The landscape is a reminder that before the coming of the railroad Sunnyside stood on a point with water to the south and west, a stepped-gabled sentinel keeping watch over the river. Irving, who in the introduction to a collection of his writings about the Hudson River thanked God that he was born on its banks and attributed to his childhood landscape "much of what is good and pleasant in my own heterogeneous compound," was deeply concerned at the prospect of a railroad on the east bank of the Hudson, which, according to his nephew, would "bring the nuisance, with all its noise and unsightliness, to his very door, and mar forever ... the peculiar charms for which he had chosen the spot—its quiet and retirement." The railroad literally invaded the authorial garden, and on August 7, 1850 Irving wrote an aggrieved letter to Gouverneur Kemble protesting the "infernal alarum of your railroad

steam trumpet" that awakened him at midnight and left him in a "deplorable state of nervous agitation." Irving once commented tellingly on the spirit of improvement abroad in the land: "if the garden of Eden were now on Earth, they would not hesitate to run a railroad through it." T. Addison Richards, who together with George P. Morris visited Sunnyside in 1855, surely reflected Irving's sentiments when he observed that the "intrusion of the railroad" had "profaned so much of the river shore" and destroyed some of the "sweetest features" of the author's landscape.[33]

Cooper, Cole, and Irving were not the only voices lamenting the impact of civilization on the American landscape. Just as ominous a warning was sounded by a critic in the *Literary World*. Reviewing the annual exhibition of the National Academy of Design in 1847, an anonymous author found special poignancy in a pair of Staten Island landscapes painted by Jasper Francis Cropsey. There was an essential lesson in Cropsey's works:

> The axe of civilization is busy with our old forests, and artisan ingenuity is fast sweeping away the relics of our national infancy. What were once the wild and picturesque haunts of the Red Man, and where the wild deer roamed in freedom, are becoming the abodes of commerce and the seats of manufacture. Our inland lakes, once sheltered and secluded in the midst of noble forests, are now laid bare and covered with busy craft; and even the old primordial hills, once bristling with shaggy pine and hemlock, like old Titans as they were, are being shorn of their locks, and left to blister in cold nakedness in the sun.

This anonymous reviewer recognized that "Yankee enterprise has little sympathy with the picturesque," and charged American artists with the responsibility to "rescue from its grasp the little that is left, before it is for ever too late." The recording of the American landscape, this writer concluded, was the artist's high and sacred "mission." The advance of civilization was destroying nature, and it became the painter's mission—a word replete with religious connotations—to capture and preserve the beauties of the New World before they were sacrificed to Mammon.[34]

Few people heeded the warnings of the artists and writers who articulated a preservationist ethic, or found in the pages of the *Literary World* a compelling reason to protect the landscape. Even the enduring popularity of George P. Morris's poem "Woodman, Spare That Tree," which had been set to music by Henry Russell in 1837 and which pledged that the

woodman's "axe shall harm it not," did not foster a change in attitude that promoted a conservationist ethic. The pattern of development, of fundamental transformation of landscape, continued. In the century and a half that followed Cole's and Irving's deaths, however, their beloved Hudson Valley became the most important place in the emergence of modern environmentalism in the United States. In the early years of the twentieth century the American Scenic and Historic Preservation Society successfully campaigned to preserve the Palisades as well as the Revolutionary War battleground at Stony Point. A generation later Maxwell Anderson served as chair of the Committee to Save High Tor, one of the most identifiable mountains on the west bank of the Hudson, near Haverstraw, and helped raise money to purchase the land and transfer it to Palisades Interstate Park. The origins of the Storm King case, which led directly to the National Environmental Policy Act of 1969, as well as other landmark victories in the environmental movement, can surely be traced to the preservationist ethic Cole, Irving, and Cooper articulated, and to the nineteenth-century artists and writers whose works sanctified the Hudson Valley as the iconic American landscape.[35]

Notes

I am grateful to the Center for Advanced Study in the Visual Arts, National Gallery of Art, where I had the privilege of being an Ailsa Mellon Bruce Visiting Senior Fellow, and to the Winterthur Museum, where I was a Robert Gill Research Fellow, during the time I completed much of the research and writing of this article. I am especially indebted to Deans Elizabeth Cropper, Therese O'Malley, and Peter Lukehart as well as members of the Center for their encouragement, and to Gary Kulik and Cate Cooney at Winterthur. I am also grateful to Nancy Siegel and Phillip Earenfight for the care with which they conceived, edited, and produced this volume.

1. James Fenimore Cooper, *The Pioneers; Or, The Sources of the Susquehanna* (1823; New York: Penguin Books, 1988), 292–294.

2. Roland Van Zandt, *The Catskill Mountain House* (1966; Hensonville, NY: Black Dome Press, 1991), 19–44; John Sears, *Sacred Places: American Tourist Attractions in the Nineteenth Century* (1989; Amherst, MA: University of Massachusetts Press, 1998), 3–11. See also Kenneth J. Myers, *The Catskills: Painters, Writers, and Tourists in the Mountains, 1820–1895* (Yonkers, NY: Hudson River Museum of Westchester, 1988).

3. Kenneth J. Myers, "On the Cultural Construction of Landscape Experience: Contact to 1830," in David C. Miller, ed., *American Iconology: New Approaches to Nineteenth-Century Art and Literature* (New Haven: Yale University Press, 1993), 75; James Fenimore Cooper, *Home as Found* (1838; New York: Capricorn Books, 1961), 202. In a review of Adam Seybert's *Statistical Annals of the United States of America* (1818) published in *Edinburgh Review* 33 (January 1820): 79, Sidney Smith wrote: "In the four quarters of the globe, who reads an American book, or goes to an American play, or looks at an American picture or statue?" See also Sears, *Sacred Places*, 4.

4. Andrew Jackson Downing, "A Visit to Montgomery Place," in *Rural Essays. By A. J.*

Downing. Edited, with a memoir of the author, by George William Curtis; and a letter to his friends, by Frederika Bremer (New York: George P. Putnam, 1853), 192.

5. Auguste Levasseur, *Lafayette in America in 1824 and 1825; Or, Journal of a Voyage to the United States,* trans. John D. Godman, 2 vols. (Philadelphia: Carey and Lea, 1829), 1:99–100; John Fowler, *Journal of a Tour in the State of New York, in the Year 1830* (London: Whittaker, Treacher, and Arnot, 1831), 38.

6. Washington Irving, *A History of New York, From the Beginning of the World to the End of the Dutch Dynasty...by Diedrich Knickerbocker* (1809; Philadelphia: J. B. Lippincott & Co., 1871), 389–390.

7. James Silk Buckingham, *America, Historical, Statistical, and Descriptive,* 3 vols. (London: Fisher, Son & Co, 1841), 2:241–242; George Wilson Pierson, *Tocqueville in America* (1938; Baltimore: Johns Hopkins University Press, 1996), 172; Irving, *History of New York,* 391–392. Several publications described the mountain as St. Anthony's Nose. See, for example, *Sketches of the North River* (New York: W. H. Collyer, 1838), 58–59, and *The New York State Tourist. Descriptive of the Scenery of the Hudson, Mohawk, & St. Lawrence Rivers* (New York: A. T. Goodrich, 1842), 20–21.

8. In his Afterword to Irving's *The Sketch-Book of Geoffrey Crayon, Gent.* (New York: New American Library, 1961), 377, for example, Perry Miller characterized "Rip Van Winkle" as "an adaptation to the Hudson River landscape of an old German tale" and dismissed it and "The Legend of Sleepy Hollow" as "plagiarisms from German folklore." A more persuasive assessment of Irving's sense of place and contribution to American folklore is Judith Richardson, *Possessions: The History and Uses of Haunting in the Hudson Valley* (Cambridge: Harvard University Press, 2003), 40–80. See also Timothy Dwight, *Travels in New England and New York,* ed. Barbara Miller Solomon, 4 vols. (1821–1822; Cambridge: Belknap Press of Harvard University Press, 1969), 3:281, 250, 312–313.

9. Raymond O'Brien, *American Sublime: Landscape and Scenery of the Lower Hudson Valley* (New York: Columbia University Press, 1981), 140–141; A. J. Downing, "American Highland Scenery. Beacon Hill," *New-York Mirror* 12 (March 14, 1835): 293–294; Wallace Bruce, *The Hudson River by Daylight* (1873; New York: Gaylord Watson, 1876), n.p.

10. Fowler, *Journal of a Tour in the State of New York,* 39; Frances Trollope, *Domestic Manners of the Americans,* ed. Donald Smalley (1832; New York: Vintage Books, 1960), 368; Pierson, *Tocqueville in America,* 172; Buckingham, *America, Historical, Statistical, and Descriptive,* 2:214–242; John Hill, with engravings after watercolors of William G. Wall, *Hudson River Port Folio* (1821–1825; New York: G. & C. & H. Carvill, 1828), text accompanying pl. XVI. For information on John Agg see Myers, *Catskills,* 188.

11. Thomas Cole, "Essay on American Scenery" (1835), in John W. McCoubrey, ed., *American Art 1700–1960: Sources and Documents* (Englewood Cliffs, NJ: Prentice Hall, 1965), 108; Benson John Lossing, *The Pictorial Field-Book of the American Revolution; Or, Illustrations, by Pen and Pencil, of the History, Biography, Scenery, Relics, and Traditions of the War for Independence,* 2 vols. (New York: Harper & Brothers, 1850), 2:98–102; O. L. Holley, *The Picturesque Tourist; Being A Guide through the Northern and Eastern States and Canada* (New York: J. Disturnell, 1844), 55; Charles Newhall Taintor, *The Hudson River Route. New York to Albany, Saratoga Springs, Lake George, Lake Champlain, Adirondacks and Montreal* (New York: Taintor Brothers, 1869), facing 31; *New York State Tourist,* 20; Cooper, *Pioneers,* 292. The author of *The Hudson Illustrated with Pen and Pencil* (New York: T. W. Strong, 1852), 3, observed, "Besides its physical

beauties, however, the Hudson is consecrated by hallowed memories of some of the most heroic and touching passages in the story of our War of Independence." See also Frances F. Dunwell, *The Hudson River Highlands* (New York: Columbia University Press, 1991), 13–31.

12. Dunwell, *Hudson River Highlands,* 25–31; Tracie Felker, "First Impressions: Thomas Cole's Drawings of His 1825 Trip Up the Hudson River," *American Art Journal* 24, nos. 1 and 2 (1992): 60–93. See also Lossing, *Pictorial Field-Book,* passim, and Lincoln Diamant, *Chaining the Hudson: The Fight for the River in the American Revolution* (New York: Citadel Press, 1989).

13. Dwight, *Travels in New England and New York,* 3:303–304, 313.

14. Dwight, *Travels in New England and New York,* 2:346–347; Downing quoted this passage in "The Moral Influence of Good Houses," *Horticulturist* 2 (February 1848): 346. See also Solomon's introduction to Dwight, *Travels in New England and New York,* 1: xxxiii–xxxiv.

15. Hill, *Hudson River Port Folio,* text accompanying pl. XV.

16. O'Brien, *American Sublime,* 85–101; Hill, *Hudson River Port Folio,* text accompanying pl. XV (quoting Isaiah 40:3-5).

17. Cecilia Tichi, *New World, New Earth: Environmental Reform in American Literature from the Puritans through Whitman* (New Haven: Yale University Press, 1979), 1–36; Downing, "American Highland Scenery. Beacon Hill," 293–294; Downing, "The Dans-Kamer. A Reverie in the Highlands," *New-York Mirror* 13 (October 10, 1835): 117–118; *Hudson Illustrated with Pen and Pencil,* 3. The author of *New York State Tourist,* 30, shared Downing's assessment that the view from Beacon Hill was superior to that from the Catskill escarpment.

18. Nathaniel Parker Willis, with illustrations by William H. Bartlett, *American Scenery; Or, Land, Lake, and River Illustrations of Transatlantic Nature,* 2 vols. in 1(1840; Barre, MA: Imprint Society, 1971), 6, 2. In his "Essay on American Scenery" Cole wrote, "American associations are not so much of the past as of the present and the future." See McCoubrey, *American Art 1700–1960,* 108.

19. Hill, *Hudson River Port Folio,* text accompanying pl. XIV; Willis, *American Scenery,* 74, 69, 321; *Hudson River, and the Hudson River Railroad, with a complete map, and wood cut views of the principal objects of interest upon the line* (New York: W. C. Locke; Boston: Bradbury & Guild, 1851), 41. On the preservation of the Hasbrouck House see David Schuyler, "The Sanctified Landscape: The Hudson River Valley, 1820 to 1850," in *Landscape in America,* ed. George F. Thompson (Austin: University of Texas Press, 1995), 93–109.

20. Dwight, *Travels in New England and New York,* 4:122–123; Bruce, *Hudson River by Daylight,* n.p., 57, 67.

21. Van Zandt, *Catskill Mountain House,* 3-44; Harriet Martineau, *Retrospect of Western Travel,* 3 vols. (1838; reprint ed., New York: Greenwood Press, 1969), 1:84; Fowler, *Journal of a Tour in the State of New York,* 171; Buckingham, *America, Historical, Statistical, and Descriptive,* 2:252, 259–260.

22. Willis, *American Scenery,* 152–153; Willis Gaylord Clark, "Extract from the 'Ollapodiana' Papers of Willis Gaylord Clark," in [Charles L. Beach, compiler], *Scenery of the Catskill Mountains as described by Irving, Cooper, Bryant, Willis Gaylord Clark, N. P. Willis, Miss Martineau, Tyrone Power, Park Benjamin, Thomas Cole, and Other Eminent Writers* (New York: D. Fanshaw, 1843), 14; [Elizabeth Fries] Ellett, "The Fourth at Pine Orchard," in [Beach], *Scenery of the Catskill Mountains,* 24–25. See also Van

Zandt, *Catskill Mountain House,* and Alf Evers, *The Catskills: From Wilderness to Woodstock,* rev. ed. (1972; Woodstock, NY: Overlook Press, 1982), 351–365.

23. Willis, *American Scenery,* 152–154.

24. Louis Legrand Noble, *The Life and Works of Thomas Cole,* ed. Elliot S. Vesell (1853; Cambridge: Harvard University Press, 1964), 34, 148, 258–259.

25. Noble, *Life and Works of Thomas Cole,* 140; Cole to Asher B. Durand, Sept. 12, 1836, Thomas Cole Papers, New York State Library, Albany, NY (hereafter cited as Cole Papers). See also Cole to Durand, June 12, August 30, and November 18, 1836, Cole Papers.

26. Washington Irving, "The Catskill Mountains," in *A Landscape Book, by American Artists and American Authors: Sixteen Engravings on Steel from Paintings by Cole, Church, Cropsey, Durand, Gignoux, Kensett, Miller, Richards, Smillie, Talbot, Weir* (New York: G. P. Putnam & Son, 1868), 23; Cooper, *Pioneers,* 212, 248.

27. Felker, "First Impressions," 80–81; Myers, *Catskills,* 40–46; Ellett, "The Fourth at Pine Orchard," 26; George W. Curtis, *Lotus-Eating: A Summer Book* (New York: Harper & Brothers, 1852), 47–56. The "canny sawmiller," to borrow Catskills chronicler Alf Evers's characterization, saw an opportunity to turn a profit: he built a shanty at the top of the falls, and when tourists neared the base of the cataract the manager, for a fee, "opened the gates of the millpond" and provided them with a spectacle of nature. Evers, *Catskills,* 363. Kevin Avery, catalogue entry for *Hunter Mountain, Twilight,* in Metropolitan Museum of Art, *American Paradise: The World of the Hudson River School* (New York: Metropolitan Museum of Art, 1987), 229–231, presents a conservationist interpretation of the painting. In *Gifford Pinchot and the Making of Modern Environmentalism* (Washington, DC: Island Press, 2001), Char Miller also interprets *Hunter Mountain, Twilight* as a conservationist painting. By contrast, Oswaldo Rodriguez Roque, "The Exaltation of American Landscape Painting," in *American Paradise,* 41, argues that the "well-established formulas of anecdotal landscape painting first set down by Cole in this country served admirably in allowing American artists to deal with the march of progress."

28. Cole, journal, July 5, 1835, in *Thomas Cole, The Collected Essays and Prose Sketches,* ed. Marshall Tymn (St. Paul, MN: The John Colet Press, 1980), 130; [Beach], *Scenery of the Catskill Mountains,* n.p.; Elizabeth Cromley, "A Room With a View," in John S. Margolies and Alf Evers, *Resorts of the Catskills* (New York: St. Martin's Press for the Architectural League of New York, 1979), 5–30; Rev. Charles Rockwell, *The Catskill Mountains and the Region Around. Their Beauty, Legends, and History. With sketches in prose and verse, by Cooper, Irving, Bryant, Cole, and Others* (New York: Taintor Brothers, 1867), 323–331; *New York State Tourist,* 42.

29. Cole, "Essay on American Scenery," 109; Cole to Luman Reed, March 6 and March 20, 1836, Cole Papers. There is a striking similarity between Cole's language and that of Henry David Thoreau. In "Walking," *Atlantic Monthly* 9 (June 1862): 660, Thoreau wrote: "Nowadays almost all man's improvements, so called, as the building of houses, and the cutting down of the forest and of all large trees, simply deform the landscape, and make it more and more tame and cheap."

30. Cole to Reed, March 20, 1836, Cole Papers.

31. Alan Wallach, "Thomas Cole's *River in the Catskills* as Antipastoral," *Art Bulletin* 84 (June 2002): 334–350; Noble, *Life and Works of Thomas Cole,* 164; Cole, "Lecture on American Scenery: Delivered Before the Catskill Lyceum, April 1, 1841," *Northern Light* 1 (May 1841): 25–26, in Tymn, *Thomas Cole, Collected Essays and Prose Sketches,* 211.

Thoreau shared Cole's perception that the railroad was an intrusion on the landscape. See also Leo Marx, *The Machine in the Garden: Technology and the Pastoral Ideal in America* (New York: Oxford University Press, 1965) and Susan Danly and Leo Marx, eds., *The Railroad in American Art: Representations of Technological Change* (Cambridge: MIT Press, 1988).

32. Irving, *Sketch-Book*, 329; Geoffrey Crayon [pseud. for Washington Irving], ed., *A Book of the Hudson, Collected from the Various Works of Diedrich Knickerbocker* (New York: G. P. Putnam, 1849), vii; Washington Irving to Peter Irving, July 8, 1835, in Pierre M. Irving, *Life and Letters of Washington Irving*, 4 vols. (New York: G. P. Putnam, 1862–1864), 3:75; "Sunnyside," in Wallace Bruce, ed., *Along the Hudson with Washington Irving* (Poughkeepsie, NY: A.V. Haight, 1913), 109; Andrew Jackson Downing, *A Treatise on the Theory and Practice of Landscape Gardening, Adapted to North America...*(New York: Wiley & Putnam, 1841); [T. Addison Richards], "Sunnyside," *Harper's Monthly* 14 (December 1856): 1–21.

33. Irving, *Book of the Hudson*, vii; Irving, *Life and Letters of Washington Irving*, 4:36–37, 67; Historic Hudson Valley, *Visions of Washington Irving: Selected Works from the Collections of Historic Hudson Valley* (Tarrytown, NY: Historic Hudson Valley, 1991), 122; Richards, "Sunnyside," 8. James Fenimore Cooper, "American and European Scenery Compared," in Washington Irving, et al., *The Home Book of the Picturesque: Or, American Scenery, Art, and Literature* (New York: G. P. Putnam, 1852), 65, also expressed a sense of loss at the impact of the railroad: "this great improvement of modern intercourse has done very little towards the embellishment of a country in the way of landscapes."

34. "The Fine Arts. Exhibition at the National Academy," *Literary World* 1 (May 15, 1847): 347–348. See also Nicolai Cikovsky Jr., "'The Ravages of the Axe': The Meaning of the Tree Stump in Nineteenth-Century American Art," *Art Bulletin* 61 (December 1979): 611–626.

35. George Pope Morris, "Woodman, Spare That Tree," in Edmund Clarence Stedman, *Poems, Lyrical and Idyllic* (New York: Charles Scribner, 1860), 64–65; Richardson, *Possessions*, 173–203, presents an excellent discussion of Anderson's 1937 play *High Tor* and the battle to preserve the mountain.

Decorative Nature:

The Emblematic Imagery
of Thomas Cole

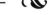

NANCY SIEGEL

*A*fter the last spoonful of potage had been consumed, imagine the delight of a mid-nineteenth-century dinner guest finding a land-scape scene by Thomas Cole at the bottom of his or her soup plate, revealed under layers of broth, vegetables, and bits of meat. What better complement to such a satisfying meal than to remind the diner of America's bounty, scenic wonders, and the success of democracy in the New World. But how could such overarching sentiments be gleaned from staring at the bottom of dinnerware, and why were American landscapes gracing the bottom of soup plates? The answer has less to do with culinary matters and more to do with the rise in interest in American landscape imagery, a market driven economy, and the value of ornamented utilitari-an objects in America between 1830 and 1860. This essay addresses the popular demand for American landscape imagery in the mid-nineteenth century and the dissemination of such imagery in the art market through engraved and ceramic variations and copies. In the case of Cole's work, aesthetic values were transmitted through the purchase of objects adorned with the artist's imagery. During a short span of time between 1819 and 1823, Thomas Cole traveled twice through Pennsylvania along the Juniata River and across the Allegheny Mountains. Four years later he captured his memories of those days in a drawing, *Scene in the Alleghany Mountains* (c.1827) (fig. 16), that formed the basis for a painting (now lost), which in turn provided the imagery for a widely published engraving (fig. 17; pl. II) in John Howard Hinton's two-volume book *The History and Topography of the United States* (1830–1832), and ultimately became the pattern for transfer ware soup plates (c.1831–1861) by the pottery firm of William Adams & Sons in Staffordshire, England (fig. 18; pl. III). Appealing to an emerging middle class and a variety of tastes, the application of Cole's

Fig. 16. Thomas Cole, *Scene in the Alleghany Mountains*, c. 1827. Black ink on paper, 6 ¼ x 9 ½ in. Juniata College Museum of Art, Huntingdon, PA.

work to mass-produced items such as engravings and Staffordshire soup plates serves as a case study in material culture as a means of promoting interest in the American landscape through its dissemination to a wide audience.[1] Such objects, then, become a vehicle to promulgate values and ideas. The intended meaning and the received meaning of these items may have differed; however, as objects with inherent content, they functioned as barometers of aesthetic, didactic, and even patriotic significance as a rise in nationalism coincided with a rise in interest in American landscape imagery by the 1830s.

The point of origin for this extensive dissemination of imagery begins with Cole's 1827 drawing *Scene in the Alleghany Mountains* (fig. 16), which is based upon recollections of the travels he made through the Allegheny Mountains of Pennsylvania first in 1819 and again in 1823.[2] Prior to his arrival in the United States in 1818, Cole was exposed in his native England to a juxtaposition of harsh industrial urbanism and rural, bucolic country-side that would shape his disdain for industrial progress, his love of nature,

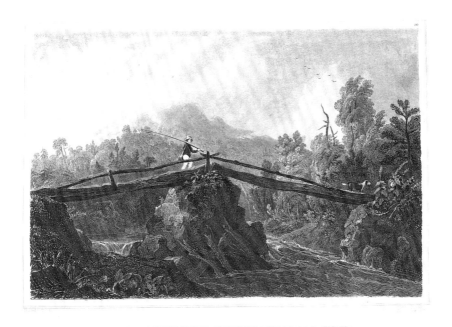

Fig. 17. Fenner Sears & Co. after Thomas Cole, *Head Waters of the Juniata Alleghany Mountains, Pen[n]sylvania,* 1831. Hand-colored engraving. John Howard Hinton, *The History and Topography of the United States,* 2 vols. (London: I. T. Hinton & Simpkin & Marshall, 1830–1832), 2: pl. 20. Juniata College Museum of Art, Huntingdon, PA.

and would last throughout his life. The Cole family arrived in Philadelphia in July of 1818, and as a result of failed business attempts, Cole's father, James, moved the family to Steubenville, Ohio. Thomas remained behind temporarily, having found work making woodcut illustrations for an 1818 American edition of John Bunyan's *The Holy War* (1682).[3] In the summer of 1819, Cole decided to leave Philadelphia and join his family in Steubenville to assist in his father's paper hanging business.[4] He would have traveled from Philadelphia to Pittsburgh by way of the Pennsylvania Road (now Route 30) via wagon, coach, and on foot. This southern route across the state would have provided him access to the imagery of the Allegheny Mountains. Once Cole crossed the Alleghenies and rejoined his family in Ohio, he spent the next two years in Steubenville at work drawing patterns for wallpaper designs and mixing colors as well as making engravings upon wood. He then traveled throughout Ohio as an unsuccessful itinerant portraitist and by 1823 made his way back through the

Fig. 18. William Adams & Sons, Staffordshire, England, after Thomas Cole, *Head Waters of the Juniata, U.S.*, c. 1831–1845. Ceramic soup plate, 10 ½ in. dia. Private collection.

Allegheny region on his way east to Philadelphia and ultimately to New York to pursue the practice of his art.[5]

So where precisely is the location depicted in Cole's drawing? Based on a travel diary by Cole's father, plus information on the development of roadways between 1819 and 1823, and on the topographical details Cole included in his drawing, this scene may well depict a bridge crossing in Bedford County a few miles off of the Pennsylvania Road and a likely stopping point for the artist. The Pennsylvania Road originated as the Raystown Path, a Native American Indian footpath that eventually evolved into an expanded transportation system.[6] During the French and Indian Wars (1754–1763) General John Forbes enlarged the Raystown Path for use as a military road.[7] The later transition from military road to public transport system meant the development of industry and lodging establishments along the way. The Pennsylvania Road (following the main line of the old Forbes Road and subsuming the Allegheny and Raystown Paths, as well as the Philadelphia-Lancaster Turnpike) provided numerous opportunities for lodging, food, and drink between Philadelphia and

Pittsburgh. In the early 1800s, the trip could be made by stage coach in six days, although James Cole took the slower (and ostensibly less expensive) means of traveling approximately three hundred miles via freight wagon which, according to his journal, took about three weeks (fig. 19). One famous rest area was the "Juniata Crossings" six and a half miles east of Everett, where the Pennsylvania Road crosses the Raystown Branch of the Juniata River. General Forbes gave the crossing its notoriety and numerous taverns and stage coach offices were established in this location.[8] McGraw's Old Tavern, built in 1818, was located two plus miles on the west side of the bridge. Additionally, a second crossing was located thirteen miles west of the "Juniata Crossings" in Bedford.[9] Within Bedford County, this area was viewed as "one of the most glorious sections of the highway [which] lies between Everett and the covered bridge, buried in the forest, which leads across the Raystown Juniata."[10] Benjamin Latrobe, who traveled from Washington to Pittsburgh between 1813 and 1816, was also taken by the scenery around Bedford. In 1815, he stayed at Hartley's Tavern (currently a private residence), four and a half miles east of Bedford and, like Cole, stopped to sketch along the Raystown Branch of the Juniata River.[11] This region remained popular for tourists and travelers alike and was illustrated and photographed throughout the nineteenth century.

Cole's drawing is inscribed "*Scene in the Alleghany Mountains*" and captures with substantial specificity the landscape of the Allegheny region. The focus takes place in the middle ground of a river view where a young man crosses a bridge accompanied by his dog. With a fishing pole slung over his left shoulder, the figure makes his way across a rudimentary bridge that spans the Raystown Branch of the Juniata River. The crossing is laid out to take advantage of a large standing stone midway across the river that serves as a structural component, while in the distance, faint lines suggest the Allegheny Mountains. The drawing presents detail of foliage and identifiable flora such as the mullein stalks in the lower left corner while white pines, common to the region, appear in the right foreground and are scattered in more diminutive forms in the middle distance. The large tree on the left has the architecture, or shape, of an elm tree and the overall effect is one of a lush, dense wooded area with the currents of the river creating a physical divide.[12] Additionally, the geology presented by Cole in this drawing is consistent with the Bedford, Pennsylvania region. The mountains depicted compare with the Tuscarora Ridge, and the steep cliffs are typical of the area along the Juniata River near Everett. On the right side of the drawing, the rock formations with notched shad-

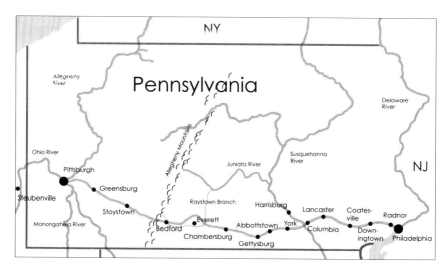

Fig. 19. Map of James Cole's 1818 route from Philadelphia to Pittsburgh.

ing typify the cross-bedding found in the area, as does the horizontality of the flat-lying rocks.[13] The most identifiable object depicted by Cole is a standing stone, a scientific fascination from the eighteenth century, on which rest the timbers of the bridge that crosses an unusually wide section of the river.

However, one must be mindful that while Cole's depiction borders on topographical accuracy, it is truly an idealized memory based upon scenery experienced and viewed years earlier. The drawing was not made on site and was once part of an 1827 sketchbook titled "Book of Sketches from the Pictures which I have painted since my return from the White Mountains, August 1827."[14] The pencil border serving as a compositional frame suggests a finished quality or completed view. As Cole was in the practice as early as 1823 of keeping sketchbooks with studies of individual forms such as trees and geological examples, it is probable that *Scene in the Alleghany Mountains* is a composite image drawn from numerous studies made earlier.[15] Cole's landscape is not wilderness, but neither is it a picturesque ideal. The drawing reflects Cole's ability to combine attributes of Salvator Rosa's sublime with Claude Lorrain's pastoral and results in a suggestively "safe" composition. With regard to progress and the taming of nature, Cole presents not a disturbing presence of mankind or an industrial concern (the railroad is yet to come), but the simple need to traverse the great divide—here, the banks of the Juniata River. As Cole's drawing was not made until four years after his last visit to the area, one must ques-

tion why he chose this location for such a well-developed study if he had not been through central Pennsylvania since 1823. Evidence is found in a second 1827 sketchbook in which Cole noted under possible subjects for future pictures "Views of the Sources of the Rivers of US America— or of Europe would do well for a series of Engravings."[16] While such a commission never came to fruition, the notation reveals that Cole was thinking of imagery related to U.S. rivers in 1827 and this perhaps refreshed his memory of the Juniata.

Further, in both pictures and poems, Cole captured his impressions of nature on paper. He wrote ode-like poetry about locations such as Lake George in 1826, Mount Washington in 1828, Niagara in 1829, and in his "Essay on American Scenery" of 1835 Cole refers specifically to the Allegheny Mountains whose beauty, if not height, rivaled that of Europe's mountain ranges.[17] In 1827, the year of Cole's drawing of central Pennsylvania, he wrote a lengthy poem detailing his impressions of this region. This first stanza describes the travels of a wanderer far from home:

> Over the Alleghany's savage steeps
> My weary feet have borne me
> When the cold rain has fallen and the storm
> Has howl'd around. Oh! Then I knew what 'twas
> To be a wanderer distant from home
> Friendless and poor—Yet though my heart was chill'd
> Despair was far, for beams of pleasure shot
> A thwart the gloom. And the rude storm around
> Was musical to me, and in my soul
> A light was brightly burning—it was hope
> Which is a dream of joy—a glowing beam
> Sent us by heaven to cheer our darksome away.
> Star of our midnight life in lov'd cherished hope
> Deceiving ever but for aye believed
> Thou promiser of joys that never come
> To thee th' afflicted cling—The dying wretch
> Who withering lies beneath the noonday sun
> On Sahara's desert ever and anon
> Ope's his dim eyes upon the burning waste
> And fondly fancies the far whirling sands
> A caravan quite hasting with relief.[18]

Of course, the wanderer is Cole and the tenor of the poem reflects poignantly his recollections of the hardships and joy he faced on his jour-

neys in 1819 and 1823 between Philadelphia and Pittsburgh, across the Alleghenies. Cole's poetic, if often melodramatic, memory of his travel is far more imaginative than the topographical drawing that accompanies his poem. Here, image and text speak somewhat different languages, as the drawing suggests the solitude of the traveler across the bridge without the sense of emotive effervescence so prevalent in Cole's poetry.[19] Lastly, it is probable that *Scene in the Alleghany Mountains* provided the basis for a small 1827 painting titled *Crossing the Stream* (private collection) as the compositional similarities are unmistakable. This may be the painting referred to by Cole as *View in the Alleghanies* in his 1830s "List of Pictures painted by me."[20] It is apparent that for Cole the year 1827 was replete with memories of central Pennsylvania.

Cole would take *Scene in the Alleghany Mountains* with him to Europe in June of 1829, as he had secured a commission in London to provide twelve views representative of the American landscape for a book edited by John Howard Hinton on the history and topography of the United States.[21] Cole chose from his sketchbooks popular sites such as Niagara Falls and picturesque scenery such as the Allegheny Mountains of Pennsylvania as the inspiration for paintings he would loan to engravers to illustrate Hinton's two-volume publication *The History and Topography of the United States* (1830–1832). Cole provided ten paintings and two drawings from which the engraving team of Fenner Sears & Co. made the following illustrations: *Head Waters of the Juniata Alleghany Mountains, Pen[n]sylvania* (fig. 17; pl. II); *Ruins of Fort Ticonderoga, New York* (fig. 20); *Lake George* (fig. 21); *A View Near Conway, N. Hampshire* (fig. 22); *White Mountains, New Hampshire* (fig. 23); *A Distant View of the Falls of Niagara. From an original Picture in the possession of Joshua Bates. Esq. Painted by T Cole, Esq.* (fig. 24); *Monte Video the Residence of D. Wadsworth, Esq., Near Hartford, Connecticut* (fig. 25); *The Falls of Cattskill, New York* (fig. 26); *Hartford, Connecticut* (fig. 27); *Timber Raft on Lake Champlain* (fig. 28); *View of the Cattskill Mountain House, N.Y.* (fig. 29); and *View from Mount Washington* (fig. 30).[22]

The title from the 1827 drawing has become *Head Waters of the Juniata, Alleghany Mountains, Pennsylvania,* which may have been the title for the painting (now lost) from which engravers made this scene. Like the drawing, the engraving features the young lad with a fishing pole slung casually over his shoulder, crossing a rudimentary wood bridge accompanied by his dog. The center of the bridge rests upon a rocky outcropping with the currents of the river flowing below. However, the engravers, who were working not from the drawing but from a painting, tended to simplify

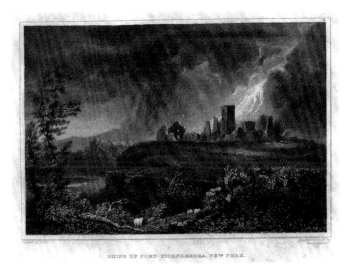

Fig. 20. Fenner Sears & Co. after Thomas Cole, *Ruins of Fort Ticonderoga, New York*, 1831.
Engraving. John Howard Hinton, *The History and Topography of the United States,*
2 vols. (London: Simpkin & Marshall, and Philadelphia: Thomas Wardle, 1832),
1: pl. 21. Photograph: Courtesy of Archives and Special Collections, Franklin and
Marshall College, Lancaster, PA.

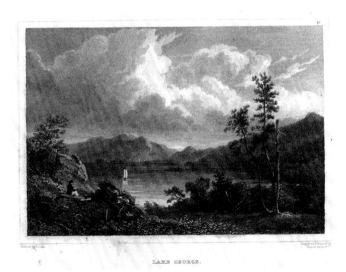

Fig. 21. Fenner Sears & Co. after Thomas Cole, *Lake George*, 1831. Engraving. John
Howard Hinton, *The History and Topography of the United States*, 2 vols.
(London: Simpkin & Marshall, and Philadelphia: Thomas Wardle, 1832), 2: pl. 25.
Photograph: Courtesy of Archives and Special Collections, Franklin and Marshall
College, Lancaster, PA.

Fig. 22. Fenner Sears & Co. after Thomas Cole, *A View Near Conway, N. Hampshire*, 1831. Engraving. John Howard Hinton, *The History and Topography of the United States*, 2 vols. (London: Simpkin & Marshall, and Philadelphia: Thomas Wardle, 1832), 2: pl. 28. Photograph: Courtesy of Archives and Special Collections, Franklin and Marshall College, Lancaster, PA.

Fig. 23. Fenner Sears & Co. after Thomas Cole, *White Mountains, New Hampshire*, 1831. Engraving. John Howard Hinton, *The History and Topography of the United States*, 2 vols. (London: Simpkin & Marshall, and Philadelphia: Thomas Wardle, 1832), 2: pl. 30. Photograph: Courtesy of Archives and Special Collections, Franklin and Marshall College, Lancaster, PA.

Fig. 24. Fenner Sears & Co. after Thomas Cole, *A Distant View of the Falls of Niagara. From an original Picture in the possession of Joshua Bates. Esqr. Painted by T Cole Esqr.*, 1831. Engraving. John Howard Hinton, *The History and Topography of the United States,* 2 vols. (London: Simpkin & Marshall, and Philadelphia: Thomas Wardle, 1832), 2: pl. 37. Photograph: Courtesy of Archives and Special Collections, Franklin and Marshall College, Lancaster, PA.

Fig. 25. Fenner Sears & Co. after Thomas Cole, *Monte Video the Residence of D. Wadsworth, Esqr., Near Hartford, Connecticut*, 1831. Engraving. John Howard Hinton, *The History and Topography of the United States,* 2 vols. (London: Simpkin & Marshall, and Philadelphia: Thomas Wardle, 1832), 2: pl. 39. Photograph: Courtesy of Archives and Special Collections, Franklin and Marshall College, Lancaster, PA.

Fig. 26. Fenner Sears & Co. after Thomas Cole, *The Falls of Cattskill, New York*, 1831.
Engraving. John Howard Hinton, *The History and Topography of the United States*,
2 vols. (London: Simpkin & Marshall, and Philadelphia: Thomas Wardle, 1832),
2: pl. 44. Photograph: Courtesy of Archives and Special Collections, Franklin and
Marshall College, Lancaster, PA.

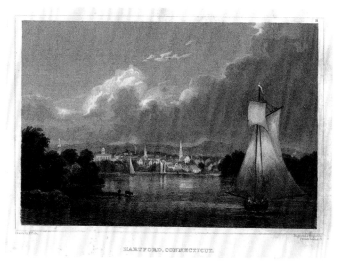

Fig. 27. Fenner Sears & Co. after Thomas Cole, *Hartford, Connecticut*, 1831. Engraving.
John Howard Hinton, *The History and Topography of the United States*, 2 vols.
(London: Simpkin & Marshall, and Philadelphia: Thomas Wardle, 1832), 2: pl. 51.
Photograph: Courtesy of Archives and Special Collections, Franklin and Marshall
College, Lancaster, PA.

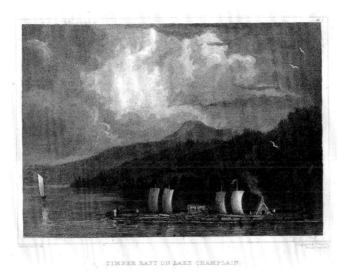

Fig. 28. Fenner Sears & Co. after Thomas Cole, *Timber Raft on Lake Champlain*, 1831.
Engraving. John Howard Hinton, *The History and Topography of the United States,*
2 vols. (London: Simpkin & Marshall, and Philadelphia: Thomas Wardle, 1832),
2: pl. 55. Photograph: Courtesy of Archives and Special Collections, Franklin and
Marshall College, Lancaster, PA.

Fig. 29.
Fenner Sears & Co. after
Thomas Cole, *View of the
Cattskill Mountain House,
N.Y.*, 1831. Engraving.
John Howard Hinton,
*The History and
Topography of the United
States,* 2 vols. (London:
Simpkin & Marshall, and
Philadelphia: Thomas
Wardle, 1832), 2: pl. 59.
Photograph: Courtesy of
Archives and Special
Collections, Franklin and
Marshall College,
Lancaster, PA.

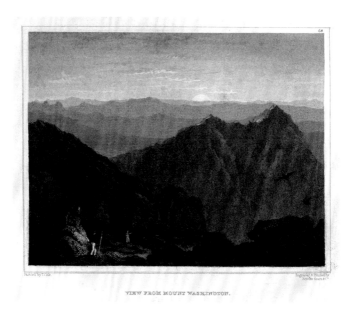

VIEW FROM MOUNT WASHINGTON.

Fig. 30. Fenner Sears & Co. after Thomas Cole, *View from Mount Washington*, 1831.
Engraving. John Howard Hinton, *The History and Topography of the United States,*
2 vols. (London: Simpkin & Marshall, and Philadelphia: Thomas Wardle, 1832),
2: pl. 68. Photograph: Courtesy of Archives and Special Collections, Franklin and
Marshall College, Lancaster, PA.

characteristics. As a result, the landscape became stylized and flat, thus losing a fair amount of its identifiable flora. The highly recognizable mullein stalks are included, but the majority of foliage has the appearance of generalized brush. The background now includes stylized spruces instead of identifiable white pines.[23] The majority of the trees appear too simplified to recognize with specificity, and in the foreground the boy crossing the river has become most awkward in his proportions. His legs, located beneath the wooden railing, fail to align with his torso. A greater bulbous quality is apparent in the depiction of his head and posterior, the latter of which appears to ride atop the wooden rail.

Of those ten paintings Cole provided for this project, their whereabouts, including the *Head Waters of the Juniata*, remain a mystery. However, Ellwood Parry has noted the existence of two small oils which correspond to the Hinton project. He believes that a small painting titled *Storm near Mt. Washington* (Yale University Art Gallery) may have been the basis for the engraving *White Mountains, New Hampshire*, while *Distant View of Niagara Falls* (The Art Institute of Chicago), an 1830 com-

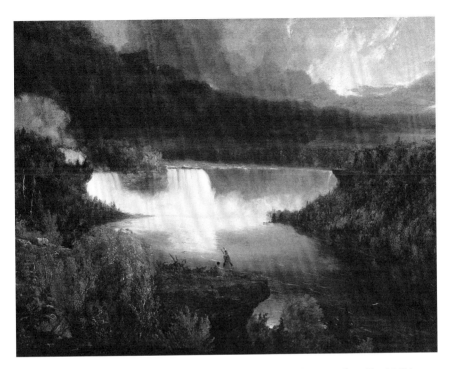

Fig. 31. Thomas Cole, *Distant View of Niagara Falls,* 1830. Oil on panel, 18 ⅞ x 23 ⅞ in. The Art Institute of Chicago. Friends of American Art Collection (1946.396). Photograph: © The Art Institute of Chicago.

position (fig. 31; pl. V), served as the basis for the engraving *A Distant View of the Falls of Niagara.*[24] The Niagara engraving appeared as the frontispiece of volume two in the 1830–1832 edition with the caption reading: "A DISTANT VIEW OF THE FALLS OF NIAGARA. From an Original Picture in the possession of Joshua Bates. Esq. Painted by T Cole Esq." Scholars at first assumed that the engraving was made from the seven-foot-long canvas of the scene owned by Joshua Bates. However, Cole painted six known views of the falls (Bates owned two views), thus complicating which version was used for Hinton's project.[25] However, a comparison of the engraving (fig. 24) with the painting in the Art Institute of Chicago reveals a strong compositional relationship.

Although Cole provided paintings for ten of the above-mentioned images, the engravings for his Connecticut views, *Hartford, Connecticut* and *Monte Video the Residence of D. Wadsworth, Esq., Near Hartford, Connecticut,* were based on drawings. Cole was obviously pleased with the commission and curious to know of its reception in the United States. In

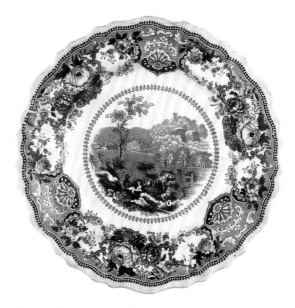

Fig. 32. William Adams & Sons, Staffordshire, England, after Thomas Cole, *Monte Video, Connecticut, U.S.*, c. 1831–1845. Ceramic plate, 6 ¾ in. dia. Private collection.

a letter to his patron and friend Daniel Wadsworth, Cole wrote from Florence enquiring if Wadsworth knew of the Hinton publication as Cole's depiction of Monte Video, Wadsworth's summer home, was one of the featured engravings. "One of the views of Monte Video I had engraved in England & I intended to send you a number of the proofs but I left England rather suddenly…You have perhaps seen the Work for which the View was engraved—The History & Topography of the US."[26] Although Cole had composed an earlier 1828 painting of the estate (Hartford, Wadsworth Atheneum) looking south, his engraving of Monte Video (looking north) compares with greater accuracy to an 1820 engraving after a drawing by Wadsworth himself of his estate (fig. 48).[27] This view would also be selected and copied by Staffordshire artisans (fig. 32; pl. IV).

Hinton's publication was intended to serve as a compendium of information, a most exhaustive book on the collective topic of the United States. Volume one provided the history of the country until roughly 1825. Volume two provided topographical material divided into chapters on geography, geology, mineralogy, zoology, botany, customs and religion, and other esoteric discussions. The two-volume set was adorned with engraved illustrations to which Hinton made reference in the original preface:

It is with pleasure that reference can be made to the plates by which this history is illustrated. They exhibit to the eye, in no inferior style of sort, a more extended series of American views than has hitherto been given to the public in any form, and tend more to familiarize the mind of a foreigner with American objects and scenery than the most accurate verbal description.[28]

Hinton accentuated the importance of the illustrations contained within, and purchasers of the book were treated to a set of fine engravings illustrating the American landscape by prominent artists. Volume two contained seventy-five engravings by eleven identified artists including Cole (twelve views), Alexander Jackson Davis (thirteen views), and William Guy Wall (three views).[29] Hinton's book was immediately popular and subsequent editions were reissued by American publishers almost simultaneously in Boston, New York, and Philadelphia which continued until the 1860s.

As early as 1832 American publishers relied upon sets of engravings sent from London and hand-tipped onto stock paper to serve as illustrations for their editions. However, American publishers were under no obligation to utilize the same quantity or placement of images and most editions are markedly different from one another in terms of content and visual imagery. Some publishers even commissioned entirely new plates, larger in dimension, and often of lesser quality than their English counterparts. These later American engravings often eliminated reference to the artists responsible for providing the imagery; thus the engraving of Cole's *Head Waters of the Juniata*, for example, is not credited to the artist in some instances and is completely omitted in other editions. One can also find examples of engravings in later editions that have added marginalia specific to American history (such as battle scenes from the American Revolution) to increase their popular appeal. Riding on the tide of growing nationalism, detailed scenes of famous American events only added to the individual's desire to own a piece of America's history through the inexpensive medium of engravings. Oftentimes, illustration pages were cut from their bindings, hand-colored, and framed, thus becoming independent works of art (fig.17; pl. II). By adding color, the owner of the engraving enhanced (with varying degrees of success) the printed image, attempting to make it more realistic and more like a painted scene by Thomas Cole himself.[30] The imagery from the engraving would also be utilized in later publications unrelated to the Hinton project, suggestive of its broad appeal and connection to the American landscape. For example, the scene was included as a simplified woodblock illustration (fig. 33) in

Fig. 33.
Engraver unknown,
Trout-fishing in Wyoming
[PA], 1852. Wood
engraving. Eli Bowen,
The Pictorial Sketch-Book
of Pennsylvania. Or, Its
Scenery, Internal
Improvement, Resources
and Agriculture, Popularly
Described (Philadelphia:
Willis P. Hazard, 1852),
238. Private collection.

Eli Bowen's *The Pictorial Sketch-Book of Pennsylvania* (1852), which featured a discussion of popular fishing locations. The figure with his fishing pole, now taller and more slender and without his dog, was employed as a generic representative for sporting activities in the region.

The manner in which Cole's contributions to Hinton's book functioned, as a visual embellishment to a text, played an important role in the marketing, sale, and ultimate success of the publication. Both scientific and poetic discourses on the American landscape were deemed more valuable by the public when texts were accompanied by illustrations, as noted by Hinton in his preface. Thus, prose could be read verbally and visually, demonstrating the symbiotic relationship between the written word and the printed image. How one "read" the landscape contributed to a greater interest in and appreciation of the land in the formation of a national identity. American landscape illustrations reflected on a larger level evolving philosophies concerning national sentiment and scientific knowledge, oftentimes instructing viewers how they should receive images of the land through geological, historical, or romanticized portrayals, even if most

readers were uncertain whether the images depicted correct views, romantic adaptations, or embellished memories. How the landscape was depicted versus how it existed provided readers, who relied upon illustrations and engraved images, with information on regions they were unfamiliar with, which is of great importance as there is a strong relationship between the reception of engraved landscape views and the promotion of tourism.[31] Enormous potential existed for illustrated texts to educate and enlighten, thus defining how the public viewed and valued the American landscape. The desire for American and European publishers to include depictions of the landscape connected the physical landscape to the cultural landscape, which in turn promoted interest, both national and international, in the American landscape experience.

Cole would continue to contribute to the field of illustration throughout the 1820s and 1830s. He made at least two lithographs with Anthony Imbert in New York City, and in addition to his participation in Hinton's *The History and Topography of the United States*, Cole provided numerous works to be engraved in publications throughout the 1830s.[32] For example, in 1830 *A View Near Ticonderoga* appeared in *The Talisman* (also in Hinton's book); *Chocorua's Curse* was published in *The Token*; and an illustration of Cole's painting *Winnipiseogee Lake* was engraved by Asher Brown Durand and included in volume one of William Cullen Bryant's *The American Landscape* (1830). Cole also contributed to *The Magnolia* in 1837, and an engraving after his painting *Schroon Lake* was utilized posthumously in *The Home Book of the Picturesque* (1852); numerous engravings after Cole can also be found in *Ornaments of Memory* (1856).[33] Thus, the popularity of Cole's images, while not available to the widest audience as painted originals, could certainly be enjoyed by a growing segment of society through mass-produced reproductions.

The dissemination of landscape imagery is a fascinating study that includes not only nineteenth-century publishing practices but also the decorative arts market, specifically transfer ware ceramics imported from Staffordshire, England. With the release of the first edition of Hinton's *The History and Topography of the United States* came wide exposure of Cole's artistry through his engravings. The recipients of these engravings included English potters such as William Adams, Job and John Jackson, and Enoch Wood, who would prosper by transferring Cole's images onto their ceramic soup plates and platters. Many of Cole's engraved images from Hinton's book were immediately adopted for use on Staffordshire pottery, and it would appear that the issuance of Hinton's book proved the popularity of American scenery as salable subject matter. As Esther Seaver has

Fig. 34. William Adams & Sons, Staffordshire, England, after Thomas Cole, *Head Waters of the Juniata, U.S.*, c. 1831–1845, detail illustrating misaligned border pattern. Ceramic soup plate, 10 ½ in. dia. Private collection.

noted, "not only did this publication [Hinton's] bring the artist's American subjects to the attention of the English, but it was the source from which the Staffordshire potters Adams, Jackson and Wood appropriated the paintings of Cole for their wares."[34]

The soup plate *Head Waters of the Juniata* (fig. 18, pl. III) is an example of such imported pottery produced between 1831 and 1861 by the William Adams & Sons firm. The image depicted was copied from the Hinton engraving after Cole. The young man on his way to fish crosses the rudimentary bridge over a portion of the Juniata River. His dog leads the way in this scene set within the Allegheny Mountains. The relationship between the engraving in Hinton's book and the Staffordshire soup plate is immediately evident. It is interesting to note how the image that Cole originally sketched in 1827 has become simplified and coarse as it was transferred from drawing to painting to engraving to soup plate. Measuring 10 ½ inches in diameter and printed in pink on a white body, this soup plate, which was also offered in sepia, is part of a series of dinnerware service known as the *American Views* series (c. 1831–1861). Its function is utilitarian and the service would have been marketed to middle-class individuals who need not have possessed great economic advan-

tage. The plate, with its scalloped rim, is not to be confused with fine porcelain, which is more vitreous due to the use of purer ingredients that result in a whiter, thinner product. This is not to suggest that Staffordshire pottery was poorly made or not sought after. To the contrary, mid-nineteenth-century buyers from the growing middle class to the rural worker demanded a ready supply of refined household objects, including attractive dinnerware, from their retail merchants. The desire to display the well-appointed table, and proof of one's taste and status, did much to encourage potters in England to supply mass-marketed yet handsome and affordable ware.[35]

The process of producing transfer ware involved numerous steps. After a particular scene or pattern had been selected (such as an engraving from Hinton's book), a designer would modify the image and adapt it for use on a desired ceramic shape before engraving it onto a copper plate. The plate was then warmed and oil-based color was rubbed into the engraved lines of the plate and the excess wiped away. The plate was then covered with a thin sheet of transfer paper (the weight of tissue paper) and put through a printing press. Pressure from the press transferred the image from the plate onto the paper, which was then given to a worker (usually a woman) to trim, leaving only the design. The women then carefully placed the designs on unglazed pieces of pottery which were immersed in cold water. The water forced the ink from the paper to constrict while the paper floated away, leaving the design on the ceramic form. The pieces were dried, baked in a kiln, and glazed. Once glazed with a protective coating, the works were re-fired to make them non-porous and durable. Because the transferred image was placed under the glaze, called underglaze printing and perfected by the 1750s, Staffordshire ware would be less resistant to chipping or wear from repeated soap and water cleanings. As the process of engraving copper plates was expensive, the transfer technique was employed when a large run of objects was to be produced.[36]

The advantages of this process allowed not only for quantity but for consistency of design if not always for quality. The workers who were hired to place the transfer designs carefully laid the paper in a manner to match the shape of the object. However, as these were not generally skilled artisans, but poorly paid workers, great care was often lacking.[37] For example, on the *Head Waters of the Juniata* soup plate, one can find areas where the pattern does not line up properly (fig. 34). An inch above the shell on the left-hand side of this soup plate the outlines of the outermost patterns do not meet. In fact, there is a discernable juncture between two different sections of border, demonstrating an error in the cutting and placement of

the border transfers. As the border pattern was individually cut and placed for every piece in the series, each object possesses its own idiosyncratic markings. Stray lines of color and a variety of border mishaps are typical of Staffordshire ceramics. To the modern collector, such charming occurrences add character to these earthenware pieces as they suggest the presence of human fallibility in industrial, mass-produced goods.

The Staffordshire potters took a certain degree of artistic license with their use of engraved images, often altering designs, simplifying imagery, or adding features to increase their attractiveness. By examining the Hinton engraving and the *Head Waters of the Juniata* soup plate, one finds that interesting variations are present. The sky and mountains show the effect of a stipple technique as the cloud formations in particular demonstrate the use of dotted marks to suggest atmosphere. The foreground foliage has become overly simplified by comparison and feathery treetops frame the earthenware image. A tall, wispy tree, not present in the engraving, has been added, filling the space to eliminate undue amounts of unadorned sky while adding to the overall decorative nature of the soup plate. The flora in the foreground lacks all semblance of scale in relation to the scene, but it becomes a visual link to the floral border. The figure of the young man has become even more awkward than in the engraving and the sense of dense scenery has been eliminated. Although the appearance is somewhat schematic, the inclusion and position of the telltale mountains, the young man, and the bridge perched upon a rocky mass with timbers run aground demonstrate that the Staffordshire soup plate has its history ultimately in the drawing by Thomas Cole as interpreted through the engraving from Hinton's publication.

Stylized shells and large peony flowers surround the border of this plate with smaller garlands of flowers encircling and entwining around scrolls. Flowers were a popular motif for decorative borders, and peonies, roses, camellias, and forget-me-nots were often employed. While they are beautiful, it is unlikely that these flowers were chosen for symbolic meaning as opposed to elegant embellishment.[38] The pink tone found on the border and on the interior scene is complemented with areas of deeper burgundy, and both tones stand out against the white background. Beyond the border of the plate is the slope, or cavetto, left unadorned, but linked to the central image through the use of a foliate design that encircles the central scene and the object of the viewer's attention.[39] On the reverse of this plate, the backstamp contains the inscription, "HEAD WATERS OF THE JUNIATA U.S." (a shortened version of the Hinton title) surrounded by an oval floral cornucopia and crowned with an American eagle, a mark

utilized by potters to designate those objects destined for the market in the United States.[40]

Such ceramics were imported from England in a variety of shapes and sizes and in large quantities to serve every need a diner may have had.[41] By the late eighteenth and early nineteenth centuries, changing patterns in eating and the social mores associated with food gave rise to the interest in earthenware that was not only utilitarian but attractive.[42] Thus, potters in Staffordshire commanded a wide margin both in popularity and in the production and sale of ceramics. The Industrial Revolution and the ability to mass-produce inexpensive goods allowed potters in the Staffordshire district to dominate the market.[43] Major producers included William Adams & Sons, Enoch Wood, James and Ralph Clews, and Job and John Jackson. From the earliest pre-Revolutionary imports to the middle of the nineteenth century, tastes in Staffordshire pottery in America changed to include plain creamware, Asian-inspired patterns, historical imagery, and popular by the 1830s, landscape views.

The William Adams & Sons potters, out of Stoke-on-Trent and Tunstall, produced two very popular series designed specifically for the export market to the United States: the *Columbus Views* and the *American Views* series, the latter of which included the soup plate with Cole's imagery.[44] The series consists of twelve views depicting locations of picturesque or historical interest.[45] All of the scenes in the *American Views* series were adapted from engravings in Hinton's *The History and Topography of the United States*. Seven of the Staffordshire plates were based on engravings after Thomas Cole: *Cattskill Mountain House* (fig. 35); *Falls of Niagara*; *Head Waters of the Juniata* (fig. 18; pl. III); *Lake George*; *Monte Video, Connecticut* (fig. 32, pl. IV); *View Near Conway, N Hampshire* (fig. 36); and *White Mountains, New Hampshire*. Other artists represented include William Guy Wall (*Skenectady on the Mohawk River*), Jacques Milbert (*Military School, West Point, N.Y.*), J[ules?] Dupré (*New York*), William Goodacre, Jr. (*Harper's Ferry*), and Charles W. Burton (*Shannondale Springs, Virginia*). Technical advances in firing techniques allowed for these ceramics to be offered in various colors such as red, green, sepia, purple, and pink.[46] The set was united not by the color of the items, or by the type of plate or dish, but by the floral border pattern which remained consistent regardless of the scene depicted.

The height of production for exported transfer ware items occurred between 1815 and 1835. It is difficult to ascertain with precision the popularity of series such as *American Views*; however, George Miller has conducted exhaustive research into the index values and import quantities of

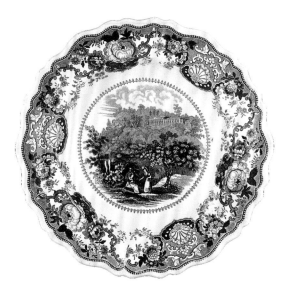

Fig. 35. William Adams & Sons, Staffordshire, England, after Thomas Cole, *Cattskill Mountain House, U.S.*, c. 1831–1845. Ceramic soup plate, 10 ½ in. dia. Private collection.

Staffordshire pottery.[47] Because of the large amount of Staffordshire pottery being imported, potteries discounted their merchandise to counter the import taxes levied by the United States. Based on invoice evidence in 1830 for example, 13,945,234 pieces of Staffordshire ware were imported into the United States, while in 1835 that number increased to 17,527,271 pieces to be sold.[48] Demand was still high after this period; between 1835 and 1845 the Staffordshire potters targeted an even wider portion of the consumer population (lower income earners) while lessening the quality and creativity of their designs.[49] Popular border patterns with decorative floral medallions were often copied by competing manufacturers and potters could appropriate images from any book with impunity, without financial remuneration to artists or publishers.

The ability of a family to purchase a set of dishes and serving pieces signaled more than financial status. Domestic refinement and the addition of attractive wares was comparable to social betterment and cultural awareness. As Stuart Blumin has noted, middle-class women were responsible for the decoration and adornment of their home as "central to the new canons of domesticity," with the parlor perceived as an "emblem of the respectable woman."[50] The selection of household goods for public spaces raises issues of not only refinement, but of morality as well. Diana

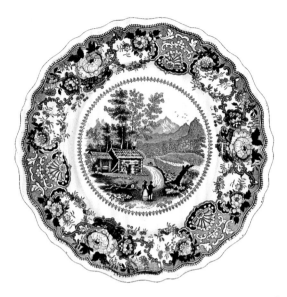

Fig. 36. William Adams & Sons, Staffordshire, England, after Thomas Cole, *View Near Conway, N Hampshire, U.S.*, c. 1831–1845. Ceramic plate, 9 in. dia. Private collection.

di Zerega Wall discusses the "language of dishes" from the perspective of historical archaeology, asserting that middle-class women served as the moral guardians of their families.[51] The selection of the appropriate dish pattern could instill a desire for finery in her children and perhaps, and more importantly, educate them on the history and topography of the United States. These highly decorous items exemplify the economics of purchasing beauty. As examples of material culture, they demonstrate consumers' desire to possess items that ornament a household in addition to serve a useful function.[52] Through their use, social meaning and status were implied and provided the middle class with an ability to replicate a *perceived* lifestyle of more affluent members of society. The desire to emulate the cultural values of the wealthy was fulfilled in some measure through the purchase and acquisition of a matching set of tableware.

Additionally, a change occurred by the late eighteenth century in eating patterns, social graces, and manners.[53] Anne Smart Martin discusses how the shift from eating out of a common trencher to dining off of individual plates with separate serving pieces communicates ideas about economic and social status.[54] Modifications in eating patterns from the late eighteenth century to the mid-nineteenth century relate to changes from a pre-industrial age when home and the workplace were often one and the

same to an industrial society in which the workers (usually men) left the home in the morning and returned in the evening.[55] Owning a large set of dishes, while commonplace by modern thought, emerged as an important demonstration of proper breeding and social/societal awareness. "The availability of new and better wares engendered aesthetic appreciation, better manners, and a more pleasant dwelling environment," notes Martin.[56] The early nineteenth-century, middle-class consumer of household goods preferred to demonstrate sophistication through the purchase of objects related to social entertaining such as a tea or dining service. This practice often took precedence over buying "necessities" such as individual beds.[57] Allowing greater numbers to obtain objects of beauty and worth, relatively speaking, was a distinctly positive benefit of the Industrial Revolution. Our modern notions of individuality and uniqueness when searching for collectibles is out of step with the utilitarian prospect of the early nineteenth-century diner. "Factory" produced was a plus not a negative as industry was viewed by the consumer (not the romantic) as a time-saving, luxury-enabling entity.

A debate exists as to the popularity of transfer ware with historical views. Collectors will confirm the desirability of such pieces, while some historical archaeologists refute this claim based on the limited number of shards and remains that have been found in archaeological digs.[58] These ceramics were valued as collectible in addition to their function as dinnerware and were often displayed in cabinets and passed through family lines as keepsakes and not merely discarded. Further, some scholars question why a diner would want to own ceramics adorned with views of not only landscapes, but of almshouses, hospitals, or penitentiaries. However, the reader must keep in mind that the building of state and federal structures was looked upon with great pride in the early to mid-nineteenth century. Such buildings demonstrated an ability to care for and protect the citizens of the new Republic. The Pittsburgh Penitentiary, for example (as depicted on a 15 inch-long platter by the Clews Brothers of Staffordshire, c. 1832–1834), then the Western State Penitentiary, was allotted funds for construction in 1818 and received its first prisoners in 1826, making it an architectural highlight of western Pennsylvania.[59] The existence of so few trained architects at a time of great population growth resulted in urban development at an increased rate with fame quickly achieved for those responsible for providing new buildings. Large, new structures relating to the establishment and success of republican values were cause for celebration and outings often formed around touring new buildings and their grounds, becoming imagery certainly worthy of gracing the bottom of a plate.

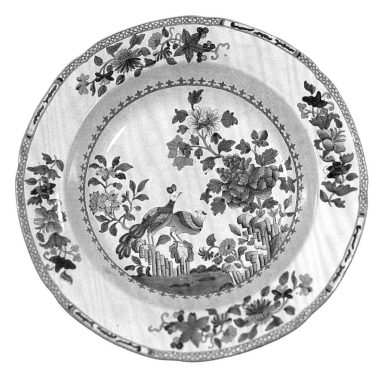

Fig. 37. Staffordshire, England, ceramic soup plate with peacock and peahen design, 10 in. dia. Cole family dinnerware, Cedar Grove, Catskill, NY. Courtesy of the Thomas Cole National Historic Site at Cedar Grove, Catskill, NY. Photograph: Phillip Earenfight.

From a marketing perspective, one wonders also whether or not buyers of this series were aware of the prominent artists ultimately responsible for providing (without their consent or compensation) the images so sought after. For example, Cole's name did not appear on the front of the soup plate, and the backstamp revealed only the scene's location and the Staffordshire pattern symbol. In an interesting turn of events, the middle-class buyer was purchasing the name and reputation not of Thomas Cole, but of Staffordshire products, which proved to be a significant demonstration of cultural refinement to this segment of the market. Even engravings included in later editions (after 1832) of Hinton's *The History and Topography of the United States* omitted the names of the artists responsible for providing painted images for their engravings. Therefore, how could the public know that the *Head Waters of the Juniata* soup plate orig-

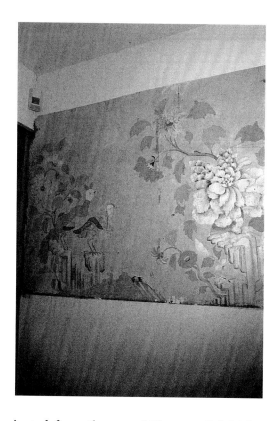

Fig. 38.
Artist unknown, Peacock and peahen decoration based on Staffordshire ceramic design. Fresco, 40 ½ x 63 in. Cedar Grove, Catskill, NY. Courtesy of the Thomas Cole National Historic Site at Cedar Grove, Catskill, NY. Photograph: Phillip Earenfight.

inated from the art of Thomas Cole? These consumers were acquiring taste, not art, thus Staffordshire's ranking over Cole's.

At issue as well is the question of whether or not Thomas Cole, himself, was aware that his engraved images had been pilfered by potters for the *American Views* series, as he would have received no financial remuneration. Advertisements appeared regularly in New York newspapers announcing the arrival of new shipments from England. If Cole knew of the Staffordshire items bearing his imagery, there is no mention of it in his letters or journals.[60] However, given the widespread access to such wares in cities such as New York, one would imagine that if Cole had been unaware of their existence, at least one of his many friends, fellow artists, or patrons would have alerted him to the fact. The transfer of Cole's initial 1827 drawing from an 1819/1823 memory onto a set of Staffordshire soup plates would appear to be the conclusion in this dissemination of imagery—from concept to cupboard. However, Staffordshire pottery plays a further role in the life of Thomas Cole and makes a far more intimate connection. At Cedar Grove, the family home of Cole's wife Maria Bartow,

and where Cole resided from his marriage in 1836 until his death in 1848, the Cole family utilized Staffordshire dinnerware (produced earlier than the Adams *American Views* series) of an Asian-inspired design (fig. 37).[61] During recent conservation efforts at the home, a mural of a peacock and peahen in a fanciful landscape was uncovered in the family dining room revealing a faithful reproduction of the decorative pattern found on the family's ceramics (fig. 38). The hues are more pastel than on the actual plates and the style is a bit naive, but the fact that this scene exists suggests enduring and endearing elements about Staffordshire pottery that would warrant its reproduction by yet another means, the fresco.[62]

When Thomas Cole first arrived in the United States in 1818, the demand for Staffordshire historical ware was just beginning to reach its peak. These wares were both utilitarian and decorative. They were inexpensive and widely available with subject matter that was at once accessible, romantic, and capitalized on increasing national awareness and pride for the American landscape. These works can be classified as examples of both the decorative and industrial arts, for they speak to issues that concern taste and aesthetics as well as social meaning and function. Not only do Staffordshire ceramics reflect how Americans chose to adorn their tables in the early to mid-nineteenth century, but their subjects—the American landscape, sometimes with noteworthy buildings—often included figures walking through the scenery as a means to make these plates and platters more accessible to the viewer. The presence of figures provided a sense of scale for the enormity of the landscape while allowing the user to identify with the locales presented. If they had not actually been to these places, diners at least could romanticize about such an escape.

Thus, the eager soul need not have ventured far from one's library or dinner table to experience American scenery as a result of developments in printing, publishing, and the potter's art. The recipients of engravings and plates adorned with Cole's imagery were not concerned about the scientific accuracy of the flora and foliage depicted. Rather, they were pleased with an enjoyable representation of nature that they believed to be part of the landscape experience as they hoped it still existed. We forgive geographical trespasses and botanical flaws for the intended meaning of an overall impression. Although we know that Cole's landscapes often contain contrived and altered elements, we read his landscapes as identifiably American. Of course the artist depicted fanciful scenes, religious subjects, historical tales, and European views filled with ruins and quaint peasants or pilgrims. However, his views of American scenery fulfilled a desire by the American viewing public in the 1830s and 1840s to attach nebulous

ideologies such as nationalism and ownership to tangible entities in American scenery. As Cole's drawing of a memory that was once specific to the mountains of Pennsylvania was transformed into engravings and transferred onto pottery, a growing segment of American society could afford to purchase these objects and interpret the imagery as emblematic of a cultural identity found within the American landscape.

Notes

This essay is excerpted with additional information from the author's book *Along the Juniata: Thomas Cole and the Dissemination of American Landscape Imagery* (Juniata College Museum of Art in association with University of Washington Press, 2003). The premise of this publication provided the basis for a traveling exhibition of the same title and the ensuing symposium, "Within the Landscape: Perspectives on Nineteenth-Century American Scenery," held at The Trout Gallery, Dickinson College, Carlisle, PA on March 27, 2004. I wish to thank my fellow contributors—Kevin Avery, Matthew Baigell, David Schuyler, and Alan Wallach—for their participation and their generosity as colleagues. Special thanks as well to Phillip Earenfight, Director of The Trout Gallery, for organizing the symposium and leading the process for this publication.

1. For the purpose of this study, the middle class represents an emerging group of primarily urban Americans from the 1820s to the 1840s who were both economically and socially motivated within a capitalist concept of growth and unified by a common cultural ethic to achieve. The matter of defining "middle class" is fraught with difficulties, as Stuart Blumin notes the term is "both pervasive and elusive." Blumin discusses the importance of nonmanual laborers such as retailers, clerks, and merchants as part of this emerging group. See Stuart M. Blumin, *The Emergence of the Middle Class* (New York: Cambridge University Press, 1989), 2–3, 66–107. Material culture has been referred to as "the study through artifacts of the beliefs—values, ideas, attitudes, and assumptions—of a particular community or society at a given time." Jules David Prown, *Art as Evidence—Writings on Art and Material Culture* (New Haven: Yale University Press, 2001), 70.

2. *Scene in the Alleghany Mountains* was given to Juniata College in 1938 by Homer B. Vanderblue. In a note that accompanied a gift of several items pertaining to Cole, Vanderblue wrote, "This sketch is the original from Thomas Cole's notebook bought 1936 from his granddaughter of Catskill NY (Mrs. Vincent who lived in his studio home) of the Headwaters of the Juniata of which I own the painting, engravings, and 2 pink soup plates. HB Vanderblue." The sketchbook to which he refers is Cole's 1827 sketchbook titled "Book of Sketches from the Pictures which I have painted since my return from the White Mountains, August 1827." Curatorial file, Juniata College Museum of Art, from the files of Harold B. Brumbaugh. The existence of this drawing was brought to the attention of Ellwood C. Parry III in 1983 and included in his essay "Thomas Cole's Early Drawings: In Search of a Signature Style," in Detroit Institute of Arts, "A Special Issue: the Drawings of Thomas Cole," *Bulletin of the Detroit Institute of Arts*, 66, no. 1 (1990): 15, n. 27. The removal of this drawing has been noted by Ellwood C. Parry III in *The Art of Thomas Cole: Ambition and Imagination* (Newark, DE: University of Delaware Press, 1988), 58, n. 102, in addition to the curatorial files at the Juniata College Museum of Art. The sketchbook is located

in the Detroit Institute of Arts. However, another page from this sketchbook, which contains the record drawing for *Corroway Peak, N.H. after Sunset*, as illustrated by Parry measures 9 ¼ x 15 ½ inches. *Scene in the Alleghany Mountains* appears on a sheet measuring 9 ¼ x 11 ¾ inches suggesting that this drawing was cut down from its original size or perhaps is a page from a different sketchbook.

3. For a full discussion of Cole's early biography see Siegel, *Along the Juniata*, 18–24. A copy of the 1818 American edition of John Bunyan's *The Holy War* is located at the Pittsburgh Theological Seminary, Pittsburgh, Pennsylvania. Many thanks to Dr. Linda Miller for her assistance in locating this book. The arrival of the Cole family in Philadelphia on July 3rd, 1818 is significant, as the date of Cole's arrival had been in dispute as to whether it occurred in 1818 or 1819. However, Cole's work on the McCarty and Davis edition of *The Holy War* proves his residence in America in 1818, as the next American edition was not published until 1829. This date is important, as Cole's earliest engraved work in America dates to 1818. See Nancy Siegel, "Painted Image, Inspirational Text: Thomas Cole and the Influence of John Bunyan," in Mark Andrew White, ed., *Image and Text: American Creativity and the Relationship between Writing and the Visual Arts* (Wichita: the Edwin A. Ulrich Museum of Art, 2000): 15–26, and David Smith, "Publications of John Bunyan's Work In America," *Bulletin of the New York Public Library* 66 (December 1962): 642. See also Alan Wallach's important discussion of the Cole family lineage, origins, and the relationship to cultural/social mores in England and America in "The Ideal American Artist and the Dissenting Tradition: A Study of Thomas Cole's Popular Reputation," PhD dissertation, Columbia University, 1973; and "Thomas Cole: Landscape and the Course of American Empire," in William H. Truettner and Alan Wallach, eds., *Thomas Cole: Landscape into History* (New Haven: Yale University Press, 1994), 24–25.

4. While Cole was in Philadelphia, a young law student became Thomas's roommate. That summer, Cole traveled with his roommate for a healthful journey to St. Eustatia from January 4 to May 1819. There, Cole drew both inspiration to write as well as to sketch the people and the landscape. His resulting story, "Emma Moreton, A West Indian Tale," was published later in the *Saturday Evening Post* (May 14, 1825). See Parry, *The Art of Thomas Cole*, 373. William Dunlap provides the reader with Cole's biography in Ohio. See Dunlap, *The History of the Rise and Progress of the Arts of Design in the United States*, 3 vols. (1834; Boston: C.E. Goodspeed & Co., 1918), 139.

5. For a detailed chronology of Cole's life in Western Pennsylvania and Ohio see Siegel, *Along the Juniata*, 23–40.

6. Canal travel was not yet possible. Although the Pennsylvania state legislature approved building a canal from Harrisburg to Pittsburgh in December of 1823, construction of the Pennsylvania Canal did not begin until July of 1826, three years after Cole moved through the area. See Harry Sinclair Drago, *Canal Days in America: the History and Romance of Old Towpaths and Waterways* (New York: Clarkson N. Potter, Inc., 1972), 141–143. Canal travel for freight and individuals was popular throughout the 1830s and 1840s, only to be superceded by rail travel.

7. William H. Shank, *Indian Trails to Super Highway* (York, PA: American Canal and Transportation Center, 1988), 4–7, 16.

8. Robert Bruce, *The Lincoln Highway in Pennsylvania* (Washington, DC: National Highways Association, 1920), 81.

9. Bruce, *Lincoln Highway*, 82–84.

10. John T. Faris, *Old Trails and Roads in Penn's Land* (Philadelphia: J.B. Lippincott Co., 1927), 206.

11. See Edward C. Carter III, John C. Van Horne, and Charles E. Brownwell, eds., *Latrobe's View of America, 1795–1820: Selections from the Watercolors and Sketches* (New Haven: Yale University Press, 1985), 326–327.

12. Conversation with Dr. Charles Yohn, Director of the Raystown Field Station, Huntingdon, Pennsylvania, regarding the foliage and flora of central Pennsylvania, September 3, 2002.

13. My thanks to Drs. Helen Delano, Roger Faill, and Donald Hoskins of the Pennsylvania Department of Conservation and Natural Resources for their insight and assistance on the geological aspects included by Cole in this drawing. This conversation about the accuracy of geological depictions by Cole originated from my lecture presented at the Bureau of Topographic and Geologic Survey (Middletown, PA) on October 18, 2002, "Over the River and Through the Woods: Topographical Accuracy and the Art of Thomas Cole."

14. See note 2.

15. Many thanks to Tammis Groft, Chief Curator at the Albany Institute of History & Art for granting me access to Cole's 1823 sketchbook.

16. This sketchbook is at the New York State Library, Albany, NY.

17. These poems are transcribed in Marshall Tymn, *Thomas Cole's Poetry* (York, PA: Liberty Cap Books, 1972).

18. This is the first stanza of the poem; the complete version is found in the Thomas Cole Papers, New York State Library, Albany, NY.

19. Cole's early fondness for the Allegheny Mountains would be maintained throughout his career, at least in a geological sense, as the Catskill Mountains, which provided Cole with a large percentage of his landscape imagery, are part of the Allegheny Plateau.

20. Mention of this connection is made by Ellwood Parry in "Recent Discoveries in the Art of Thomas Cole," *Magazine Antiques* 120, no. 5 (November 1981): 1156. The painting was sold by Cole to Charles Wilkes of New York. See Parry, *The Art of Thomas Cole*, 58.

21. For a discussion of the commission, see Siegel, *Along the Juniata*, 51–61. No evidence has been found to prove with certainty that he had secured his commission with the publishers of Hinton's book before he left for England.

22. This listing comes from the London (1830–1832) edition of Hinton's publication located at the University of Pittsburgh. The Lake George engraving was not present in this version; however, a listing of these illustrations by their date of publication is produced in Parry, *The Art of Thomas Cole,* 109.

23. Thanks to Dr. Charles Yohn, Director of the Field Station at Lake Raystown, Huntingdon, PA for his reading of this painting and for his identification of species of trees and flora related to central Pennsylvania.

24. Parry, *The Art of Thomas Cole*, 108–109.

25. Henry Glassie, "Reevaluation of a Thomas Cole Painting," *Museum Studies* 8 (1976): 106. See Parry, *The Art of Thomas Cole*, 102 for a copy of the advertisement offering Cole's work. Bates was in possession of a second view of the falls, now in the Art Institute of Chicago, which Henry Glassie has identified as the one which appeared in Hinton's book. See Henry Glassie, "Thomas Cole and Niagara Falls," *The New-York Historical Society Quarterly* 2 (April 1974): 91–99.

26. Letter from Cole to Wadsworth, Florence, Italy, July 13, 1832, in J. Bard McNulty, ed., *The Correspondence of Thomas Cole and Daniel Wadsworth* (Hartford: Connecticut Historical Society, 1983), 57.

27. The Wadsworth engraving appears in Benjamin Silliman's, *Remarks Made, On a Short Tour, Between Hartford and Quebec in the Autumn of 1819* (New Haven, CT: S. Converse, 1820). For a discussion of Wadsworth's Tower, see Alan Wallach, "Wadsworth's Tower: An Episode in the History of American Landscape Vision," *American Art* 10, no. 3 (Fall 1996): 9–27.

28. John Howard Hinton, *The History and Topography of the United States*, 2 vols. (London: Fenner Sears & Co., 1830–1832), unpaginated preface.

29. There are several unidentified images. *Military School, West Point, NY* is one; however, Staffordshire records from the *American Views* series reveal that Jacques Milbert was the artist who provided the image. Additionally, reference to H. Brown may be Henry Brown (1816–1870) who provided illustrations while in London in the 1830s.

30. The 1855–1856 Boston edition published by Samuel Walker, for example, makes no reference to the artists ultimately responsible for providing the original art work.

31. For a discussion of tourism in New York State, see Georgia B. Barnhill, "Illustrations of the Adirondacks in the Popular Press," in *Adirondack Prints and Printmakers*, ed. Caroline Mastin Welsh (New York: The Adirondack Museum, 1998), 45; see also Kenneth J. Myers, "Selling the Sublime: The Catskills and the Social Construction of Landscape Experience in the United States, 1776–1876," PhD Dissertation, Yale University, 1990; Kenneth J. Myers, *The Catskills: Painters, Writers and Tourists in the Mountains 1820–1895* (Yonkers, NY: Hudson River Museum, 1987); Raymond J. O'Brien, *American Sublime: Landscape Scenery and the Lower Hudson Valley* (New York: Columbia University Press, 1981).

32. The third known lithograph is a posthumous edition of *The Good Shepherd* (1849). See Janet Flint, "The American Painter-Lithographer," in *Art & Commerce: American Prints of the Nineteenth Century* (Boston: Museum of Fine Arts, distributed by the University Press of Virginia, 1975), 126–129. See also John Carbonell, "Anthony Imbert: New York's Pioneer Lithographer," 20 as cited in Thomas P. Bruhn, *The American Print: Originality and Experimentation* (Storrs, CT: William Benton Museum of Art, 1993), 45.

33. Ralph Thompson, *American Literary Annuals & Gift Books 1825–1865* (New York: H.W. Wilson Co., 1936), appendix catalog.

34. Esther Isabel Seaver, *Thomas Cole 1801–1848: One Hundred Years Later* (Hartford: Wadsworth Atheneum, 1949), 8.

35. For a discussion of the enlarging American household see, Richard L. Bushman, *The Refinement of America: Persons, Houses, Cities* (New York: Alfred A. Knopf, 1992), 76–77, 228–229.

36. Ellouise Baker Larsen, *American Historical Views on Staffordshire China* (1935; New York: Dover Publications, 1975), 285–286; and Jeffrey B. Snyder, *Historical Staffordshire: American Patriots and Views* (Atglen, PA: Schiffer Publishing, 1995), 30.

37. The women hired to cut and lay borders were of the lower working classes, the most poorly paid, and worked in unhealthy conditions. These women served as assistants to the men, and were often paid a percentage of the men's wage. While the women usually worked as transfer and paper cutters, children were also hired to carry clay and turn potters' wheels. Ray Hall discusses these conditions in *Women in the Labor Force: A Case Study of the Potteries in the Nineteenth Century* (Queen Mary College: University of London, 1986), 11–13.

38. Krannert Art Museum, *At Home and Abroad in Staffordshire* (Champaign, IL: Krannert Art Museum, 1988), 20.

39. Krannert Art Museum, *At Home and Abroad in Staffordshire*, 20.

40. David A. Furniss, Richard J. Wagner, and Judith Wagner, *Adams Ceramics, Staffordshire Potters and Pots, 1779–1998* (Atglen, PA: Schiffer Publishing, 1999), 24. There is little consistency to the placement of the backstamp as examples are found in which the mark appears right side up or sometimes upside down relative to the image on the front.

41. George L. Miller, "A Revised Set of CC Index Values for Classification and Economic Scaling of English Ceramics from 1787 to 1880," *Historical Archaeology* 25, no. 1 (1991): 11.

42. Krannert Art Museum, *At Home and Abroad in Staffordshire*, 12.

43. Furniss, et al., *Adams Ceramics, Staffordshire Potters and Pots, 1779–1998*, 21, n. 2. Jeffrey B. Snyder lists the long Staffordshire region and includes more towns in *Historical Staffordshire: American Patriots and Views*, 8. Between 1762 and 1829, the number of people employed in the potteries in Burslem alone rose from 7,000 to 50,000. See Krannert Art Museum, *At Home and Abroad in Staffordshire*, 14.

44. The William Adams family first began as potters in 1448 as noted by legal records relating to a fine imposed upon two Adams brothers for digging up clay along a public highway in Burslem for the intended use of making utilitarian earthenware pots. While providing us with perhaps the origins of the term "pothole," this record establishes the Adams family in the heart of what would become the Staffordshire district. The family expanded and grew in the north Staffordshire region and by 1657 John Adams (1624–1687) established the base pottery, Brick House, from which the Adams family dynasty would grow. Often confusing to follow, the family was run for many decades by a series of cousins all named William: William Adams of Greengates (1746–1805); William Adams of the Brick House, Burslem and Cobridge (1748–1831); William Adams III of Stoke-upon-Trent (1772–1829); and William Adams IV of Greenfield (1798–1865), son of William Adams III. William of Greengates apprenticed under Josiah Wedgwood, producing jasper ware, while the three later branches of the Adams family ran the business during and after the Industrial Revolution. William Adams III set up a pottery for himself, making useful items for the home. In 1819 his eldest son, William Adams IV, appropriately entered the family business and it was under his control that the company name became William Adams & Sons. See Furniss, et al., *Adams Ceramics, Staffordshire Potters and Pots, 1779–1998*, 6–7; and Larsen, *American Historical Views on Staffordshire China*, 141.

45. Larsen, *American Historical Views on Staffordshire China*, 171 notes *Fort Niagara* and *Humphreys U.S.* as listed in the series but examples not yet located. See also Ellouise Baker Larsen, "William Adams," *Magazine Antiques* 4 (October 1939): 171

46. Miller, "A Revised Set of CC Index Values," 9. Underglaze techniques, perfected in the 1750s, allowed for the introduction of new colors such as black, green, sepia, yellow, pink, and red by 1828. This technology also allowed for the application of multiple colors (red, yellow, and blue) to appear on a single transfer. The color of the transfer print can assist in the dating of wares. For example, brown wares were imported into America by 1807. By 1818, dark blue printed wares became very popular and the market bears witness to this trend. See Snyder, *Historical Staffordshire: American Patriots and Views*, 33.

47. See for example Miller, "A Revised Set of CC Index Values," 1–25.

48. Neil Ewins, "'Supplying the Present Wants of Our Yankee Cousins…,': Staffordshire Ceramics and the American Market," *Journal of Ceramic History* 15 (1997): 6, 18.

49. Snyder, *Historical Staffordshire: American Patriots and Views*, 35.

50. Blumin, *The Emergence of the Middle Class*, 238.

51. Diana di Zerega Wall, "Family Dinners and Social Teas: Ceramics and Domestic Rituals," in *Everyday Life in the Early Republic*, ed. Catherine E. Hutchins (Winterthur, DE: Winterthur Museum, 1994), 261.

52. Ann Smart Martin, "Magical, Mythical, Practical, and Sublime: The Meanings and Uses of Ceramics in America," in Robert Hunter, ed., *Ceramics in America* (Milwaukee: Chipstone Foundation, 2001), 30.

53. Martin, "Magical, Mythical, Practical, and Sublime," 37.

54. Martin, "Magical, Mythical, Practical, and Sublime," 39, notes that Native American Indians and African slaves, for example, utilized and maintained their own technologies for producing ceramic ware.

55. Wall, "Family Dinners and Social Teas: Ceramics and Domestic Rituals," 260–261.

56. Martin, "Magical, Mythical, Practical, and Sublime," 29.

57. Ann Smart Martin, "Makers, Buyers, and Users: Consumerism as a Material Culture Framework," *Winterthur Portfolio* 28, no. 2/3 (1993): 154–155.

58. George L. Miller, Ann Smart Martin, and Nancy S. Dickinson, "Changing Consumption Patterns: English Ceramics and the American Market from 1770 to 1840," in *Everyday Life in the Early Republic*, ed. Catherine E. Hutchins (Winterthur, DE: Winterthur Museum,1994), 232.

59. For a history of the penitentiary in America see Norval Morris and David J. Rothman, eds., *The Oxford History of the Prison* (New York: Oxford University Press, 1995).

60. To date, I have found no archival evidence to suggest that Cole was aware of ceramics bearing his engraved images.

61. Raymond Beecher, Greene County Historian, has established the history of this set of Staffordshire: Thomas T. Thomson, son of Dr. Thomas Thomson of Catskill Landing, and brother of John Alexander Thomson and his spinster sister Catherine Thomson, was employed by a New York City firm and sent as a young adult to South America (British Guiana) to straighten out business affairs at a trading station. He stayed for almost two decades until after the War of 1812. He then departed for England to establish his own trading post. Around the time of his departure from South America, Thomas T. Thomson sent instructions to his brother John A. Thomson to build a family home, Cedar Grove. While in England, Thomas ordered a quantity of inexpensive Staffordshire ware as a profitable sideline in his brother John's ironmonger shop in Catskill. Whether the dinner set for the newly finished Cedar Grove was from England or was left over from the Main Street shop after John Alexander Thomson inherited Cedar Grove and closed his store is uncertain. This information was provided to me generously through correspondence with scholar and historian Raymond Beecher. Letter to author, November 3, 2002. Cole's great-granddaughter Edith Cole Silberstein offered the estate, including the contents and the paintings, to the state of New York for a sum approximating $175,000. The state declined as it had recently assumed stewardship of Frederic Church's home, Olana. Edith Cole Silberstein then auctioned the contents of the house. The Staffordshire set was purchased by Harry Van Dyke of Columbia County who donated the set back to Cedar Grove when restorations began. Raymond Beecher, letter to author, November 3, 2002.

62. The fresco is located on the west corner of the north wall and measures 40 ½ x 63 inches. The fresco technique is meant to be long lasting and the Cole family intended

to keep this mural for some length of time. Cole's granddaughter Florence Cole Vincent, who ultimately inherited Cedar Grove and much of its contents, used the present kitchen-dining area as a formal dining room. She hired one or two still unidentified Catskill painters with some artistic ability to copy the pattern from the family dinner set onto the wall above the wainscoting. After Cole's great-granddaughter Edith Cole Hill (later Edith Cole Silberstein) inherited Cedar Grove, the mural had deteriorated to such an extent that she had covered it with wallpaper. Letter from Raymond Beecher to the author, November 3, 2002. This renovation project is part of a long-term restoration plan for Cedar Grove.

Color Plates

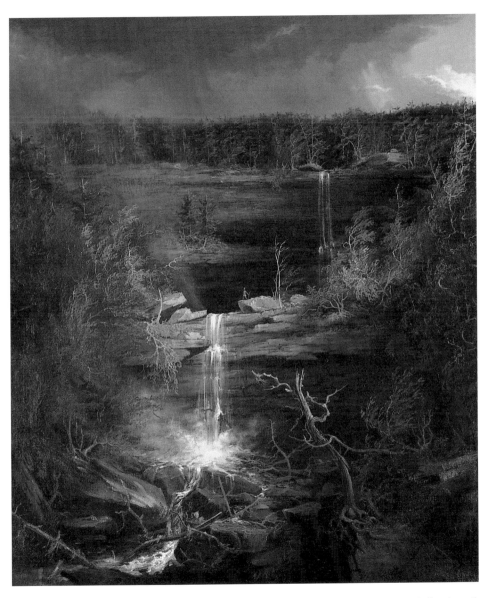

I. Thomas Cole, *Falls of Kaaterskill*, 1826. Oil on canvas, 43 x 36 in. From The Warner Collection of Gulf States Paper Corporation on view at The Westervelt-Warner Museum of Art, Tuscaloosa, AL.

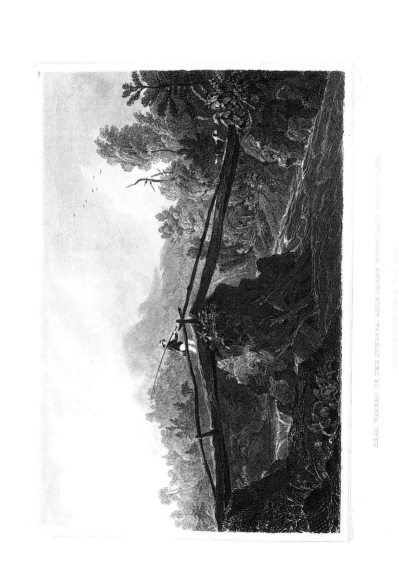

II. Fenner Sears & Co. after Thomas Cole, *Head Waters of the Juniata Alleghany Mountains, Pen[n]sylvania*, 1831. Hand-colored engraving. John Howard Hinton, *The History and Topography of the United States*, 2 vols. (London: I. T. Hinton & Simpkin & Marshall, 1830–1832). 2: pl. 20. Juniata College Museum of Art, Huntingdon, PA.

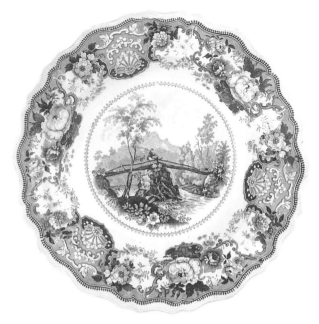

III. William Adams & Sons, Staffordshire, England, after Thomas Cole, *Head Waters of the Juniata, U.S.*, c. 1831–1845. Ceramic soup plate, 10 ½ in. dia. Private collection.

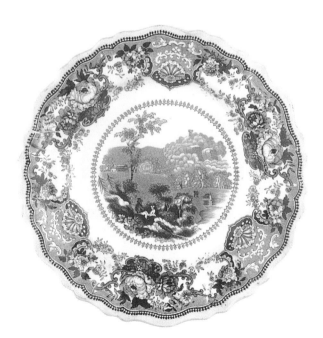

IV. William Adams & Sons, Staffordshire, England, after Thomas Cole, *Monte Video, Connecticut, U.S.*, c. 1831–1845. Ceramic plate, 6 ¾ in. dia. Private collection.

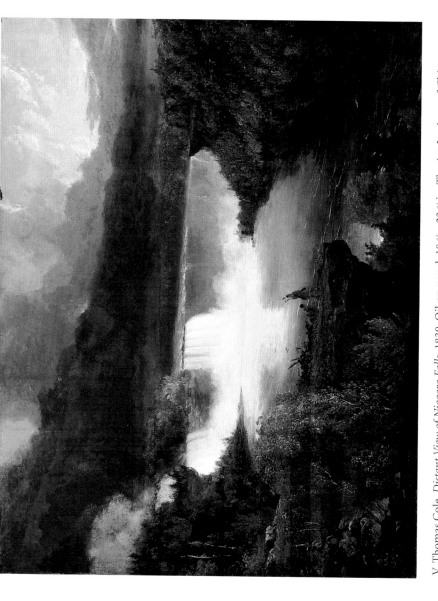

V. Thomas Cole, *Distant View of Niagara Falls*, 1830. Oil on panel, 18 ⅞ x 23 ⅞ in. The Art Institute of Chicago. Friends of American Art Collection (1946.396). Photograph: © The Art Institute of Chicago.

VI. Thomas Cole, *View from Mount Holyoke, Northampton, Massachusetts, after a Thunderstorm—The Oxbow*, 1836. Oil on canvas, 51 ½ x 76 in. The Metropolitan Museum of Art, New York. Gift of Mrs. Russell Sage, 1908 (08.228). Photograph: © 1995 The Metropolitan Museum of Art.

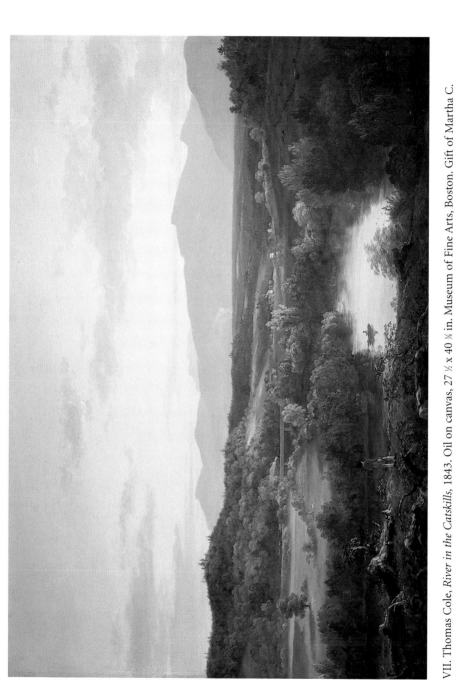

VII. Thomas Cole, *River in the Catskills*, 1843. Oil on canvas, 27 ½ x 40 ⅜ in. Museum of Fine Arts, Boston. Gift of Martha C. Karolik for the M. and M. Karolik Collection of American Paintings, 1815–1865 (47.1201). Photograph: © 2005 Museum of Fine Arts, Boston.

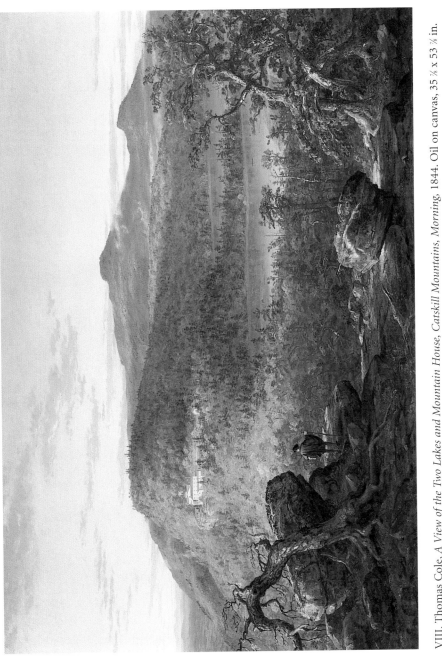

VIII. Thomas Cole, *A View of the Two Lakes and Mountain House, Catskill Mountains, Morning*, 1844. Oil on canvas, 35 ⅞ x 53 ⅛ in. Brooklyn Museum. Dick S. Ramsay Fund (52.16).

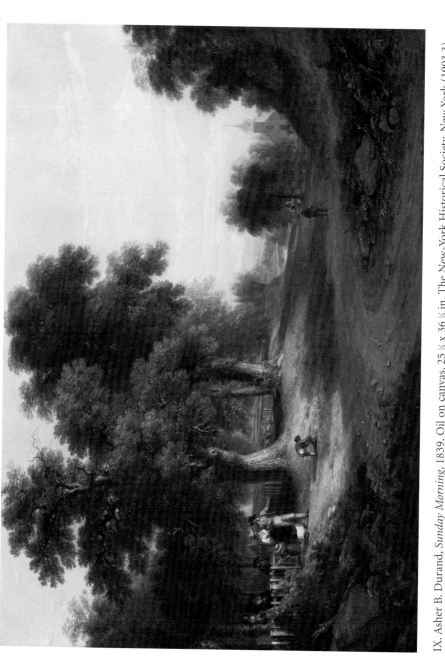

IX. Asher B. Durand, *Sunday Morning*, 1839. Oil on canvas, 25 ¼ x 36 ¼ in. The New-York Historical Society, New York (1903.3). Photograph: Collection of The New-York Historical Society.

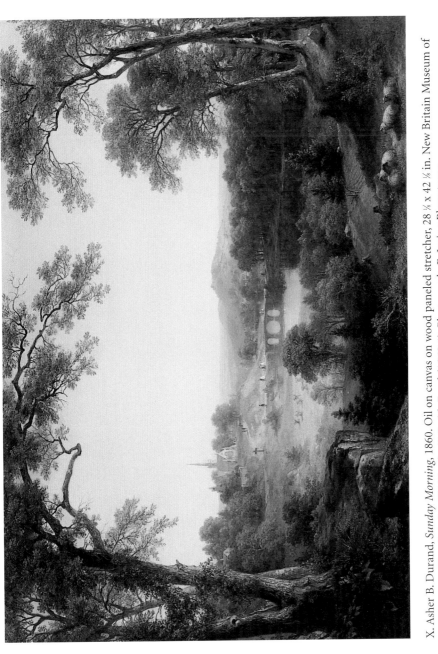

X. Asher B. Durand, *Sunday Morning*, 1860. Oil on canvas on wood paneled stretcher, 28 ⅛ x 42 ⅛ in. New Britain Museum of American Art, New Britain, CT. Charles F. Smith Fund (1963.4). Photograph: E. Irving Blomstrann.

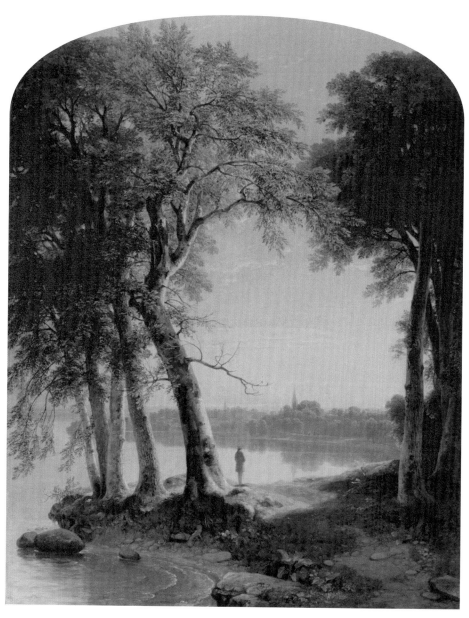

XI. Asher B. Durand, *Early Morning at Cold Spring*, 1850. Oil on canvas, 59 x 47 ½ in. Montclair Art Museum, Montclair, NJ. Museum Purchase, Lang Acquisition Fund (1945.8).

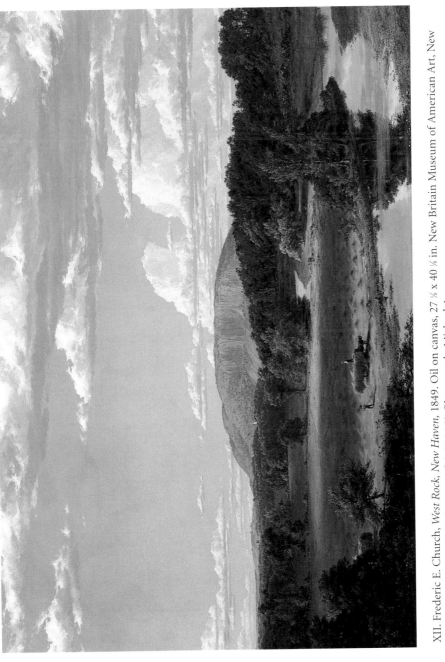

XII. Frederic E. Church, *West Rock, New Haven*, 1849. Oil on canvas, 27 ⅛ x 40 ⅛ in. New Britain Museum of American Art, New Britain, CT. John Butler Talcott Fund (1950.10). Photograph: Michael Agee.

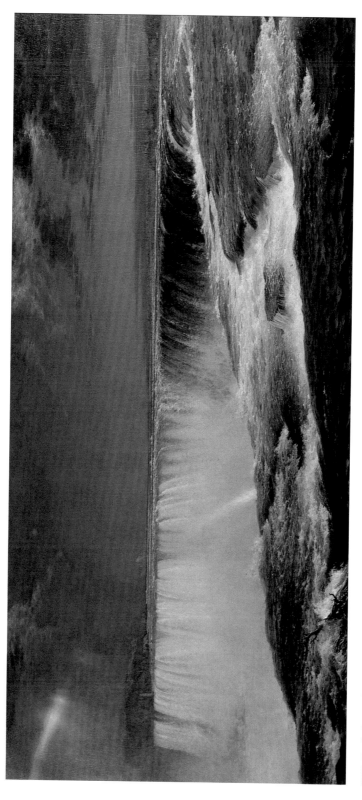

XIII. Frederic E. Church, *Niagara*, 1857. Oil on canvas, 42 ½ x 90 ½ in. Corcoran Gallery of Art, Washington, DC. Museum Purchase, Gallery Fund (1976.15).

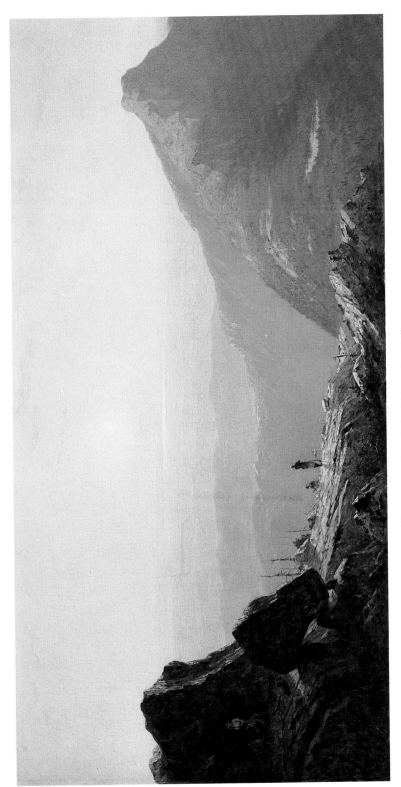

XIV. Sanford R. Gifford, *Mansfield Mountain*, 1859. Oil on canvas, 30 x 60 in. Manoogian Collection.

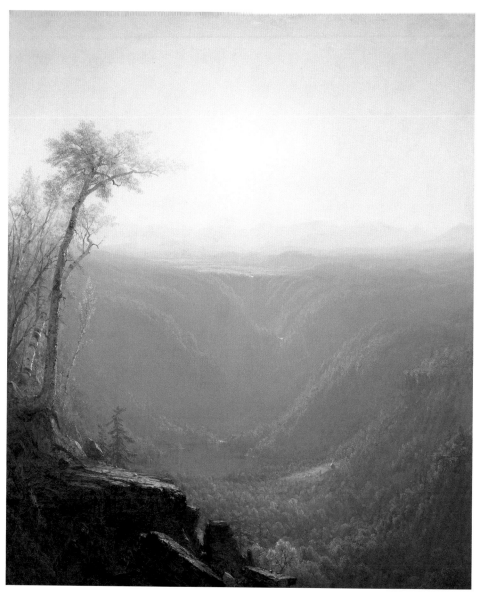

XV. Sanford R. Gifford, *A Gorge in the Mountains (Kauterskill Clove)*, 1862. Oil on canvas, 48 x 39⅞ in. The Metropolitan Museum of Art, New York. Bequest of Maria DeWitt Jesup, from the collection of her husband, Morris K. Jesup, 1914 (15.30.62). Photograph: © 1987 The Metropolitan Museum of Art.

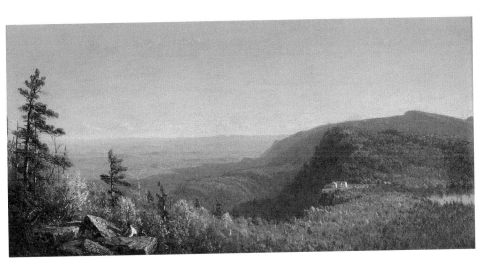

XVI. Sanford R. Gifford, *The Catskill Mountain House,* 1862. Oil on canvas, 9 ⅝₆ x 18 ½ in. Private collection.

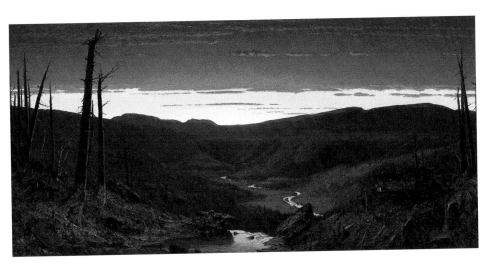

XVII. Sanford R. Gifford, *A Twilight in the Catskills,* 1861. Oil on canvas, 25 x 54 in. Private collection.

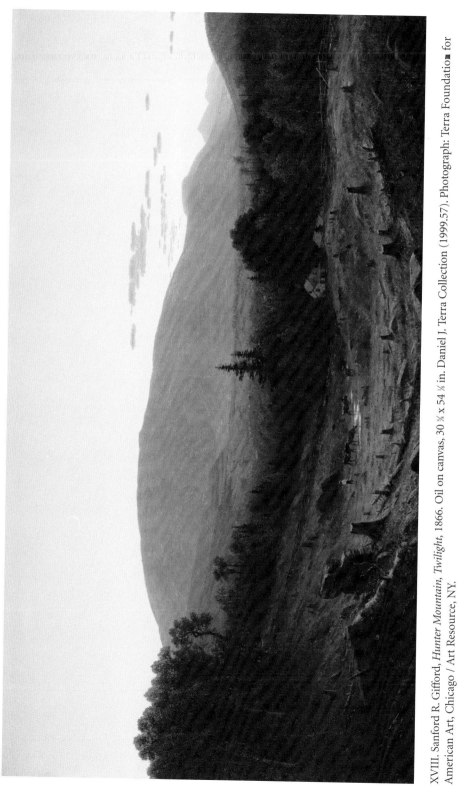

XVIII. Sanford R. Gifford, *Hunter Mountain, Twilight*, 1866. Oil on canvas, 30 ⅛ x 54 ⅛ in. Daniel J. Terra Collection (1999.57). Photograph: Terra Foundation for American Art, Chicago / Art Resource, NY.

Some Further Thoughts on The Panoramic Mode in Hudson River School Landscape Painting

ALAN WALLACH

Accounting for the Panoramic Mode

I have for some time been interested in the relation between what might be called panoramic vision and Hudson River School land-scape painting. My interest dates back to my reading in the 1960s of a book published in 1948 by the German émigré art historian Wolfgang Born entitled *American Landscape Painting*. To my knowledge, Born was the first scholar to notice that Hudson River School artists tried to adapt for their two-dimensional canvases "the technical peculiarities of a real panorama."[1] Born observed that Thomas Cole's *View from Mount Holyoke, Northampton, Massachusetts, after a Thunderstorm—The Oxbow* (fig. 39; pl. VI), which the artist painted in 1836, represented a "first step in the development of panoramic landscape."[2] Later artists, according to Born, developed the panoramic convention or mode for the sake of verisimili-tude. In Born's view, the panoramic mode allowed them to simulate "the traveler's way of seeing a landscape" while representing America's "great open spaces…the rugged mountains and the enormous rivers—an over-size landscape in which the tiny human being did not count at all."[3]

Although I remain skeptical of this explanation of the artists' motives, I have long been convinced that Born hit upon an important clue to understanding the overall development of the Hudson River School.[4] Cole's *Oxbow* may have been an early experiment in the panoramic mode of representation, but it seemed to anticipate, as Born implied, much that was to come later on. By the end of the 1850s, the panoramic mode had become a familiar feature of American landscape painting. We encounter it in popular, mainstream works, such as Frederic Church's *Niagara* of

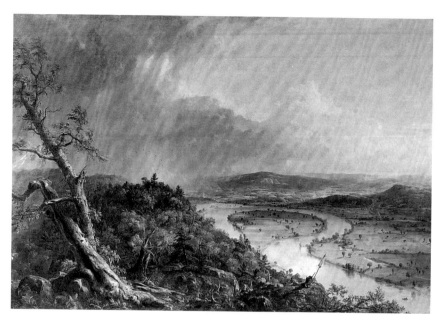

Fig. 39. Thomas Cole, *View from Mount Holyoke, Northampton, Massachusetts, after a Thunderstorm—The Oxbow,* 1836. Oil on canvas, 51 ½ x 76 in. The Metropolitan Museum of Art, New York. Gift of Mrs. Russell Sage, 1908 (08.228). Photograph: all rights reserved, The Metropolitan Museum of Art.

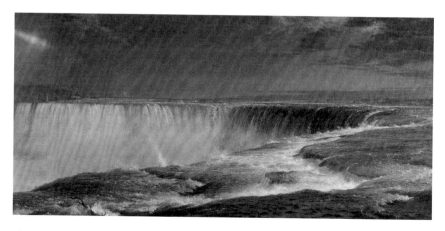

Fig. 40. Frederic E. Church, *Niagara,* 1857. Oil on canvas, 42 ½ x 90 ½ in. Corcoran Gallery of Art, Washington, DC. Museum Purchase, Gallery Fund (1976.15).

1857 (fig. 40; pl. XIII), which created a sensation when it was exhibited in the United States and England in the late 1850s. We also see it in much smaller paintings by so-called "luminist" artists, for example in John Kensett's *View from Cozzens's Hotel* of 1863 (fig. 41).

Born's attempt to explain the rise of the panoramic mode raises a critical question. That question can be posed by comparing Cole's *Distant View of Niagara Falls* of 1830 (fig. 42; pl. V) with Church's far more panoramic view of the same subject completed twenty-seven years later. In Cole's small canvas we are on the American side of the Niagara River looking south toward the American and Horseshoe Falls. Cole places the tiny figures of two Native Americans on a small, rocky promontory in the foreground to the left. The eye moves along a diagonal from the promontory to the tree-covered slopes on the Canadian side of the Niagara River, to the falls in the distance, to the black and gray rain clouds above the falls, and finally, to a patch of light blue sky surrounded with white and gray clouds tinged pink by the setting sun. By contrast, Church's *Niagara* places the viewer at the edge of the torrent just above the falls on the Canadian side looking northeast towards Goat Island and the Terrapin Tower. The eye follows the line of the rainbow that rises from the falls, breaks off, and then reappears in the stormy sky above the tower, a visual climax reminiscent of the distant, clearing sky in Cole's painting.

In Cole's *Niagara* the falls are seen in the distance framed by the surrounding landscape. In Church's painting the viewer is placed at the falls' edge. There are no framing devices, no promontories, no repoussoirs standing between us and the raging waters of the Niagara River. By comparison with Cole's *Niagara*, Church's painting gives the illusion of an unmediated relationship between viewer and falls, an illusion that is enhanced by Church's mastery of an impersonal technique in which the artist attempted to replicate photography's seeming objectivity, in the process creating a slick or what the nineteenth century sometimes called a "licked" surface as opposed to Cole's far more apparent and far more expressive use of the oil paint medium.[5] The new emphasis on illusionism in Church's painting goes hand-in-hand with the artist's deliberate elimination of traditional compositional elements and framing devices and also with his resort to an elongated or panoramic compositional format. At about seven and a half feet wide, Church's painting is not very large, at least not by later Hudson River School standards, but it will be noticed that the height-to-width ratio is less than 1:2 while the ratio for Cole's painting is about 1:1.4. Cole's is the more traditional composition—what we might expect from a relatively young and mainly self-taught artist (Cole was

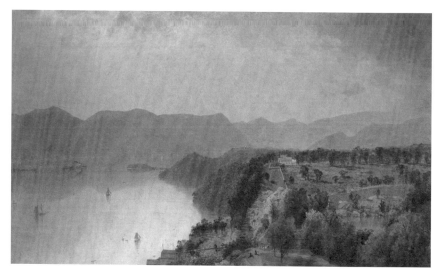

Fig. 41. John F. Kensett, *View from Cozzens's Hotel Near West Point, N.Y.*, 1863. Oil on canvas, 20 x 34 in. The Robert L. Stuart Collection, on permanent loan from the New York Public Library. Photograph: Collection of The New-York Historical Society, New York (S-189).

twenty-nine when he painted his *Niagara*) who had begun his career struggling to master current landscape conventions and techniques.[6]

Here then is a crucial point: landscape painting like any other art form depends upon convention. To be a landscape artist, a Cole or a Church was obliged to adhere to more or less established conventions of style, compositional format, and subject matter. Cole's precocious early triumph—he was twenty-four when in 1825 he gained recognition as the United States' most accomplished landscape painter—and his ongoing success as an artist resulted from his mastery of a broad range of landscape painting conventions. Thus, Cole's *Niagara* is exactly what we might expect of a gifted young American landscapist working in the 1820s. The composition hews closely to established Anglo-American landscape painting conventions; the painting's format is unexceptional. How then do we account for the changes we observed in Church's innovative, which is to say, *unconventional* composition?

This observation brings us to the heart of my argument. Art does not evolve or develop by itself. A static society generally produces a static or unchanging art. Nineteenth-century America was an extraordinarily dynamic society, developing at a rate unprecedented in world history. In a number of critical respects, nineteenth-century American art can be

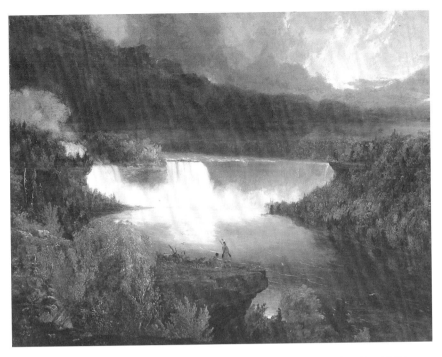

Fig. 42. Thomas Cole, *Distant View of Niagara Falls,* 1830. Oil on panel, 18 ⅞ x 23 ⅞ in. The Art Institute of Chicago. Friends of American Art Collection (1946.396). Photograph: © The Art Institute of Chicago.

understood in terms of a response to rapid social change.

But a generalized sense of social dynamism begs the question. I am asking what is perhaps the oldest art historical question: why and how do artistic forms change? What explains the development of Italian painting from, say, the High Renaissance classicism of Raphael to the baroque of Caravaggio? A century ago, art historians such as Heinrich Wölfflin argued that artistic styles changed first of all because of their intrinsic or imma- nent characteristics.[7] In Wölfflin's famous cyclical scheme the primitive style inevitably leads to the classic, the classic to the baroque, and the baroque to the impressionist, at which point the cycle begins anew. According to Wölfflin, the cycle could be accelerated or retarded by exter- nal factors, especially by what he thought of as "racial" characteristics (southern Europeans inclined to the classic, while northerners had a predilection for the baroque). Emmanuel Löwy, a contemporary of Wölfflin, proposed a non-cyclical theory of stylistic evolution in which art becomes more naturalistic over time, beginning abstractly and conceptu-

ally and then undergoing a process of adjustment in which it more and more accurately mirrors natural appearances. Other thinkers looked to external factors: not only "race" but a culture's or society's *Weltanschauung* or worldview, or its peculiar psychology.[8]

Wölfflin's and other scholars' theories furnished art historians with a vocabulary for describing styles and stylistic change, and these theories played a role in the study of American landscape painting. For example, Barbara Novak, in her book *American Painting of the Nineteenth Century*, published in 1969, employed a Wölfflinian scheme in which the primitive precedes the classic, the classic precedes the baroque, etc.[9] But Novak frequently resorted to another scheme of stylistic development, a scheme that recalls Löwy's in which the Ideal or conceptual leads to the Real or naturalistic, which in turn metamorphoses into what Novak and others called "Luminism." In this sequence, change is immanent inasmuch as one phase can lead directly only to the next in the series—the Ideal is followed by the Real, the Real by the Luminist—but Novak implies that the whole development is to some extent motivated by external influences, particularly natural science's influence on artistic practice.[10]

Immanent and cyclical theories of style are now pretty much discredited because of their failure to accommodate empirical findings (Wölfflin's theory notoriously omitted Mannerism, which appeared between the classic style of the High Renaissance and the Baroque). And while the notion of influence may help us understand artistic change, it will lack explanatory power unless the mechanisms by which influence worked can be specified. For example, it is a scholarly commonplace to say that in his *Niagara*, Church was influenced by his reading of the critic John Ruskin, who emphasized the importance of truth to nature.[11] Or, to take another example, Church's style might be explained by his fascination with science, in particular his reading of Alexander von Humboldt's *Kosmos*, an encyclopedic study, very much in vogue in the mid-nineteenth century, of the flora and fauna of South America, which first appeared in English in 1849.[12] But while I would immediately concede that Church's objectifying, photographic style was meant to stand for scientific precision in the rendering of nature, I do not think that the influence of then-contemporary science tells us everything about the appearance, the distinctive *visual* characteristics of Church's painting or the many differences we have observed between Cole's and Church's versions of Niagara Falls.

We can, however, begin to grasp some of the reasons for the changes suggested by our comparison by considering the conventions that defined landscape as an art form for artists associated with the Hudson River

School. Once we have described the principal landscape conventions we will be in a position to say more precisely how such artists as Cole and Church registered or responded to cultural pressure. The issue boils down to an artistic problem: given the conventional nature of landscape painting, how did landscape artists modify or transform convention? How did they arrive at a new set of conventions—what we have been calling "the panoramic mode"?

Landscape Convention

American landscape artists of the 1820s and 1830s produced essentially four different types or genres of landscape: the pastoral, the prospect, what can be called "the sublime prospect," and the view. As we shall observe, each of these landscape types had its roots in European artistic practice. Moreover, these types were, at least to some extent, identified with familiar categories of late eighteenth-century English aesthetics—the beautiful, the sublime, and the picturesque. Thus the pastoral was often associated with the beautiful; the sublime prospect was by definition linked to the sublime; while the picturesque, a more recent and somewhat vaguer category which could stand for a sort of roughed-up beautiful or toned-down sublime, could be associated with all four landscape conventions.

The pastoral had its roots in the elegiac or Arcadian tradition of landscape painting and poetry that originated with Virgil in Roman antiquity and was revived during the Renaissance. In painting, the seventeenth-century French painter Claude Lorrain was the tradition's greatest exponent and he provided authoritative models for future generations who found in the image of Arcadia a locus for comfortingly melancholy reflections on lost innocence or a lost Eden—a place without—or maybe with—suffering and death. Thomas Cole painted a large number of pastorals of which *View on the Catskill, Early Autumn* (fig. 43) of 1837 is probably his best known. Cole was a great admirer of Claude—during the 1830s he came to be known as the "American Claude"—and in *View on the Catskill, Early Autumn* we notice his debt to the earlier artist.[13] Cole's composition, which depicts a late afternoon scene looking west from the town of Catskill towards the Catskill Mountains, is apparently "real," but its conformity to the conventions of Claudian pastoral—the placement of foreground trees, the easy recessional movement into space, the pervasive harmonizing of landscape elements, the golden sunset glow that suffuses the scene—endows it with a melancholy, retrospective cast. In the words of Cole's patron Jonathan Sturges, the artist painted *View on the Catskill, Early Autumn* as a memento of the appearance of the valley of the Catskill

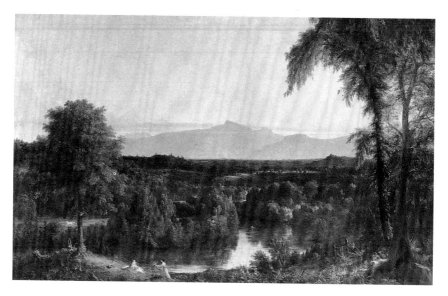

Fig. 43. Thomas Cole, *View on the Catskill, Early Autumn*, 1836–1837. Oil on canvas, 39 x 63 in. The Metropolitan Museum of Art, New York. Gift in memory of Jonathan Sturges by his children, 1895 (95.13.3). Photograph: all rights reserved, The Metropolitan Museum of Art.

"before the art of modern improvement found footing there"—that is, before many of the trees were cut down and a railroad line was built through the middle of the scene Cole portrayed.[14] *View on the Catskill, Early Autumn* thus depicted an American Arcadia, a realm of ideal rural beauty lost to the present and existing only in a golden haze of memory.

Claudian pastoral represented an ideal of rural felicity that was almost always retrospective. By contrast, the prospect was a type of landscape in which, as its name implies, the viewer, looking out into the distance, is given a privileged glimpse of the future. Like the pastoral, the prospect was a literary as well as pictorial convention, and scholars have traced its roots to seventeenth-century English landscape poetry.[15] Cole's *View of L'Esperance on the Schoharie River* painted in 1828, epitomizes the prospect.[16] In the foreground, a man with an ax stands on a raised promontory looking into the landscape. The sequence is precisely ordered: the eye moves from wilderness to cultivated landscape in the middle ground, to the burgeoning town in the distance—a series of transformations that follow upon the arrival in the wilderness of the man with the ax.

Both the pastoral and the prospect were well-defined landscape types when Cole appeared upon New York's fledgling artistic scene. The sublime

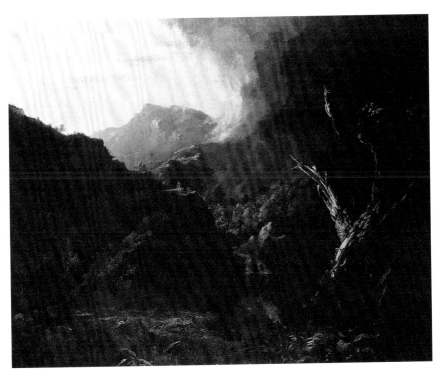

Fig. 44. Thomas Cole, *Landscape*, 1828. Oil on canvas, 26 x 32 ¼ in. Museum of Art, Rhode Island School of Design, Providence, RI. Walter H. Kimball Fund (30.063).

prospect was perhaps less clearly defined, yet it too had historical roots extending back to the seventeenth century. We can locate predecessors for Cole's sublime landscapes of the 1820s and 1830s in the work of seventeenth-century Dutch landscapists such as Ruiysdael and Italian landscapists of the same period such as Salvator Rosa who was something of a hero to both European and American romantics during the first half of the nineteenth century.[17] If Claude was identified with the beautiful-pastoral, then Rosa was identified with the sublime, which by Cole's time had come to stand for the representation of the terrible and awesome in nature and human history. Cole's *Niagara* and his *Landscape* (fig. 44) of 1828 exemplify the sublime prospect. In the latter painting, the contorted, blasted tree trunks at the lower right of the composition and the storm with its angry black and gray clouds attest to nature's awesome, obliterating power while the blue sky to the left, with its wispy pink clouds and its hint of sunrise, is a realm of light and transcendence, a point of resolution for the fear and turmoil associated with the sublime.

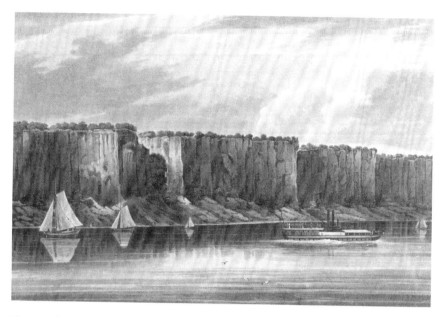

Fig. 45. John W. Hill, *Palisades.* Hand-colored aquatint after a watercolor by William G. Wall. *Hudson River Port Folio* (New York: H. I. Megarey & W. B. Gilley; and Charleston: John Mill, 1821–1825), pl. XIX. Photograph: Courtesy, The Winterthur Library: Printed Book and Periodical Collection.

During the 1820s, 1830s, and 1840s, an artist embarking on a work for exhibition or for sale to a collector would almost automatically select one of the three conventional landscape types described above. Our fourth type, the view, was another matter. As an art form, the view can be traced to the work of the Veduta, or view painters, of the eighteenth century and to the work of topographical draftsmen, some of them army officers who had acquired the ability to delineate the contours of landscape as part of their military training.[18] Because a view served a mainly utilitarian purpose—recording the appearance of a particular piece of terrain—it did not often qualify as a full-scale work of art. Consequently, views were for the most part confined to what were considered lesser artistic media: drawings, prints, watercolors, and oil sketches. William Wall's *Palisades*, a hand-colored aquatint published in 1823 as part of the *Hudson River Port Folio* (fig. 45), exemplifies the view. As a landscape, the aquatint lacks the dramatic and historical dimensions of the pastoral, the prospect, and the sublime prospect. We do not learn a great deal from it about the past or the future and the artist does little to dramatize nature's awesome power (which in this instance is being tamed by the steamboat). Composition is

simple and seemingly straightforward. The artist does not include framing trees, raised foreground promontories, or other repoussoir devices. The viewer, looking west, observes the river, which flows parallel to the picture plane, and the Palisades, which appear in the middle distance. As a landscape type, the view was based upon the assumption that the appearance of the subject would be of sufficient interest to the viewer and would require no embellishment. It was also the most flexible, the most adaptable of the four conventional landscape types I have described, and therefore the first to register the panoramic.

From the Panorama to the Panoramic Mode

One way to describe the historical evolution of the Hudson River School in the period 1825–1865 involves observing the evolution of landscape convention: how, under the pressure of the panoramic, the relatively fixed landscape formulas Cole inherited from the Anglo-American landscape tradition became unfrozen. To understand this process, we must first turn to the panorama itself and to the question of how, during the period under consideration, it increasingly influenced or shaped landscape vision and representation.[19]

The panorama was an invention of the late eighteenth century.[20] Robert Barker created the first large-scale panorama in London in 1788; the word panorama—meaning, literally, all-seeing (from the Greek "pan" + "horama")—was coined a few years later. Typically, panorama paintings were exhibited in specially designed rotundas. To view such a painting spectators climbed a tower, located at the center of the rotunda, to a viewing platform. The viewing platform was positioned in such a way that the painting's horizon-line roughly coincided with the spectators' eye level, which meant that spectators experienced a sensation of looking down at the scene. This was only one of several carefully calculated visual effects. The painting was illuminated by hidden skylights while the rotunda and its contents (the tower, the viewing platform) remained shrouded in darkness. The resulting contrast between light and dark, between the painting and the ghostly or insubstantial realm inhabited by the spectators—who thereby became anonymous and invisible witnesses to the scene—produced a powerful trompe-l'oeil effect, making the painting the only visible "reality." All this was done to maximize visual drama since spectators did not casually come upon the painting but emerged from the shadowy space of the tower onto the viewing platform where the painting suddenly burst upon them. This was a dramatic and no doubt sublime moment that early panorama visitors often found overwhelming. A visit to a panorama could

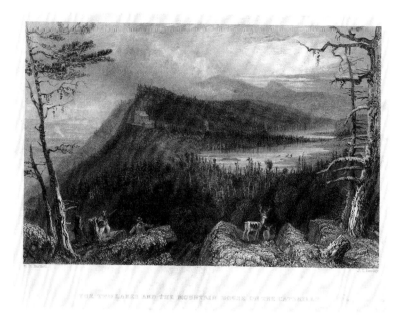

Fig. 46. J. C. Bentley, *The Two Lakes and the Mountain House on the Catskills.* Engraving after a drawing by William Henry Bartlett. Nathaniel Parker Willis, *American Scenery; Or, Land, Lake, and River Illustrations of Transatlantic Nature*, 2 vols. (London: George Virtue, 1840), 1: pl. 50. Photograph: Archives and Special Collections, Dickinson College.

result in dizziness and, according to one German viewer of an early panorama, "*Sehkrank*," or see-sickness.[21] The panorama might thus be thought of as a machine or engine of sight in which the visible world was reproduced in a way that hid or disguised the fact that vision required an apparatus of production, and that what was being produced was not only a spectacle but a spectator with a particular relation to "reality."

The historian Stephan Oettermann has argued for the historical specificity of panoramic vision: that the invention of the panorama belongs to a period in which new forms of middle-class hegemony arose and that the panorama itself encoded these forms. Consequently, Oettermann along with Michel Foucault has linked the panorama to Jeremy Bentham's almost contemporaneous invention of the panopticon (the word also translates as all-seeing), a circular prison with a tower at its center designed for the constant surveillance of inmates.[22] In the panopticon, inmates were subject to an anonymous authority, "the eye of power" or "sovereign gaze," as Foucault has called it, that emanated from the

Fig. 47. R. Brandard, *The Horse Shoe Fall, at Niagara.—With the Tower.* Engraving after a drawing by William Henry Bartlett. Nathaniel Parker Willis, *American Scenery; Or, Land, Lake, and River Illustrations of Transatlantic Nature,* 2 vols. (London: George Virtue, 1840), 1: pl. 16. Photograph: Archives and Special Collections, Dickinson College.

tower. The sovereign gaze represented a new equation between vision and power—power that now aspired to total domination. The panorama embodied a similar aspiration. In the panorama, the world is presented as a form of totality; nothing seems hidden; the spectator, looking down upon a vast scene from its center, appears to preside over all visibility.[23]

This analysis leads to what might be called the panoramic or panoptic sublime. Having reached the topmost point in an optical hierarchy, the visitor experienced a sudden access of power, a dizzying sense of having suddenly come into possession of a terrain stretching as far as the eye could see. The ascent of a panorama tower was in this respect a stunning metaphor for social aspiration and social dominance. The multiple displacements involved—the way in which social meanings were projected onto landscape, were absorbed into the forms of landscape, were quite literally naturalized—should obscure neither the historic roots nor the historical specificity of the process. To the visitor the panoptic sublime was primarily a matter of vision; however, it was something else as well. The

MONTE VIDEO.

Fig. 48. Nathaniel and Simeon Smith Jocelyn, *View of Monte Video Approach to the House.* Engraving after a drawing by Daniel Wadsworth. Benjamin Silliman, *Remarks Made, On a Short Tour, Between Hartford and Quebec in the Autumn of 1819* (New Haven: S. Converse, 1820), pl. 2. Photograph: Courtesy, The Winterthur Library: Printed Book and Periodical Collection.

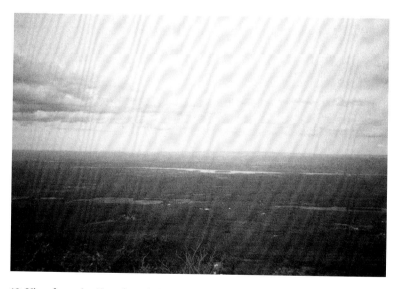

Fig. 49. View from the Site of Catskill Mountain House. Photograph: author.

panoptic sublime drew its explosive energy from prevailing ideologies in which the exercise of power and the maintenance of social order required vision and supervision, foresight and, especially, oversight—a word equally applicable to panoramic views and to the operation of the reformed social institutions of the period: the prison, the hospital, the school, and the factory.

Barker's panorama proved an immediate sensation and the panorama soon became a familiar form of popular entertainment not only in England but also in France and the United States. The first American panorama appeared in New York in 1795, only a year after Barker opened a permanent panorama rotunda in London's Leicester Square. During the first half of the nineteenth century, panorama paintings were to be seen in New York, Philadelphia, Boston, Charleston, New Bedford, and New Orleans. The history painter John Vanderlyn opened a panorama rotunda in New York in 1818 with a painting of Versailles. In 1837, Frederick Catherwood built a wooden panorama rotunda on Broadway, in New York, modeled on Barker's Leicester Square rotunda, where he exhibited panoramas of Jerusalem, Thebes, Balbec, Lima, Rome, the Bay Islands of New Zealand, and Niagara Falls, until a fire, in July 1842, put him out of business.[24]

The panorama represented not only a new and undoubtedly modern form of entertainment; it also represented a new mode of vision. Its impact, in this regard, would be difficult to overestimate. Early landscape tourism in the United States centered on sites where tourists could experience the landscape as a panorama. Beginning in the 1820s, tourists following what was soon to become a standard landscape tour climbed Mount Holyoke in Massachusetts and Mount Washington in the White Mountains of New Hampshire.[25] They visited the Catskill Mountain House (fig. 46) perched on a high cliff, where on a clear day they could take in a stunning, panoramic vista of the Hudson Valley.[26] They traveled to Niagara Falls (fig. 47), where the Terrapin Tower, built in the late 1820s, in effect functioned like the tower in a panorama, allowing visitors to view the falls and the surrounding terrain as one vast natural panorama.[27] Indeed, towers became—and continue to be—a frequent feature of American landscape tourism. For example, about 1810, Daniel Wadsworth, a Hartford financier and amateur landscape painter, built an estate on the summit of Talcott Mountain six miles west of Hartford (fig. 48). He named his estate Monte Video or mount of vision. Monte Video had its gardens, its boathouse, its icehouse, its tenant farmer, and working farm, but the feature that drew landscape tourists was a fifty-five foot

viewing tower located near the mountain's summit. From the tower, a sightseer could take in a panoramic view of the Connecticut Valley extending forty-five miles in all directions.[28]

Yet despite the popularity of landscape panoramas, American landscape artists of the 1820s and 1830s found the view from mountaintop or tower virtually unrepresentable. A photograph (fig. 49) taken from the site of the Catskill Mountain House (we are looking east towards the Hudson River and the Berkshire Mountains) makes the point—without a foreground and with nothing to frame the scene, it is in terms of early nineteenth-century aesthetics unimaginable as a conventional, which is to say, aesthetically satisfying, landscape image. Yet, with the rise of landscape tourism, the panoramic was by the late 1820s an inescapable feature of American landscape culture. For landscape artists, this development created a seemingly insurmountable problem. How to make a painting out of the panoramic views that were drawing tourists in increasing numbers to Mount Holyoke, Mount Washington, Niagara Falls, the Catskill Mountain House, and other panoramic landscape sites? How to represent what hitherto had been deemed unrepresentable?

These questions seem to have weighed heavily on the young Thomas Cole. At the urging of Daniel Wadsworth, who, in addition to being the proprietor of Monte Video, was one of the artist's earliest patrons, Cole visited the White Mountains in 1827 and again in 1828. In a letter to Wadsworth written in August 1827, Cole described his ascent of Red Hill overlooking Lake Winnipesaukee. Note how here panoramic convention operates like a reflex:

> I climbed [Cole wrote] without looking on either side [in other words, as if he were climbing the tower of a panorama]: I denied myself that pleasure so that the full effect of the scene might be experienced—Standing on the topmost rock I looked abroad!—With what an ocean of beauty, and magnificence, was I surrounded.[29]

A year later, climbing Mount Chocura in the White Mountains, Cole saw "on every side prospects mighty and sublime [that] opened upon the vision: lakes, mountains, streams, woodlands, dwellings and farms wove themselves into a vast and varied landscape." Yet for "all its beauty the scene was one too extended and map-like for the canvass."[30]

Cole's remark points to a formidable conceptual difficulty. As the critic Blake Nevius has observed, "writers on the picturesque were unanimous in condemning the [long] view on canvas because of its extent and

its lack of variety, detail, and foreground interest."[31] William Gilpin, an influential theorist, wrote of "the absurdity of carrying a painter to the top of a high hill to take a view. He cannot do it. Extension alone, though amusing in nature, will never make a picture."[32] Uvedale Price, another widely read theorist, argued that a long view could never be a fit subject for landscape painting because "any view that is unbroken, unvaried, undivided by any objects in the nearer parts, whether it be from a mountain or from a plain, is, generally speaking, ill suited to the painter."[33]

Cole absorbed these prohibitions. The landscape paintings he executed during the 1820s adhered to established convention. Yet the ever-increasing popularity of the panoramic was probably never far from his thoughts. In London between 1829 and 1831 he very likely saw Thomas Horner's panorama and perhaps other panoramic entertainments. On a tour of Italy in 1832, he began sketching the Bay of Naples with the idea of creating a full-scale panorama painting when he returned to the United States. Only a half-finished drawing remains (fig. 50) since the Neapolitan authorities, suspecting the artist might be a spy intent upon recording the city's fortifications, put an end to the project.[34] Note that Cole's drawing extends across two pages of his sketchbook. Thinking of a panorama, Cole in effect established for himself a panoramic sketching convention which emphasized the horizontal or lateral direction of sight. One year later he traveled to Mount Holyoke where he made a topographical drawing (fig. 51) covering almost two sketchbook pages—a drawing that served as the basis for *The Oxbow* which he painted three years later. The drawing reveals, once again, his fascination with the panoramic and his interest in finding a way to represent it.

For the painting (fig. 39; pl. VI), Cole stuck to a more traditional—and more salable—format. The canvas's height-to-width ratio is approximately 7:10.3 as opposed to 7:11 for a single sheet in the sketchbook and 7:22 (or approximately 1:3) for the two-page spread. Nonetheless, the painting of the Oxbow enlarges the angle of vision. Instead of producing a view involving a conventional angle of vision of about 55 degrees, Cole manipulated the composition in such a way that it appears to take in approximately 85 or 90 degrees (as opposed to the 110 degrees of the 1833 sketch). Cole achieves this effect by tightly juxtaposing what are almost two separate views, the sunlit vista—a pastoral—to the right, and the sublime prospect to the left. This split composition, with its abrupt transitions from left to right and from foreground to background, leads to a division or bifurcation of seeing. Two related vistas are compressed or jammed against each other and framed, on the left, by blasted trees—a traditional

Fig. 50. Thomas Cole, *View of the Bay of Naples*, 1832. Brown ink over graphite on paper, each sh
Fund (39.566.6; 39.566.7). Photograph: © 1990 The Detroit Institute of Arts.

Fig. 51. Thomas Cole, *View of the Oxbow on the Connecticut River, As Seen From Mount Holyoke,*
Society Purchase, William H. Murphy Fund (39.566.66; 39.566.67). Photograph: © 1990

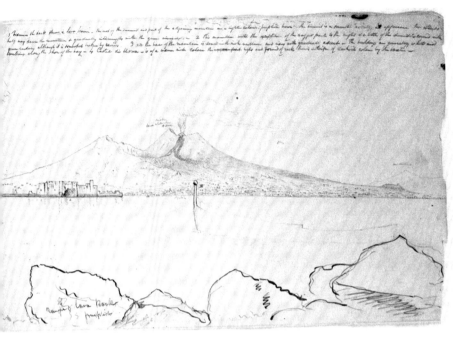

⅞ x 13 ⅜ in. The Detroit Institute of Arts. Founders Society Purchase, William H. Murphy

833. Graphite on paper, each sheet 8 ⅞ x 13 ⅜ in. The Detroit Institute of Arts. Founders
The Detroit Institute of Arts.

framing element that Cole may have hoped would impose some order on a composition that simultaneously produces a sense of panoramic breadth and a premonition of split or breakdown.

Cole was probably aware that with his experiments with extended formats and representations of hitherto unrepresentable views he was breaking with convention. In a letter of March 2, 1836, to his patron Luman Reed describing his intention of painting a view of Mount Holyoke to show at the National Academy of Design's annual exhibition he wrote: "I have already commenced a view from Mt. Holyoke—it is about the finest scene I have in my sketchbook & is well known—it will be novel and I think effective."[35] "Well known" but also "novel"? By the early 1830s Mount Holyoke was a necessary stop on any North American tour. And yet because the view from the summit had never before been pictured in an oil painting—had scarcely been pictured at all—its effect would indeed have been "novel."[36] But this novelty required adopting a new representational mode. Compared to the 1833 sketch, the painting for the most part emphasizes precisely those qualities I have called panoramic. The viewpoint is higher, the visible expanse of landscape greater. The viewer looks down upon the scene as if from a great height, an effect that is intensified by the deliberate upward tilt of the ground plane as it recedes towards the distant horizon. And because Cole introduced seemingly endless details—a flight of birds, boats on the river, figures in the boats, a horse and rider, figures working in the fields, rows of haystacks, herds of cattle, dozens of houses, each with its own chimney and plume of smoke—the viewer confronts a scene that is both vast and yet minutely rendered. Cole may have hoped that his unconventional painting, his experiment in panoramic vision, while "novel," would prove immediately legible but in this respect he was probably disappointed. The one contemporary critical comment on the painting I have been able to discover was severely negative. Reviewing the National Academy of Design's 1836 exhibition, a writer for the *[New York] Evening Star* described *The Oxbow* as "rather a failure for a painter of such merit."[37]

Establishing the Panoramic Mode

Cole's solution in *The Oxbow* to the problem of representing panoramic vision was to juxtapose two established types of landscapes. Later Hudson River School artists knew Cole's painting and on occasion took over some of its features, but they did not find in it an all-purpose compositional formula. Cole had managed to represent an equivalent of a section of a panorama by extending the angle of vision and employing, as Wolfgang Born observed, a shifting or moving vanishing point very much like the

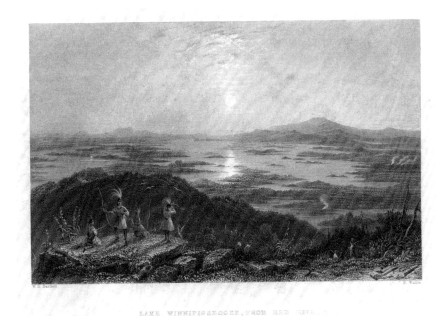

Fig. 52. R. Wallis, *Lake Winnipisseogee, From Red Hill.* Engraving after a drawing by William Henry Bartlett. Nathaniel Parker Willis, *American Scenery; Or, Land, Lake, and River Illustrations of Transatlantic Nature*, 2 vols. (London: George Virtue, 1840), 1: pl. 14. Photograph: Archives and Special Collections, Dickinson College.

shifting vanishing point in an actual panorama painting, but he did so without replicating the panorama's consistent and apparently seamless transition from point to point within the visual field. Thus, when it came to extended or panoramic views, later artists looked not only to *The Oxbow* but to other models, in particular the views produced by topographical draftsmen, who deliberately ignored or were unaware of the prohibitions against the long view put forth by theorists such as Price and Gilpin and who had less incentive than landscape painters to adhere to established landscape formulae. Indeed, during the 1820s and 1830s American landscape tourism, which as we have seen was centered on panoramic vision, in effect created a demand for images of just those views that landscape painters had considered difficult or impossible to represent.

The most important collection of panoramic views of American tourist sites of the period can be found among William Bartlett's illustrations for Nathaniel Parker Willis's *American Scenery.*[38] This book, an Anglo-American co-production, which George Virtue published in

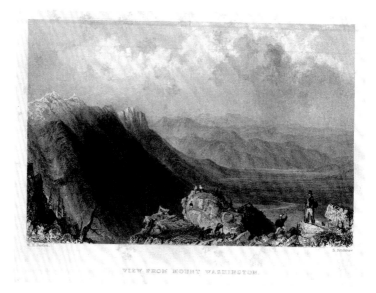

VIEW FROM MOUNT WASHINGTON.

Fig. 53. S. Bradshaw, *View from Mount Washington.* Engraving after a drawing by William Henry Bartlett. Nathaniel Parker Willis, *American Scenery; Or, Land, Lake, and River Illustrations of Transatlantic Nature,* 2 vols. (London: George Virtue, 1840), 1: pl. 47. Photograph: Archives and Special Collections, Dickinson College.

Fig. 54. Frederic E. Church, *Morning, Looking East Over the Hudson Valley from the Catskill Mountains,* 1848. Oil on canvas, 18 ¼ x 24 in. Albany Institute of History & Art. Gift of Catherine Gansevoort (Mrs. Abraham) Lansing (x1940.606.7).

London in 1840, brought together one of the United States' best known writers (in his day Willis's renown equalled that of James Fenimore Cooper and Washington Irving) and England's most prolific topographical draftsman. Bartlett produced 121 drawings for *American Scenery* including views of the Catskill Mountain House, Mount Holyoke, and Niagara Falls. Although in many of his compositions Bartlett adhered to familiar conventions of the pastoral, the prospect, and the sublime prospect, he had no qualms about breaking with convention and improvising panoramic views. For example, in *Lake Winnipisseogee, From Red Hill* (fig. 52), Bartlett depicted the view Cole had described to Wadsworth in 1827 as unpaintable. From the mountaintop, which is inhabited by stage Indians hunting birds with bows and arrows, we look out at a vast, cosmographic landscape of lake, islands, and mountains extending for miles west toward the horizon and the setting sun. The engraving contains vestiges of traditional landscape motifs. The rock on which three of the Native Americans stand recalls the promontories that often feature in prospects and sublime prospects; the two small trees to the right hint at the traditional use of framing trees. Yet these features barely intrude upon a composition in which a startling, panoramic breadth matches an equally dramatic depth. Or to take one additional example: Bartlett's *View from Mount Washington* (fig. 53) again places the viewer on a mountaintop contemplating an extended, almost map-like landscape. Bartlett does not leave us hanging in mid-air. The rocky mountaintop, inhabited by hikers, lies below our feet and it is almost as if these figures, isolated on their rocky outcropping, share with us a panorama platform and that the surrounding scenery—the receding mountains, the plain more than 6,000 feet below, the sky with its hint of a storm—constitutes a section of an annular or circular panorama painting as seen from the tower platform.

Engravings after Bartlett and other topographical draftsmen form a point of transition from the panoramic views sought by landscape tourists to landscape painting in the panoramic mode. I have no doubt that Frederic Church, who was as interested in panoramic representation as his teacher, Thomas Cole, was a close student of Bartlett's engravings and the work of other topographical draftsmen. Almost a decade before he painted his famous *Niagara*, we find Church experimenting with compositional formats that ten or fifteen years earlier would have been taboo for a finished oil painting. For example, in 1848 he painted *Morning Looking East Over the Hudson Valley from the Catskill Mountains* (fig. 54), a work which begins to break with the conventions of the prospect. A solitary hiker leaning on his hiking staff inhabits a foreground ridge high in the Catskills and

Fig. 55. Frederic E. Church, *Above the Clouds at Sunrise*, 1849. Oil on canvas, 27 ¼ x 48 ¼ in. From The Warner Collection of Gulf States Paper Corporation on view at The Westervelt-Warner Museum of Art, Tuscaloosa, AL.

Fig. 56. Frederic E. Church, *West Rock, New Haven,* 1849. Oil on canvas, 27 ⅛ x 40 ⅛ in. New Britain Museum of American Art, New Britain, CT. John Butler Talcott Fund (1950.10). Photograph: Michael Agee.

Fig. 57. Frederic E. Church, *Heart of the Andes*, 1859. Oil on canvas, 66 ⅛ x 119 ¼ in. The Metropolitan Museum of Art, New York. Bequest of Margaret E. Dows, 1909 (09.95). Photograph: all rights reserved, The Metropolitan Museum of Art.

gazes east through the mountains towards the flatlands of the Hudson Valley in the distance. *Above the Clouds at Sunrise* (fig. 55), painted a year after *Morning*, is another attempt to portray the view looking east from the Catskill escarpment. This time, however, the Hudson Valley below us is hidden by cloud. Although Church dares to paint a highly unconventional motif—a "landscape" that is nothing but cloud and sky—he cannot dispense with the framing tree at the right, a windblown survivor clinging tenaciously to the mountain's rocky soil, nor can he do away with the pine trees and rocks that extend from the immediate foreground into the middle distance and are partly engulfed by the swirling clouds. These elements frame an extended prospect that seems panoramic in scope and in which the emphasis, especially with the long trailing gray, purple, pink, and yellow stratus cloud in the distance, accentuates the composition's horizontal or, as it were, panoramic dimension. My third example, also from 1849, is *West Rock, New Haven* (fig. 56; pl. XII). As a composition, this view of a familiar New Haven landmark might seem unremarkable, but note where Church places the viewer. The painting lacks a true foreground, and we are not allowed an imaginative connection to the ground but are placed high in the air looking down into the landscape with the miniaturized scene of haying below us and West Rock looming in the distance beneath a sky filled with flying cumulus clouds. We are placed, in other words, as if we were viewing the scene from a panorama tower.

Fig. 58. Frederic E. Church, *Horseshoe Falls, December 1856–January 1857*. Oil sketch on two pieces of paper joined together, mounted on canvas, 11 ½ x 35 ⅝ in. Olana State Historic Site, New York State Office of Parks, Recreation and Historic Preservation (OL.1981.15).

Fig. 59. Sanford R. Gifford, *Mansfield Mountain*, 1859. Oil on canvas, 30 x 60 in. Manoogian Collection.

During the 1850s Church resorted to similar techniques of viewer placement culminating with his famous *Heart of the Andes* (fig. 57). But the point, finally, is not to catalog the artist's use or invention of signifiers for the panoramic but to underscore the extent to which by the late 1850s, Church and other Hudson River School painters deliberately broke with prior conventions and in their most ambitious paintings attempted to simulate panoramic vision. We find this happening above all in such works as Church's *Heart of the Andes* and *Niagara*, which he at one point conceived of in even more panoramic terms: a small oil sketch he made in 1856–1857 of Horseshoe Falls (fig. 58), with a height-to-width ratio of 1:3,

has a more extended format than the final painting, where the height-to-width ratio is a little less than 1:2. We also encounter the panoramic in the work of such leading artists of the period as Sanford Gifford (fig. 59; pl. XIV), Albert Bierstadt, and Thomas Moran, as well as in the work of such so-called "Luminist" artists as John Kensett and Martin Johnson Heade.

Given its influence on landscape tourism and the production of landscape views, the panoramic was for these artists inescapable. Compelled to break with landscape convention they developed new conventions that, as we have seen, constituted the panoramic mode.

Notes

I presented earlier versions of this essay at Yale University on 19 September 2002 and at the Smithsonian American Art Museum on 10 February 2005. I would like to thank the audiences on both occasions for their comments and insights. I would also like to thank Nancy Siegel and Phillip Earenfight for their encouragement, editorial savvy, and help in obtaining illustrations; and Phyllis Rosenzweig for her critical reading of the manuscript and her unfailing support.

1. Wolfgang Born, *American Landscape Painting: An Interpretation* (New Haven: Yale University Press, 1948), 81f.

2. Born, *American Landscape Painting*, 81f.

3. Born, "The Panoramic Landscape as an Art Form," *Art in America* 36, no. 1 (January 1948): 4–5.

4. I note that more recently Albert Boime has in an extended essay employed the phrase "Magisterial Gaze" to describe the panoramic mode in Hudson River School landscape painting. Boime's term is suggestive: it evokes the size and imaginative scope of works by such artists as Cole, Church, Cropsey, Bierstadt, and Moran and places a stress on the peculiar will to visual mastery that characterizes these works. Magisterial Gaze has to some extent entered critical discourse on the Hudson River School but Boime's analysis seems limited since it too readily equates a particular form of landscape painting (the panoramic) with a particular set of meanings or beliefs. In addition, Boime has nothing to say about the origins and development of this particular "gaze." See Albert Boime, *The Magisterial Gaze: Manifest Destiny and American Landscape Painting* (Washington, DC: Smithsonian Institution Press, 1991).

5. See David Huntington, *The Landscapes of Frederic Edwin Church: Vision of An American Era* (New York: George Braziller, 1966), 4.

6. For Cole's early career as a landscapist see Ellwood C. Parry III, "Thomas Cole's Early Career: 1818–1829," in Edward J. Nygren and Bruce Robertson, eds., *Views and Visions* (Washington, DC: The Corcoran Gallery, 1986), 161–187; Ellwood C. Parry III, *The Art of Thomas Cole: Ambition and Imagination* (Newark, DE: University of Delaware Press; London and Toronto: Associated University Presses, 1988), 21–27; and Alan Wallach, "Thomas Cole and the Course of American Empire," in Wallach and William Truettner, eds., *Thomas Cole: Landscape into History* (Washington, DC: National Museum of American Art; New Haven: Yale University Press, 1994), 23–31.

7. See Heinrich Wölfflin, *Principles of Art History*, M. D. Hottinger, trans. (1915; New York: Dover Publications, 1950).

8. For an incisive account of the history of theories of style, see Meyer Schapiro, "Style," in *Theory and Philosophy of Art* (New York: George Braziller, 1994), 51–102.

9. See Barbara Novak, *American Painting of the Nineteenth Century: Realism, Idealism, and the American Experience* (New York: Praeger, 1969).

10. See Novak, *American Painting of the Nineteenth Century*; and Novak, *Nature and Culture: American Landscape and Painting, 1825–1875* (New York: Oxford University Press, 1980). Novak was probably also influenced by the work of Ernst Gombrich, whose *Art and Illusion: A Study in the Psychology of Pictorial Representation* (New York: Pantheon Books, 1960) enjoyed widespread popularity during the 1960s as a perceptualist account of the evolution of realist and naturalistic styles. Gombrich himself, who studied art history in Vienna in the 1920s, was influenced by Löwy's theories. See E. H. Gombrich, "Art History and Psychology in Vienna Fifty Years Ago," *Art Journal* 44, no. 2 (Summer, 1984): 162–164; this text is also available at http://www.gombrich.co.uk/vienna.htm.

11. See Huntington, *The Landscapes of Frederic Edwin Church*, 44–45, 51; Franklin Kelly, "A Passion for Landscape: The Paintings of Frederic Edwin Church, in Kelly, ed., *The Paintings of Frederic Edwin Church* (Washington, DC: National Gallery of Art, 1989), 41–45.

12. See Huntington, *The Landscapes of Frederic Edwin Church*, 17–18, 41–42; Franklin Kelly, *Frederic Edwin Church and the National Landscape* (Washington, DC: Smithsonian Institution Press, 1988), 52–55; Stephen Jay Gould, "Church, Humboldt, and Darwin: The Tension and Harmony of Science and Art," in Kelly, ed., *The Paintings of Frederic Edwin Church*, 94–107.

13. For *View on the Catskill, Early Autumn*, see John K. Howat et al., *American Paradise: The World of the Hudson River School* (The Metropolitan Museum of Art, 1987), 129. Oswaldo Rodriguez Roque repeats the discussion of *River in the Catskills* in his entry for *View on the Catskill, Early Autumn*, in John Caldwell, Oswaldo Rodriguez Roque, et al., *American Paintings in the Metropolitan Museum of Art* (New York: The Metropolitan Museum of Art in association with Princeton University Press, 1994), 1: 472–476. See also Wallach, "Thomas Cole and the Course of American Empire," 70–74.

14. Sturges to Cole, 23 March 1837, Thomas Cole Papers, New York State Library, Albany, NY.

15. For discussions of the history of the prospect as a literary and pictorial convention, see James Turner, *The Politics of Landscape* (Oxford: Basil Blackwell, 1979); James Turner, "*Landscape* and the Art Prospective in England, 1584–1660," *Journal of the Warburg and Courtauld Institutes* 42 (1979): 290–293; and Carole Fabricant, "The Aesthetics and Politics of Landscape in the Eighteenth Century," in *Studies in Eighteenth-Century British Art and Aesthetics*, ed. Ralph Cohen (Berkeley: University of California Press, 1985): 49–81.

16. For a reproduction see Alan Wallach, "Thomas Cole's *River in the Catskills* as Antipastoral," *The Art Bulletin* 84, no. 2 (June 2002): 343.

17. A small oil sketch, *Salvator Rosa Sketching Banditti*, executed between 1832 and 1840 (M. and M. Karolik Collection of American Paintings, Museum of Fine Arts, Boston) suggests the extent of Cole's admiration for the seventeenth-century painter. For an account of Rosa's work in the United States and its influence (and in particular its influence on Cole), see Richard W. Wallace, *Salvator Rosa in America* (Wellesley, MA: Wellesley College Museum, Jewett Arts Center, 1979), passim and 112, 121.

18. Bruce Robertson, "Venit, Vidit, Depinxit: The Military Artist in America," in Edward J. Nygren and Bruce Robertson, eds., *Views and Visions* (Washington, DC: The Corcoran Gallery, 1986), 83–103.

19. For this section, I have drawn upon material in my article "Making a Picture of the View from Mount Holyoke," in David Miller, ed., *American Iconology: New Approaches to Nineteenth-Century Art and Literature* (New Haven: Yale University Press, 1993): 80–91, 310–312. The reader is referred to this article for additional illustrations.

20. The most comprehensive history of the panorama is Stephan Oettermann, *The Panorama: History of a Mass Medium*, Deborah Lucas Schneider, trans. (1980; New York: Zone Books, 1997). See also Ralph Hyde, *Panoramania!* (London: Trefoil, 1988); and Bernard Clement, *The Panorama*, Anne-Marie Glasheen, trans. (London: Reaktion Books, 1999).

21. Oettermann, *The Panorama*, 12.

22. See Oettermann, *The Panorama*, 5–47; Michel Foucault, *Discipline and Punish*, Alan Sheridan, trans. (New York: Vintage Books, 1979), 195–228, 317 n. 4; and "The Eye of Power," *Power/Knowledge, Selected Interviews and Other Writings 1972–1977*, Colin Gordon, ed., Colin Gordon, Leo Marshall, John Mepham, and Kate Soper, trans. (New York: Pantheon Books, 1980), 146-165. Foucault speculates that Bentham may have been inspired by Barker's panorama, but Bentham's own account seems to preclude this. See Jeremy Bentham, "Panopticon or The Inspection-House," in John Bowring, ed., *The Works of Jeremy Bentham* (Edinburgh: William Tait, 1843), 4: 37–172. For an analysis see Robin Evans, "Bentham's Panopticon, An Incident in the Social History of Architecture," *Architectural Association Quarterly* 3, no. 2 (April–July 1971): 21–37.

23. It is impossible in a relatively short article to develop the historical bases for equations between vision and power in landscape painting although I would observe that the equation was never as abstract as it appears to be in Foucault's writings. It should also be said that in landscape painting the equation evolves from an identity between sight or vision and land ownership to metaphorical forms in which landscape comes to signify "a well-constructed survey of the nation's prospects" as seen through the eyes of an aristocratic elite. See Turner, "*Landscape* and the Art Prospective," 290–293.

24. For a history of the panorama in the United States, see Kevin Avery, "The Panorama and Its Manifestation in American Landscape Painting, 1795–1870," (PhD diss., Columbia University, 1995), passim.

25. For early landscape tourism, see John F. Sears, *Sacred Places, American Tourist Attractions in the Nineteenth Century* (New York: Oxford University Press, 1989). For the White Mountains, see Donald D. Keyes et al., *The White Mountains: Place and Perceptions* (Durham, NH: University Art Galleries, University of New Hampshire, 1980); and Dona Brown, *Inventing New England: Regional Tourism in the Nineteenth Century* (Washington, DC: Smithsonian Institution Press, 1995). For Mount Holyoke tourism, see George Walter Vincent Smith Art Museum, *Arcadian Vales: Views of the Connecticut River Valley* (Springfield: Springfield Library and Museums Association, 1981); David Graci, *Mt. Holyoke, An Enduring Prospect, History of New England's Most Historic Mountain* (Holyoke: Calem Publishing Co., 1985); and Marianne Doezema, et al., *Changing Prospects: The View From Mount Holyoke* (South Hadley, MA: Mount Holyoke College Art Museum; Ithaca, NY: Cornell University Press, 2002).

26. See Roland Van Zandt, *The Catskill Mountain House* (New Brunswick: Rutgers University Press, 1966); Kenneth J. Myers, *The Catskills, Painters, Writers and Tourists in the Mountains* (Yonkers: The Hudson River Museum of Westchester, 1987).

27. See Jeremy Adamson, ed., *Niagara: Two Centuries of Changing Attitudes, 1697–1901* (Washington, DC: Corcoran Gallery of Art, 1985); Elizabeth McKinsey, *Niagara Falls: Icon of the American Sublime* (Cambridge and New York: Cambridge University Press, 1985).

28. See Alan Wallach, "Wadsworth's Tower: An Episode in the History of American Landscape Vision," *American Art* 10, no. 3 (Fall 1996): 8–27.

29. Thomas Cole to Daniel Wadsworth, August 4, 1827, in Bard McNulty, ed., *The Correspondence of Thomas Cole and Daniel Wadsworth* (Hartford: The Connecticut Historical Society, 1983), 10–11.

30. In Louis Legrand Noble, *The Life and Works of Thomas Cole*, Elliot S. Vesell, ed. (Cambridge: The Belknap Press, 1964), 65; Blake Nevius, *Cooper's Landscapes, An Essay on the Picturesque Vision* (Berkeley: University of California Press, 1976), 28, also takes note of this passage.

31. Nevius, *Cooper's Landscapes*, 27.

32. William Gilpin, *Observations on the River Wye, and Several Parts of South Wales, &c. relative chiefly to Picturesque Beauty: Made in the Year 1770*, 5th ed. (London: T. Cadell Junior and W. Davies, 1800), 128f.

33. Cited in Nevius, *Cooper's Landscapes*, 28.

34. Noble, *The Life and Works of Thomas Cole*, 119. Ellwood C. Parry III has twice published this drawing and has argued for Cole's familiarity with Vanderlyn's panorama and the London panoramas of Robert Barker's son, Henry Aston Barker. See Parry, "Landscape Theatre in America," *Art in America* 59, no. 6 (November 1971): 57, and *The Art of Thomas Cole*, 125.

35. Cole to Reed, 2 March 1836, Cole Papers, New York State Library, Albany, NY.

36. As far as I can tell only three attempts to represent the view from Mount Holyoke precede Cole's painting: the print that appeared in Theodore Dwight's *Sketches of Scenery and Manners in the United States* (New York: A. T. Goodrich, 1829); Basil Hall's view in *Forty Etchings, From Sketches Made with the Camera Lucida, in North America in 1827 and 1828* (Edinburgh: Cadell & Co.; London: Simpkin, Marshall, and Man, Boys & Graves, 1829), pl. 11; and a lithograph after Orra White Hitchcock showing "West View from Holyoke" which appeared in Hitchcock's *Report on the Geology, Mineralogy, Botany, and Zoology of Massachusetts* (Amherst, 1833), Atlas of Plates, no. V; reproduced in Parry, *The Art of Thomas Cole*, 174. None of these works would have been particularly well known.

37. [Mordecai Noah?], "Annual Exhibition of the Academy of National Design [sic]," *[New York] Evening Star, for the Country* (10 May 1836), 1.

38. See Nathaniel Parker Willis, *American Scenery; Or, Land, Lake, and River Illustrations of Transatlantic Nature*, 2 vols. (London: George Virtue, 1840).

Getting a Grip on God:
Painting the Christianized Landscape

Matthew Baigell

Certainly, many authors have written about the connections between nature and the Bible or nature and Scripture in nineteenth-century landscape painting. One aspect of that broad topic I want to consider here is the way (or ways) artists apprehended the Deity in the landscape, a slippery subject at best, but one that needs to be confronted in order to understand better the intentions of the artists and the images they employed.[1]

Half a century ago, the great scholar of American civilization Perry Miller on at least two occasions laid out the problem directly for both artists and the public in general. He observed that the editors of *The New York Review* forgot "repeatedly that the Christian should admire in Nature only the handiwork of God, and [treated instead] the landscape as a self-sufficient source of morality and law," and that "nature had somehow, by legerdemain that even Christians as highly literate as the editors…could not quite admit to themselves, effectually taken the place of the Bible: by her unremitting influence, she would guide aright the faltering steps of the young republic."[2]

Art historians, as well, have acknowledged the conflation of nature and the Bible. For example, a quarter of a century ago, Barbara Novak stated that "in the early nineteenth century in America, nature couldn't do without God, and God apparently couldn't do without nature. By the time Emerson wrote *Nature* in 1836, the terms 'God' and 'nature' were often the same thing, and could be used interchangeably."[3] And in our own time, Adrienne Baxter Bell said in her recent book on George Inness, "the overarching mission of most of Inness's colleagues—American landscape painters of the mid- to late nineteenth century—was to represent nature as a manifestation and revelation of the divine. God and the American landscape maintained a steady affiliation throughout the century."[4]

These are obviously truthful generalizations as far as they go, but I would like to suggest that there might be a more precise way to describe this interchange and affiliation. I say "suggest" because there are, no doubt, other ways and because the connections will probably never be resolved definitively. And I will do so by discussing a few works by Asher B. Durand to illustrate my points. He is an especially appropriate artist to observe because his attitudes toward nature and the Bible evolved over a period of years. That is, I am not suggesting that he or others can or should be locked into one or another point of view or that they never changed their religious attitudes, but rather I want to indicate a general framework for looking at an artist's work as it evolved over the course of their professional career.

It boils down to this. There are three chief ways in which God was invoked or understood—or at least as I understand—in the nineteenth century: through Scripture, through nature, and through a sense of God's immanence in the physical world. First, one could know God only through Scripture or the Bible. Second, one could know God through nature, either by viewing nature as an example of God's handiwork or in believing through logical argument that only God could have created nature. Third, one might experience God not only through nature, but also believe that God and nature were one without benefit of biblical authority. In this last view, the Deity was immanent in all things. Instances of these three ways to apprehend the Deity abound in nineteenth-century literature. Generally, professional religionists and strict observers accepted the first way—through Scripture; writers, artists, and some religionists the second—through nature and Scripture; and Transcendentalists the third—through personal experience. Since this is a theoretical framework, we must, of course, allow for slippage between these three ways.

The first way, God known only through Scripture, is addressed in the Westminster Confession of Faith, developed in England between 1643 and 1646. It lays out in clear and precise language the position of the strict observer and is part of the central doctrine of Presbyterianism, Congregationalism, and the Baptists. "Although the light of nature, and the works of creation and providence, do so far manifest the goodness, wisdom, and power of God, as to leave men inexcusable; yet are they not sufficient to give that knowledge of God, and of his will, which is necessary unto salvation." After dismissing nature in this way, the Confession states in precise terms exactly what will give that knowledge of God and of God's will:

> The Supreme Judge...can be no other but the Holy Spirit speaking in the Scripture.... The whole counsel of God, concerning all things necessary for His own glory, man's salvation, faith and life, is either expressly set down in Scripture, or by good and necessary consequence may be deduced from Scripture: unto which nothing at any time is to be added, whether by new revelations of the Spirit or traditions of men. Nevertheless we acknowledge the inward illumination of the Spirit of God to be necessary for the saving understanding of such things as are revealed in the Word.[5]

This means, plainly and simply, that believers accept the Bible as the authoritative compendium of Divine revelation. God is perceived through the Word—not in the woods.

The distinction between nature and the Bible could in fact be made clear to the nineteenth-century reader. For example, in the second of Durand's famous letters on landscape painting written at mid-century, the artist stated baldly that only in Scripture can one find true Revelation: "The external appearance of this our dwelling place ... is fraught with lessons of high and holy meaning, only surpassed by the light of Revelation."[6] I take this passage, to which I will return later, to mean that true Revelation cannot be obtained through nature, but only through Scripture. And in another example, a dedication sermon delivered at the Church of the Mountain in the Delaware River Water Gap in August 1854, the following was said:

> For many centuries past, has Jehovah dwelt in the rocky fastness of this mountain. Ere there was a human ear to listen, His voice was uttered in the sighing of the breeze and the thunder of the storms....But never until this day has He dwelt here in a temple made with hands.[7]

Here, I am assuming that in the contrast between nature and the "temple," the latter had become the physical as well as visual equivalent, or surrogate, for the authority of Scripture, a notion that, as I will suggest later, informs Durand's *Sunday Morning* of 1860 (fig. 60; pl. X).

The religious figure Horace Bushnell acknowledged the distinction between nature and the Bible as sources of Revelation and clearly rejected the former as equal to the latter. In fact, he criticized contemporary writers for confusing the two:

Fig. 60. Asher B. Durand, *Sunday Morning*, 1860. Oil on canvas on wood paneled stretcher, 28 ⅛ x 42 ⅛ in. New Britain Museum of American Art, New Britain, CT. Charles F. Smith Fund (1963.4). Photograph: E. Irving Blomstrann.

Fig. 61. Asher B. Durand, *Sunday Morning*, 1839. Oil on canvas, 25 ¼ x 36 ¼ in. The New-York Historical Society, New York (1903.3). Photograph: Collection of The New-York Historical Society.

> The word "Nature"…is currently used in our modern literature
> as the name of a Universal Power; be it an eternal fate, or an eter-
> nal system of matter reigning by its necessary laws, or an eternal
> God who is the All, and, is, in fact, nowise different from a sys-
> tem of matter….[But] nature plainly is not, and cannot be, the
> proper and complete system of God; or, if we speak no more of
> God, of the universe.[8]

For Bushnell, God was above the fixed and finite laws of nature. God was
expressed in, but in no way was to be measured by or to be confused with,
His works.[9]

In other ways, the distinction was also made clear and was observed
especially among the several religious organizations that flourished during
the Second Awakening between, say, 1800 and 1850, including the
American Bible Society (founded in 1816), the American Sunday School
Union (1824), the American Tract Society (1825), and the American
Mission Society (1826), and could be observed in any number of religious
magazines.[10] In the *Home Missionary and Pastor's Journal* for January 1,
1830, for example, there is an exhortation that "our National Bible Society
must be sustained in the heaven-descended enterprise of giving a revela-
tion to every destitute household in the land."[11]

In addition to the desire to place a Bible in every home, other
Protestant organizations emphasized strict observance of the Sabbath, as
suggested in Durand's *Sunday Morning* of 1839 (fig. 61; pl. IX). As the reli-
gious historian Robert T. Handy observed:

> The intensity of the nineteenth-century desire to maintain the
> observance of a strict…Christian Sabbath…was seen as an
> important sign of evangelical advance…Protestant forces across
> a wide sweep of denominational and theological opinion per-
> sistently struggled for the Sabbath as a day apart—a day that
> would characterize American civilization as Christian.[12]

No doubt, Handy was responding to a virtually endless number of state-
ments reminding the nineteenth-century reader that "there is no subject
on which American Christians are more happily united than that of the
importance of a proper observance of the Sabbath."[13]

But the big question here is: what was a proper observance of the
Sabbath? And this leads us to the second, and most tricky, way to appre-
hend the Deity—through nature. At one extreme, nature and the Bible are
inextricably bound together; at the other, nature could provide pleasantly
elevating moral lessons, and little else. For example, on facing pages of *The*

Knickerbocker for December 1850, there are two poems completely contradictory in their religious implications. In the first, the supremacy of organized religion, and by inference the Bible, was recognized. In the second, nature was acknowledged as the source of a better type of religious feeling. In the first, "The Altar," the anonymous author wrote about an oak stump that he likened to an altar. He reminisced about an earlier visit with his lady love and hoped that if she had lately visited the stump and had thought fondly of him, then he:

> from that rude trunk may gather Such hope, that when I kneel again In holy church, and humbly say, "OUR FATHER" Thy thought may strengthen my devout Amen.[14]

In contrast, on the facing page, one William Rodman in his poem, "Nature and the Church," after alluding to a flowery patch as a floral priesthood and the patch's aroma as contained in censers held by angels' hands, then said:

> I thought could but the Christian Church To nature humbly turn, And from her pure and simple page Her peaceful precepts learn. No more would fierce sectarian fires upon her altars burn. Then let us each in childish faith, To Nature yield our powers, And strive to learn her perfect law, From out her book of flowers; That the "pure faith which works by love" May evermore be ours.[15]

Both an anti-denominational and, by extension, an anti-Biblical tone can also be detected in some poems written with an obvious Christian spirit at mid-century. One, "The Miner's Sabbath," by a J. Swett, ends with the following lines:

> Not in the crowded church of GOD, My heart most bows before his throne, But when I press mountain-sod, A worshipper, unseen and lone.[16]

Among novelists, James Fenimore Cooper was quite outspoken. In *The Pathfinder,* for example, Cooper has Natty Bumppo, the Leatherstocking figure, say, "towns and settlements lead to sin…, but our lakes are bordered by forests, and one is everyday called upon to worship God in such a temple."[17] Natty Bumppo also had definite reservations about attending church:

> [I] never could raise within me the solemn feelings and true affection that I feel when alone with God in the forest. There I

seem to stand face to face with my Master, all around me is fresh and beautiful as it came from his hand, and there is no nicety or doctrine to chill the feelings. No, no: the woods are the true temple, a'ter all, for there the thoughts are free to mount higher even than the clouds.[18]

The religious figure Henry Ward Beecher wanted to have it both ways, and some of his statements could even have been called blasphemous by strict observers. On the one hand, he wrote:

How wonderful is what we call association!...Its [the soul's] life is written out, and it keeps a journal upon trees, upon hills, upon the face of heaven. Is it not for this, then, that in turn God has used every object in nature, every event in life...to represent to us by association his nature and affects? Thus the heaven and the earth do speak of God, and the great natural world is but another Bible, which clasps and binds the written one; for nature and grace are one. Grace is the heart of the flower, and nature but its surrounding petals...To the Christian, [trees, brooks, and winds] all speak of God...The tree stretches out its arms, laden with fruit, like the arm of God. The morning sprinkles him with dew, as with holy water.[19]

But at the same time, he was willing to assert that "he who denies the truth in or out of the Bible, denies God!"[20] It would seem that the Beecher of the latter quote was at that moment more of a strict observer than in the previous passage. The Beecher of that passage might very well have been—at that moment—an heir to eighteenth-century rationalism and deism according to which benign nature either corroborated Revelation or merely indicated the existence of and evidence for God.[21] One of the major modes of thought through which this type of belief reached the public was association psychology, initially popularized in this country through Archibald Alison's *Essays on the Nature and Principles of Taste* (1790). In it, Alison associated nature and the Deity in a non-specific Christian context. "Nature," he wrote, "in all its aspects around us ought only to be felt as signs of his providence, and as conducting us, by the universal language of these signs, to the throne of the Deity."[22] This kind of language, no doubt, contributed to the idea that nature could substitute for the Bible as a source of Revelation and knowledge of the Deity, or at least to hold nature and the Bible in some sort of equilibrium.

The third way to apprehend the Deity was by thinking as a pantheist, believing that the Deity was immanent in all things. One can find examples of such belief throughout the writings of Ralph Waldo Emerson and the Transcendentalists. Perry Miller pointed out that Emerson in fact "caused alarm by too carelessly dispersing with the last pretense of a specifically Christian Revelation, by proclaiming the utter sufficiency of nature to supply the life of the spirit."[23] Horace Bushnell was among those so alarmed. He identified pantheists as those "who identify God and nature, regarding the world itself and its history as a necessary development of God, or the consciousness of God." Bushnell continued, "Of course, there is no power of nature and above it to work a miracle; consequently no revelation that is more than a development of nature."[24]

Emerson might very well have rejected this observation since he depended upon intuitive perceptions of truth and rejected external authority beyond the self. Not only did he view himself as part of the continuum between spirit and matter (the transparent eyeball), but, as he wrote in his journal for May 26, 1837, "in certain moments I have known that I existed directly from God, and am, as it were, his organ, and in my ultimate consciousness am He."[25] Furthermore, in various passages from "The Oversoul," among other essays, he directly challenged strict observers such as Bushnell. For example:

> We distinguish the announcements of the soul, its manifestations of its own nature, by the term Revelation ... For this communication is an influx of the Divine mind into our mind ... The simplest person, who in his integrity worships God, becomes God.[26]

And from "Circles," "We can never see Christianity from the catechism— from the pastures, from a boat in the pond, from amidst the songs of wood-birds, we possibly may."[27] This has little connection with the Westminster Confession or anything close to it. I associate this kind of thinking with Luminist paintings such as those by John Kensett in which reflections of the sky in the water suggest both passage and continuity between the physical earth and the spiritual heavens above. Or, to say it differently, the emanations of God that spread out through the physical world and are reflected back heavenward are one and the same (fig. 62).

Durand would have rejected this point of view out of hand. We can make this assumption because we know that he was raised a Calvinist and as a youth studied the Westminster Catechism.[28] So it is reasonable to assume that the very young Durand was taught to find Revelation in

Scripture, not in nature or directly within himself. This point of view is illustrated in his 1839 painting, *Sunday Morning* (fig. 61; pl. IX), which shows a family departing for worship on the Christian Sabbath. Landscape details are basically background elements. In fact, the painting is virtually a poster picture for the various groups mentioned earlier concerned with strict observance of the Sabbath.

Now, I cannot speak to the vacillations of Durand's particular religious journey, the subject of another kind of study, but will say here that like others he altered his views from time to time. When in England, a year after he completed *Sunday Morning*, for example, he wrote in his journal:

> Today again is Sunday. I have declined attendance on church service, the better to indulge reflection unrestrained under the high canopy of heaven, amidst the expanse of waters—fit place to worship God and contemplate the wonders of his power. This mode of passing the Sabbath became habitual with me early in life.[29]

A crossed-out sentence contains the words, "The voice of Nature is always … it is the voice of God." Durand then continues, mentioning that the many sounds of nature—winds in the forest, waterfalls, rain—"all tend to

Fig. 62. John F. Kensett, *View of the Shrewsbury River New Jersey*, 1859. Oil on canvas, 12 x 20 in. Jane Voorhees Zimmerli Art Museum, Rutgers, The State University of New Jersey, New Brunswick. Gift of the Interfraternity Alumni, 1952. Photograph: Jack Abraham.

Fig. 63. Asher B. Durand, *Early Morning at Cold Spring*, 1850. Oil on canvas, 59 x 47 ½ in. Montclair Art Museum, Montclair, NJ. Museum Purchase, Lang Acquisition Fund (1945.8).

awaken thoughtful meditation, and rational man in the open walks of nature needs no temple made with hands, and the silent thought of praise or supplication, accompanied by that fitting voice asks no other aid to bear it to the mercy-seat of Heaven."[30]

These words recall the thoughts of Archibald Alison, James Fenimore Cooper, and Henry Ward Beecher in his more nature-ridden moments. But Durand was not an ideologue and, evidently, subject to changing his mind as he matured. In *Early Morning at Cold Spring* (1850) (fig. 63; pl. XI), we see a world in which Durand is balancing nature against the word of God as revealed in Scripture, the church being the visual symbol for Scripture. The isolated figure in the center stares across the inlet at people walking to church. The two steeples seen in the distance are clearly meant to act as terminal points for our attention. Above the man, a dead branch, a halo of sorts, suggests that nature alone is not sufficient as a source of revelation, especially since it separates the man from those going to church. Perhaps Durand came to realize that those Sunday walks in England were not as spiritually sustaining as he had once thought. Or per-haps he came to realize, as Horace Bushnell had, that nature was not "the proper and complete system of God," that God was expressed in, but was not to be confused with His works, and that the power of nature was clear-ly subservient to that of God.

In any event, within a few years time, Durand returned to the belief in which he had been instructed as a child, that of a strict observer. For in 1855, in the previously mentioned second letter on landscape painting, Durand wrote that the study of nature is important for "its influence on the mind and heart." But then he continued, "The external appearance of this our dwelling place, apart from its wondrous structure and functions that minister to our well-being, is fraught with lessons of high and holy meaning, only surpassed by the light of Revelation."[31] I assume that for Durand, Revelation—with a capital R—meant Scripture, as in the Westminster Confession. At least that seems to be the meaning of his 1860 version of *Sunday Morning* (fig. 60). Here, Durand does not pose a person in opposition to or looking longingly toward the church, as in *Early Morning at Cold Spring*. Rather, nature is literally the frame through which the church is apprehended. The church is the terminus of the rural path on which the small figures walk. Here, nature is clearly subservient to organized religion and to the Bible as the source of Revelation, symbolized by the church building.

Not all paintings, of course, contain such overt Christian references. And as earlier indicated, not all of Durand's landscapes before or after cer-

Fig. 64. Asher B. Durand, *Kaaterskill Clove*, 1866. Oil on canvas, 39 x 60 in. The Century Association, New York. Photograph: Frick Art Reference Library.

tain dates will illustrate only the points of view of the strict observer or the person who reads nature as the Bible. I would argue, however, that Durand's work never reveals a sense of pantheism even though in an otherwise exemplary book on Arthur Dove, Sherrye Cohn referred to Durand's *Kaaterskill Clove* of 1866 (fig. 64) as "vast, solitary, and rife with mythic potential, the perfect embodiment of a pantheistic philosophy."[32] In response to that assertion, I would argue that there is a logical disconnect in placing "mythic potential" and "pantheistic philosophy" in the same sentence. Mythic potential might refer here to reading the work as the embodiment of American purity or innocence in the natural landscape. *That* concerns the subject of national identity, of identifying something about the nation through its landscape. This is a political observation. Mythic potential has no connection to pantheistic philosophy. The latter means that God is equated with the forces of nature, that they are one and the same insofar as God is immanent in nature. *This* is a religious or spiritual observation, not a political one. Further, knowing what we do know about Durand's religious concerns, I doubt that he intended to illustrate Emersonian pantheism, to conflate God with nature. Instead he probably intended to explore the idea that the beauties of nature in some

Fig. 65. Thomas Cole, *The Cross in the Wilderness*, c. 1844. Graphite with white, gray-green, and green-brown chalks on gray paper, 7 ⁵/₁₆ in dia. National Gallery of Art, Washington, DC. John Davis Hatch Collection, Avalon Fund (1983.2.2). Image © 2004 Board of Trustees, National Gallery of Art.

Fig. 66. Frederic E. Church, *Twilight in the Wilderness*, 1860. Oil on canvas, 40 x 64 in. The Cleveland Museum of Art. Mr. and Mrs. William H. Marlatt Fund (1965.233). Photograph: © The Cleveland Museum of Art.

way reflected God's handiwork, that there are lessons to be learned just by observing nature, but that these are ultimately, as he wrote, second to Revelation. Otherwise, why would he place the church and what it represents at the end of the road in *Sunday Morning* (fig. 60)?

I do not mean to set up a gigantic scorecard of American landscape painting and mechanically place artists in one of the three categories with regard to their religious beliefs and how they visualized them. But rather I wish to say that we need to find more precise ways to discuss how artists expressed themselves in these matters within the contexts of the different degrees of beliefs at the time. For example—and I mean only to raise the issue, not to explore, let alone to resolve it—artists such as Thomas Cole and Frederic Church placed crosses in the landscape (figs. 65 and 66). Whether these were human-made as with Cole in his *The Cross in the Wilderness* (c. 1844), or natural as in Church's *Twilight in the Wilderness* (1860) (seen on the upper profile of the stump in the left foreground), each cross signifies more than just the Christianization of the landscape or of finding moral lessons in it. Cole's painting suggests the subservience of the landscape to Scripture as a source of Revelation, the human-made cross being their surrogates. Church's painting suggests that nature of its own accord can offer a path to God separate from Scripture as a source of Revelation.

So, rather than just say that nature and the Bible are inextricably intertwined in nineteenth-century thought and art, it would seem that a next step would be to understand an artist's immediate motivation for a particular image. One way, as I have suggested here, is to think about the ways the Deity is manifested in a painting—through Scripture often symbolized by a church building or a human-made cross, through the conflation of nature and religion, or through some sense of pantheistic immanence—and then try to observe how an artist's particular religious beliefs, his or her particular personal religious identity, can be read in a particular work. This would mean going through material with which specialists are already familiar—letters, poems, and statements—but thinking about them in terms of the artist's individual religious journey and then searching out the relevant personal, religious, and social details of the moment for a closer reading of the artist's intentions. Quite possibly, this might lead to a more intimate understanding of why the artist chose, omitted, or juxtaposed particular images, and a more precise apprehension of the intimate connections between nature and the Bible in nineteenth-century landscape painting.

Notes

1. This essay began its life as a relatively short paper presented in the symposium entitled "Within the Landscape: Perspectives on Nineteenth-Century American Scenery" at Dickinson College, Carlisle, PA on March 27, 2004. I emended it minimally here rather than restructure it completely so that it would retain the spirit of the original paper. But, clearly, the possibilities of more extended discussions on specific artists as well as on topics such as the connections between art, religion, civic virtue, and social morality as well as, in nineteenth-century terms, the American landscape and Christian values are implicit in my discussion.
2. The first citation is from "The Location of American Religious Freedom" (from the book *Religion and Freedom in American Thought*, 1954), and the second from "The Romantic Dilemma in American Nationalism and the Concept of Nature" (*Harvard Theological Review*, 1955), reprinted in Perry Miller, *Nature's Nation* (Cambridge: Harvard University Press, 1967), 158, 203.
3. Barbara Novak, "The Nationalist Garden and the Holy Book," *Art in America*, 60 (January-February 1972): 46–57, reprinted in *Nature and Culture* (New York: Oxford University Press, 1980), 3.
4. Adrienne Baxter Bell, *George Inness and the Visionary Landscape* (New York: National Academy of Design, 2003), 20.
5. John H. Leith, ed., *Creeds of the Churches: A Reader's Christian Doctrine from the Bible to the Present*, rev. ed. (Richmond: John Knox Press, 1973), 193, 196.
6. Asher B. Durand, "Letters on Landscape Painting: Letter II," *The Crayon* 1 (January 1855): 34.
7. Cited in Luke Wills Brodhead, *The Delaware Water Gap: Its Scenery, the Legends and Early History* (Philadelphia: Sherman, 1870), 162.
8. Horace Bushnell, *Nature and the Supernatural* (New York: Charles Scribner, 1858), 39, 65.
9. Bushnell, *Nature and the Supernatural*, 42.
10. Winthrop S. Hudson, *Religion in America* (New York: Scribner's and Sons, 1973), 153.
11. Cited in Robert T. Handy, ed., *Religion in the American Experience* (Columbia: University of South Carolina Press, 1972), 87.
12. Robert T. Handy, *A Christian America* (New York: Oxford University Press, 1971), 48.
13. Robert Baird, *State and Prospects of Religion in America* (New York: Robert Carter, 1856), 44.
14. Anonymous, "The Altar," *The Knickerbocker* 36 (December 1850): 534.
15. William M. Rodman, "Nature and the Church," *The Knickerbocker* 36 (December 1850): 535.
16. J. Swett, "The Miner's Sabbath," *The Knickerbocker* 44 (July 1854): 19.
17. James Fenimore Cooper, *The Pathfinder* (1840; New York: New American Library, 1961), 25.
18. Cooper, *The Pathfinder*, 86. See also his comments in *The Crater* (1847) concerning sects praying at each other, as cited in John T. Frederick, *The Darkened Sky: Nineteenth-Century American Novelists and Religion* (South Bend: University of Notre Dame Press, 1969), 431.
19. Henry Ward Beecher, *Life Thoughts, Gathered from the Extemporaneous Discourses of Henry Ward Beecher* (Boston: Phillips, Sampson and Co., 1858; New York: Sheldon, 1860), 69-70, 179–180. References are to the New York edition.
20. Henry Ward Beecher, *New Star Papers; or Views and Experiences of Religious Subjects*

(New York: Derling and Jackson, 1859), 223.

21. Henry E. May, *The Enlightenment in America* (New York: Oxford University Press, 1978), 215.

22. Archibald Alison, *Essays on the Nature and Principles of Taste* (1790; New York: Carvill, 1830), 415. References are to the New York edition.

23. Miller, *Nature's Nation*, 152.

24. Bushnell, *Nature and the Supernatural*, 23.

25. Edward Waldo Emerson and Waldo Emerson Forbes, eds., *Journals of Ralph Waldo Emerson* (Boston: Houghton Mifflin, 1910), 4:249.

26. Alfred R. Ferguson and Jean Ferguson Carr, eds., *The Essays of Ralph Waldo Emerson* (Cambridge: Harvard University Press, 1987), 166.

27. Ferguson and Carr, *The Essays of Ralph Waldo Emerson*, 185.

28. David Lawall, *Asher B. Durand* (New York: Garland, 1977), 80.

29. Lawall, *Asher B. Durand,* 84.

30. Lawall, *Asher B. Durand*, 84; see also John Durand, *Life and Times of A. B. Durand* (New York: Charles Scribner's Sons, 1894), 20, 145–146; and Asher B. Durand Papers, New York Public Library.

31. Durand, "Letters on Landscape Painting," 34.

32. Sherrye Cohn, *Arthur Dove: Nature as Symbol* (Ann Arbor: UMI Research Press, 1985), 3.

Gifford and the Catskills:
Resort and Refuge

Kevin J. Avery

This paper was prompted in part by several excursions I made to the eastern Catskills in summer 2002 and autumn 2003, expressly to observe and take photographs of sites that Sanford Gifford, his artistic forbear Thomas Cole, and Gifford's contemporaries represented. In comparing the photographs to the paintings, I hoped not only to distinguish Gifford's vision from that of Cole and his contemporaries but to gain insight into the stages of idealization and refinement through which he filtered his firsthand experience of the Catskills. Even among his peers Gifford was regarded—and justly so—as the most concertedly poetic of the New York fraternity of landscape painters called the Hudson River School.[1]

I also seek to extend the analysis of Gifford's Catskill paintings to the motivations or sentiments that could have affected the artist in fashioning a vision to which his patrons so readily responded, and which differed markedly from Cole's and Gifford's colleagues. Gifford's artistic context is not ignored here, but it has often been discussed; less examined has been the cultural and especially the literary climate in which he and his patrons matured, and the special link between literary and tourist culture in the mid-century and Civil War periods. Here these issues will be discussed with reference chiefly to Gifford's Catskill paintings, but, as one will see, they have relevance to what Barbara Novak referred to as both the "luminist" and "quietistic" character of much American landscape in the third quarter of the nineteenth century.[2]

Gifford grew up in Hudson, New York, just across the river northeast of the Catskill Mountains.[3] His friend and fellow landscape painter Worthington Whittredge reports that Gifford made his decision to become a landscape painter while standing atop Mount Merino, with its view overlooking not only Hudson but south to the Catskills.[4] The latter are visible beyond Mount Merino in the 1851 view of the landmark with the skyline of Hudson in the foreground (fig. 67). Whittredge noted,

Fig. 67. Sanford R. Gifford, *Mount Merino and the City of Hudson, in Autumn*, c. 1851–1852. Oil on canvas, 18 ½ x 26 ½ in. Albany Institute of History & Art. Purchase, gift by exchange, Governor and Mrs. W. Averell Harriman (1998.2).

moreover, that from Mount Merino Gifford could see not only the Catskills but the house of Thomas Cole,[5] founder of the Hudson River School, who had lived in the village of Catskill since Gifford was thirteen years old (1836), and who painted his new neighborhood many times, including the *View on the Catskill, Early Autumn* (1837) now in the Metropolitan Museum of Art (fig. 43). In the city of Hudson, Gifford knew the portrait and landscape painter Henry Ary, who moved from Catskill to Hudson in the late 1830s and may even have given Gifford his first art lessons.[6] When Ary died in 1859 it was reported that Cole had been a major influence on him when he lived in Catskill;[7] this is not hard to believe in view of the stylistic consonance (if not commensurate technical mastery) of Ary's many views of Mount Merino with Cole's paintings of Catskill. It is not hard to imagine, in turn, Ary's communication to the young Gifford of his enthusiasm for Cole's work. Moreover, Gifford and Ary sketched together in the Catskills at least once, in summer 1849.[8]

Gifford's, Cole's, and Ary's images of the Catskills do not disclose the principal destination in the mountains in the second and third quarters of the nineteenth century, the Catskill Mountain House, which Cole painted more than once (see figs. 68, 69; pls. VIII, XVI). His and other artists' por-

trayals all testify to the popularity of the resort as early as the 1830s. Indeed, as Kenneth Myers has made clear in his excellent 1987 catalogue on artists, writers, and tourists in the Catskills, Cole might not have gone to the mountains to sketch for the first time in 1825 if the hotel had not opened there the year earlier.[9] That development in turn could not have occurred without the publicizing of the region by several popular writers, above all James Fenimore Cooper in his first Leatherstocking tale, *The Pioneers,* of 1823. There Cooper's scout-hero Natty Bumppo (or "Leatherstocking") vividly describes both the broad view of the Hudson River Valley from Pine Orchard, the site on which the hotel would be built, and the principal natural spectacle near the hotel site, Kaaterskill Falls,[10] which was the subject of several of Cole's earliest paintings.[11]

By the time Gifford began exploring the Catskills in earnest in the mid 1840s, Charles Beach had purchased the hotel and more acreage surrounding it, increased the number and improved the condition of the trails in the vicinity, and published a guide.[12] This guide chiefly excerpted from the writings of Cooper, Washington Irving, as well as many British authors who had visited the hotel in the 1830s, to introduce the reader to the attractions of the region. The improvements to the trails seem reflected in both Cole's (fig. 68; pl. VIII) and Jasper Cropsey's (1852; Minneapolis Institute of Arts) nearly identical views of the Mountain House made from Sunset Rock, about a mile north of the hotel along what is identified today as the Escarpment Trail. From there in both pictures one sees not only the Mountain House but also North and South Lakes (today joined into one large pond) which feed Kaaterskill Falls. Clearly the intent on the part of both artists was to emphasize the overpowering mountains amid which the hotel is nestled.

In a photograph taken in 2003 of essentially the same view (fig. 70) one may measure the accuracy of the two artists' renderings, with the qualification that each condensed or slightly collapsed the horizontality of what is seen in the photograph to emphasize the height of the mountains. Contrast this with Gifford's corresponding 1862 painting (fig. 69; pl. XVI). There the axis of the point of view has shifted markedly to the left, emphasizing not the mountains but the view into the Hudson River Valley that was the prime attraction of anyone's visit to the Mountain House—but which is denied the viewer of the earlier paintings. Along with that shift came a change in the time of day: in Cole's and Cropsey's paintings, it is morning, associated with the oft-touted spectacle of sunrise from the hotel escarpment; Gifford moves us to near sunset, the time of day that I selected in my photographs of the site, now including the east-biased view cor-

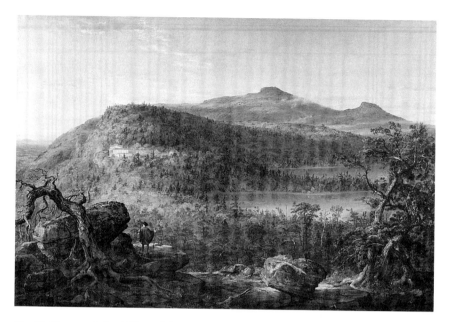

Fig. 68. Thomas Cole, *A View of the Two Lakes and Mountain House, Catskill Mountains, Morning,* 1844. Oil on canvas, 35 ⅞ x 53 ⅞ in. Brooklyn Museum. Dick S. Ramsay Fund (52.16).

Fig. 69. Sanford R. Gifford, *The Catskill Mountain House,* 1862. Oil on canvas, 9 ⁵⁄₁₆ x 18 ½ in. Private collection.

Fig. 70. View of the site of the former Catskill Mountain House, with North and South
 Lakes, from Sunset Rock, 2003. Photograph: author.

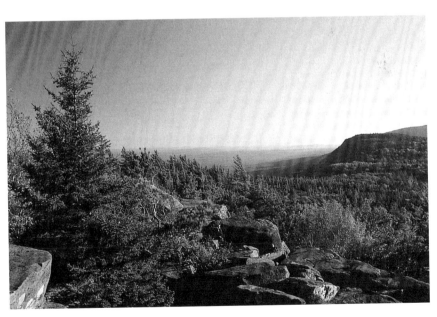

Fig. 71. View of the site of the former Catskill Mountain House, with the Hudson River
 Valley, from Sunset Rock, 2003. Photograph: author.

responding to that in his painting (fig. 71). Gifford, not wanting to lose the profile of Kaaterskill High Peak for the price of shifting his point of view, merely moved the whole mountain so that its foot extends beyond the shoulder of North Mountain in front of it. In so doing, the artist interposed an additional spatial plane to help step the viewer into the valley in the background. The shift in the time of day is curious because it was precisely the sunset hour that his friend Bayard Taylor, poet, travel writer, and lecturer, in a newspaper report of 1860 had held up as the optimal time to view the valley from the escarpment, as opposed to the earlier-preferred view at morning. Taylor described the prospect in terms very reminiscent of Gifford's picture:

> It was a quarter of an hour before sunset—perhaps the best moment of the day for the Catskill panorama. The shadows of the mountain-tops reached nearly to the Hudson, while the sun, shining directly down the [Kaaterskill] Clove, interposed a thin wedge of golden luster between. The farm-houses on a thousand hills beyond the river sparkled in the glow, and the Berkshire Mountains swam in a luminous rosy mist. The shadows strode eastward at the rate of a league a minute as we gazed.[13]

Gifford's picture thus accommodates not only the Mountain House and Kaaterskill High Peak, seen in the earlier paintings, but at least part of the famed vista *from* the Mountain House in the altered point of view. For his part, Taylor had a lot to say about the views from both North Mountain (on which is located Sunset Rock, the vantage point of the present picture) and South Mountain, the hill behind the Mountain House.

Before I continue with Taylor, let us contrast Gifford's *The View from South Mountain, in the Catskills* of 1873 with Church's 1847 version of the same site (figs. 72, 73). Until recently, Church's picture had been identified as *New England Landscape*, but it may well be identifiable with a *Kauterskill Clove, Catskill* that Church exhibited at the American Art-Union in 1847.[14] Not until I realized what Church's subject is, was I aware that anyone prior to Gifford had painted the view from South Mountain. In point of fact, Church does not really paint the *view* but the much more immediate Kaaterskill Clove, as it appears when one rounds the eastern rim of South Mountain and heads west toward Kaaterskill and Haines Falls; indeed, Church obscures the prospect with the sublime (and Cole-like) billow of fog or cloud that rises out of the valley. Gifford's painting, for its part, closely follows descriptions of a picture called *South Mountain* (unlocated) that he showed at the National Academy of Design in 1864. In

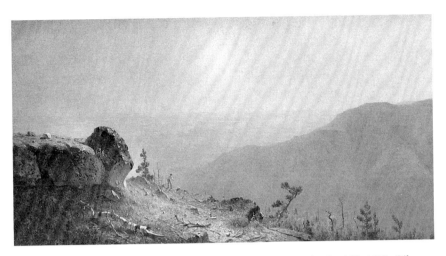

Fig. 72. Sanford R. Gifford, *The View from South Mountain, in the Catskills*, 1873. Oil on canvas, 21 x 40 in. From the collection of Saint Johnsbury Athenaeum, Saint Johnsbury, VT.

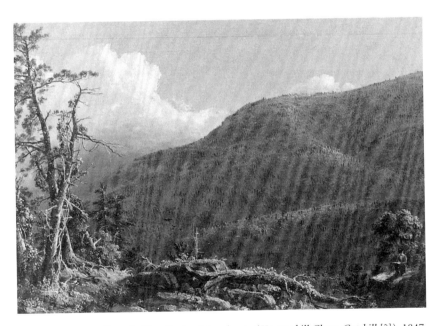

Fig. 73. Frederic E. Church, *New England Landscape* (*Kauterskill Clove, Catskill* [?]), 1847. Oil on canvas, 14 ½ x 20 ¼ in. Colorado Springs Fine Arts Center, Taylor Museum (1973.1).

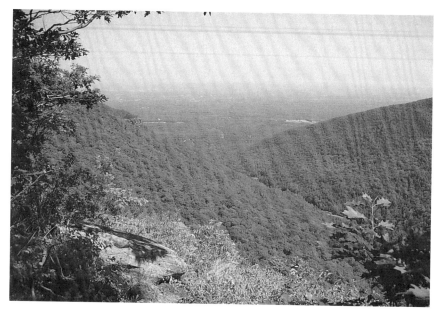

Fig. 74. View of the Hudson River Valley and foot of Kaaterskill High Peak from South
Mountain (contiguous with fig. 75), 2002. Photograph: author.

that work, a critic admired "The faraway horizon, the winding Hudson
with its tiny sails," and other minute features in the valley as well as "the
shadowed, ridgy sides" of Kaaterskill High Peak in the middle distance.[15]
In recent photographs of the view (figs. 74, 75), one can see why Gifford
was interested in it: the fading vista of the Hudson River Valley, the con-
tainer of atmosphere.

Gifford painted several plein-air oil sketches that contributed to *View
from South Mountain*. From where Gifford stood to execute at least one of
them (fig. 76), he could not appreciate the prospect of the valley and con-
centrated on the scrubby, brushy foreground of South Mountain and the
humpy, bear-back anatomy of Kaaterskill High Peak. But in the ultimate
painting (fig. 72), he regained the vista simply by raising the horizon and
reducing the foreground detail. It is the effect sought, in the words, once
again, of Taylor, in describing the view from South Mountain:

> In certain conditions of the atmosphere, the air between you and
> the lower world seems to become a visible fluid—an ocean of
> pale crystalline blue, at the bottom of which the landscape lies.
> Peering down into its depths, you at last experience a numbness
> of the senses, a delicious wandering of the imagination, such as

Fig. 75. View of Kaaterskill Clove and base of Kaaterskill High Peak from South Mountain (contiguous with fig. 74), 2002. Photograph: author.

Fig. 76. Sanford R. Gifford, *The View from South Mountain in the Catskills, a Sketch*, 1865. Oil on canvas, 10 x 18 ¾ in. Private collection.

Fig. 77. Sanford R. Gifford, *A Gorge in the Mountains (Kauterskill Clove)*, 1862. Oil on canvas, 48 x 39 ⅞ in. The Metropolitan Museum of Art, New York. Bequest of Maria DeWitt Jesup, from the collection of her husband, Morris K. Jesup, 1914 (15.30.62). Photograph: all rights reserved, The Metropolitan Museum of Art.

follows the fifth pipe of opium. Or, in the words of Walt Whitman, you "loaf, and invite your soul."[16]

I will have much more to say on the mind-altering dimension of Gifford's paintings in relation to his milieu. But first we should address one more painting in the signature Gifford mode in comparison with the actual site: that is, the Metropolitan Museum's *A Gorge in the Mountains* (formerly *Kauterskill Clove;* fig. 77; pl. XV).[17] I contrast it with Thomas Cole's well

Fig. 78. Thomas Cole, *The Clove, Catskills*, c. 1827. Oil on canvas, 25 ¼ x 35 ⅛ in. The New Britain Museum of American Art, New Britain, CT. Charles F. Smith Fund (1945.22). Photograph: E. Irving Blomstrann.

known 1827 view in the New Britain Museum of American Art (fig. 78). Instantly one sees that Gifford has reversed the point of view, preferred by Cole and virtually all his successors, of the prospect east from the head of Haines Falls towards the Hudson River Valley. Gifford preferred the prospect west, towards Haines Falls.

By August 1861, Gifford's circuits in the Clove had taken him on South Mountain to a place today located at or near a stone called Layman's Monument, named for a firefighter who died there near the turn of the twentieth century. It is quite close to Haines Falls, which, less obscured by trees in Gifford's day, became a focal highlight of the background of his painting. As one can see both in the photograph of the view from Layman's Monument (fig. 79) and in Gifford's pencil sketch of the same view (fig. 80), the prospect is actually close-at-hand, even somewhat occluded compared to that in the painting (fig. 77; pl. XV): the Clove is literally a cleft, worn by ancient Kaaterskill Creek, that narrows and becomes shallower towards Haines Falls, so unlike the "chalice" of light and air that Gifford ultimately fashioned out of the firsthand perceptions reflected in his sketch of the site.

Fig. 79.
View of Kaaterskill Clove and
Haines Falls from Layman's
Monument, South Mountain,
2002. Photograph: author.

The steps in Gifford's refining process were very deliberate: from August 1861 to November 1862 he developed two distinct pictorial ideas, the first of which was realized in the Metropolitan's picture.[18] In the earliest known of the oil studies, dated 1861 (fig. 81), one can see the artist establishing the vertical axis of the painting by locating the sun more or less directly above the waterfall; already, too, the sides of the Clove are beginning to lose their cleft-like angularity. The artist also shifts the dominant repoussoir of trees and rocks from the right side of the pencil sketch to the left side of the oil study, beginning a transfer of foreground weight that in subsequent versions of the composition will make one feel increasingly like he or she is observing the Clove from a place either on or overlooking its south wall instead of from the north wall, from where the pencil sketch and the photograph were originally taken.

An 1862 oil study (fig. 82) truly foretells the final composition. One begins to recognize that the hollowing out of the gorge is not merely to fashion a container for atmosphere but is a logical aesthetic response to

Fig. 80.
Sanford R. Gifford, *Kauterskill Clove to the West*, 1861–1862. Graphite on off-white paper, 6 x 3 ¼ in. Sketchbook, "7th Reg[iment]. & Catskills, 61," vol. 5. Albany Institute of History & Art. Gift of Marian Gifford Johnson (Mrs. William F.) Shaw and Mrs. George C. Cummings.

the shape of the painting's focal point, the sun. In a subsequent, larger and more finished study (Collection Jo Ann and Julian Ganz, Jr.), the shaping of the tree, the rock ledges at left, and the Clove walls at right becomes more deliberately—even schematically—concentric half-rings that form a kind of radial perspective of the gorge widening directly toward the viewer. The conceit is accentuated in the large painting (fig. 77; pl. XV), where other minor changes fortify the emphasis on the sun's preeminent role in shaping the terrain before us. The birch tree is reduced to a more delicate and explicitly sun-gesturing actress. Meanwhile, the orb's influence is stressed by the radiating beams that penetrate the forests cloaking the gorge's distant walls. The rays seem only paler versions of the axial cascade, which thus takes on a metaphysical suggestiveness, as the brightest of the sunbeams that spread around it.

Fig. 81. Sanford R. Gifford, *A Sketch in Kauterskill Clove*, 1861. Oil on canvas, 13 ¼ x 11 ¼ in. Collection: Family of the Artist.

A Gorge in the Mountains exemplifies the essential Gifford picture: a composition of the visible sun modified by atmosphere in which the often recumbent—even concave—terrestrial features function subserviently, undergoing a measure of de-materialization that gives them a heavenly or dreamlike aspect. The artist's prime pictorial inspiration is well known. Gifford's arrival at his mature style dates to his first European trip from 1855 to 1857, most of it spent in Italy. There he completed the largest landscape he ever made, *Lake Nemi* (1856–1857; The Toledo Museum of Art). For the first time the artist revealed most distinctly his debt to J. M. W. Turner, who made the visible, even glaring, sun a hallmark of his aesthetic, its light suffusing the space of entire canvases and absorbing terrestrial forms. Gifford had debated his perceptions of the merits and flaws of Turner's paintings with the master's most avid proponent, the British critic John Ruskin, when Gifford called on him at Coniston in September

Fig. 82. Sanford R. Gifford, *Kauterskill Clove, in the Catskills*, 1862. Oil on canvas, 12 ⅞ x 11 ⁷⁄₁₆ in. Peter and Juliana Terian Collection of American Art.

1855.[19] Countering Gifford's reservation that Turner took excessive liberties with the scene, Ruskin swayed the American with the defense that the master "treated the scene as a poet, and not as a topographer; that he painted the *impression* the scene made on his mind, rather than the literal scene."[20]

Accordingly, as we have seen, Gifford took his own broad liberties in his Catskill Mountain paintings and struck a responsive chord in both critics and patrons. Indeed, the crux of the paintings' appeal was the sunlight pervading them. They prompted one commentator in 1864, referring to Gifford's Clove pictures, to hail him as that "rare artist and genuine son of Helios."[21] But I suspect that the most telling critic was Eugene Benson. As both Gerald Carr and Franklin Kelly have shown, Benson was perhaps Gifford's most ardent advocate in the early Civil War years, when Gifford rose to prominence in New York.[22] Benson, an artist himself who just a lit-

tle later promoted the early career of Winslow Homer, like other critics found himself utterly seduced by *A Gorge in the Mountains* when he saw it at the artist's reception in the Studio Building on Tenth Street in December 1862. He declared the painting "a picture of a poet" and continued:

> ... sitting before it, bathed in the affluence and warmth of its light, luxuriating in its color, having our thought steeped in the delicious indolence of its atmosphere, and aroused by the wealth of its spirit, we *have no care,* but, *sun-steeped at noon,* ask that every pore of our body may become a gate through which sensation may flow, and every nerve an avenue along which may course the subtle messengers charged with the secret of its beauty [italics mine].[23]

It seems rare to hear the indulgence of such sensuous, even sensual language—the references to "indolence," "arousal," the metaphor of one's own body as a gate and the nerve as an avenue of sensation—in responding to a mere landscape painting. But the key terms here are the brief literal quotations and paraphrases from Alfred Tennyson's poem, "The Lotos-Eaters" (1832; revised 1842), specifically from its third choric song:

> Lo! in the middle of the wood,
> The folded leaf is wooed from out the bud
> With winds upon the branch, and there
> Grows green and broad, *and takes no care,*
> *Sun-steep'd at noon,* and in the moon
> Nightly dew-fed; and turning yellow
> Falls, and floats adown the air [italics mine].

The allusion is unmistakable. Moreover, Benson's lifting and adaptation of Tennyson's poetic language was not the first time he had applied it to Gifford's works. As Kelly has shown, just a year earlier Benson was explicit in associating what he termed Gifford's signature conceit of "sunshine tempered by thick hazy atmosphere of Indian Summer" with "the far-off-land described in Tennyson's Lotus Eaters—'a land where all things [always] seemed the same.'" Benson quoted further the following lines— immediately preceding the above characterization—which, indeed, seem illustrated in great measure by *A Gorge in the Mountains* (fig. 77; pl. XV), then in its earliest stages of formulation:

> A land of streams! some like a downward smoke,
> Slow-dropping veils of thinnest lawn did go;

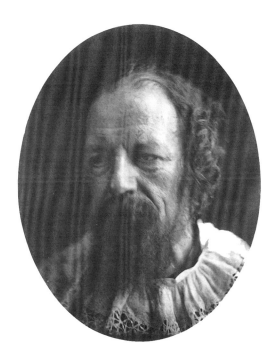

Fig. 83.
Julia Margaret Cameron, *Alfred, Lord Tennyson*, 1866. Albumen silver print from glass negative, 13 ¼ x 10 ⅝ in., printed 1905. The Metropolitan Museum of Art, New York. The Rubel Collection, Purchase, Lila Acheson Wallace, Michael and Jane Wilson, and Harry Kahn Gifts, 1997 (1997.382.36). Photograph: all rights reserved, The Metropolitan Museum of Art.

And some through wavering lights and shadows broke,
Rolling a slumbrous sheet of foam below ...

The charmèd sunset lingered low adown
In the red West: through mountain clefts the dale
Was seen far inland, and the yellow down
Bordered with palm, and many a winding vale
And meadow ...[24]

Benson preceded the above "better illustration" of the evocation of Tennyson in Gifford's pictures with the now familiar assertion that the paintings provoked "a feeling about them as of opium—of a day just this side of the Orient. They are American in character; Oriental in feeling."[25]

That we hear Tennyson (fig. 83) invoked in many contexts in this period must be expected: heir to the lyric style of the short-lived John Keats, Tennyson had been England's Poet Laureate since 1850. As any superficial reading on American literary culture will reveal, Tennyson exerted an immense influence on American poets—if probably a deleterious one overall; it was his lyricism, even musicality of language, rather

than his classically grounded poetic forms and, often, themes, that Americans admired and often sought vainly to emulate.

No product of Tennyson's genius probably was more beloved than "The Lotos-Eaters." The subject of the poem comes from the episode in Homer's *Odyssey* in which Ulysses and his men, sailing home to Ithaca from the wars in Troy, pause at an island where the inhabitants offer the visitors the lotus-plant to eat. We can see this illustrated in Robert Duncanson's 1861 painting, *Land of the Lotos-Eaters* (Collection of His Royal Majesty, the King of Sweden, Stockholm), which helps us to measure the currency of Tennyson's poem at this time.[26] Once consumed, the plant intoxicates the men with the mere contemplation of the tropical isle; when Ulysses forces them to return to their ship, they do so only with the most tearful reluctance. However, Tennyson omitted the last part of the episode; he leaves the stuporous crew on the island swearing an oath "In the hollow Lotos-Land to live and lie reclined / On the hills like Gods together," and not to "wander more" in search of home.

As is well known in literary scholarship, the biographical foil of Tennyson's beloved poem, among other things, was the opium habits of his friend, W. H. Brookfield, probably his own brother, Charles, and many of a whole generation at schools such as Trinity College, Oxford. Though those personal circumstances could not have been widely known—if at all, and certainly not to American readers—the association of the sailors' experience in the poem with the Victorian conception of drug abuse was detected almost as soon as "The Lotos-Eaters" was published. In 1833 a *Quarterly Review* critic termed the poem "a kind of classical opium-eaters....Our readers will, we think, agree [that] this is admirably characteristic, and that the singers of this song must have made pretty free with the intoxicating [lotos] fruit. How they got home you must read in Homer:—Mr. Tennyson—himself, we presume, a dreamy lotos-eater, a delicious lotos-eater—leaves them in full song."[27]

In fact, there is no evidence that Tennyson took opium. Still, his biographers portray a personality which—despite its poetic productivity—was inclined to indolence and lassitude that were informed by a family predisposition to melancholy.[28] The tendency was aggravated by the early loss of Tennyson's dearest friend, the poet Arthur Hallam, for whom he mourned for a generation. The poet's reputation for indolence surely also has a place in this discussion and was part of the more general critical awareness of Tennyson and his work. In 1845, for example, Tennyson was warned in print that "He must not linger too much upon the memories of the past, neither must he eat of the lotos nor stray in the gardens of the Castle of

Indolence, in which we hear he takes more delight than becomes a man as gifted as he is."[29] Two years later another critic admonished the poet that it was "a liability at times to resign himself to the 'Lotos-Eaters.'"[30]

Furthermore, all of the self-indulgence of which Tennyson was suspected or accused is today widely perceived in the larger foil of the milieu from which he, in both his art and his personal traits, retreated: the Industrial Revolution and faith in the modern, i.e. urban, nation-state—this even as his laureateship required occasional ceremonial verse for state purposes. One of Tennyson's modern biographers cites his most characteristic poetic quality to be "a certain life-weariness, a longing for rest through oblivion," while another finds in the "The Lotos-Eaters" itself the "loveliest expression" of the poet's "desire for escape from a world of change and the wish to be delivered from the world of action."[31] To be sure, in "The Lotos-Eaters," such "life-weariness" alternates constantly with the "rest through oblivion" found in consuming the intoxicating plant and contemplating the paradisaical landscape. Nowhere more than in the second of the sailors' choric songs does Tennyson seem to dispense with history and lament directly to his contemporaries:

> Why are we weighed upon with heaviness,
> And utterly consumed with sharp distress
> While all things else find rest from weariness?
> All things have rest: why should we toil alone,
> We only toil, who are the first of things,
> And make perpetual moan.
> Still from one sorrow to another thrown:
> Nor ever fold our wings,
> And cease from wanderings,
> Nor steep our brow in slumber's holy balm;
> Nor harken what the inner spirit sings,
> "There is no joy but calm!"
> Why should we only toil, the roof and crown of things?

And just a little less directly, in choric song IV:

> Hateful is the dark blue sky,
> Vaulted o'er the dark blue sea.
> Death is the end of life; ah, why
> Should life all labour be?
> Let us alone. Time driveth onward fast,
> And in a little while our lips are dumb....

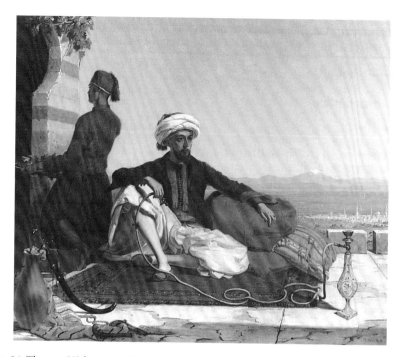

Fig. 84. Thomas Hicks, *Bayard Taylor*, 1855. Oil on canvas, 24 ½ x 29 ¾ in. National Portrait Gallery, Smithsonian Institution, Washington, DC (NPG.76.6).

That these themes resonated in American culture is without doubt. We have already heard Taylor (fig. 84) liken the aerial enchantment of the view from the vicinity of the Catskill Mountain House to "the fifth pipe of opium," or, alternatively, to Whitman's self-indulgent "I loaf, and invite my soul" in *Leaves of Grass*. Tennyson is not directly invoked in either case there. Still, his influence on Taylor is well known. Both metaphors are fascinating as well as amusing, since they illuminate the tension between Taylor's own hedonistic leanings and the moral reservation that he officially voiced about Whitman the man, and even the dubious effect on young American poets of the "intoxicating music" of Tennyson's verse.[32] He should have been more indulgent, not less: it was Taylor's compulsion to worldly success that made him bank on travel-writing, which was in such demand, easy to produce, and lucrative, rather than focus single-mindedly on his poetry, for which he preferred to be known. Taylor addressed the tension and the resulting dissatisfaction in the second series of his *Travels at Home and Abroad* published in 1862—just as Gifford was creating *A Gorge in the Mountains*. The following words savor of the

lament of Tennyson's lotos-eaters, even of the sentiments of Transcendentalists Ralph Waldo Emerson and Henry David Thoreau:

> Why should we not regulate our lives in accordance with the common sense of our own natures, whether or not it chimes with our common sense of the world? On every side we see blossoms that only seem to wait for our plucking; every wind brings us their betraying odors; yet we turn away, and go on with our old business of pulling thistles, no matter how our hands bleed. A great portion of our lives is spent in achieving something that we do not actually need.[33]

Perhaps the most telling instance of Tennyson's resonance in American culture, including landscape painting, is in *"A Summer Book,"* that is, a *vacation* book, titled *Lotus-Eating* published in London and New York in 1852.[34] Its author was George William Curtis, who in his youth was a boarder with the Transcendentalist commune at Brook Farm in West Roxbury, Massachusetts. Eventually he became editor of *Harper's Monthly*, and a representative of the "genteel tradition" of New York writers and poets that included Taylor, Richard H. Stoddard, Edmund C. Stedman, and Thomas Bailey Aldrich, with many of whom Gifford socialized.[35] It is not clear precisely when Curtis and Gifford met—certainly by 1859, when both were formally inducted into the Century Club. Curtis had made a name for himself with *Nile Notes of a Howadji* and *The Howadji in Syria*, published respectively in 1851 and 1852, both accounts of his "Grand Tour," not to Italy, but to the Mideast.[36] Along with Taylor's slightly later books, *A Journey to Central Africa* (1854) and *The Lands of the Saracen* (1855), Curtis's helped to introduce a generation of readers and would-be tourists to the alluring exoticism of the near Orient, and surely informed the travels there in the late 1860s of both Gifford and Frederic E. Church. What is important, however, is the contemporary perception of Tennyson's "The Lotos-Eaters" in Curtis's sensuous (for an American) language to describe the East, noted by at least two American critics of the period:[37]

> A voluptuous morning awakened the Howadji under the shore of Erment. Cloudless the sky as Cleopatra's eyes, when they looked upon Caesar. Warmly rosy the azure that domed the world, as if today it were a temple dedicated to beauty. And, stepping ashore, to the altars of beauty we repaired. No sacrificial, snowy lambs, no garlands of gorgeous flowers, did the worship require. The day itself was flower and feast, and triumphal song.

The day itself lingered luminously along the far mountain ranges, paling in brilliance and over the golden green of the spacious plain, that was a flower-enameled pavement this morning, for our treading, as if unceasingly to remind us that we went as worshippers of beauty only, and the fame of beauty that fills the world.[38]

Such language, and, moreover, the self-indulgent, anti-utilitarian sentiments of Tennyson's poem, extended both to the content and literally to the title of *Lotus-Eating*. In tones of *dolce far niente*, Curtis wafted the reader chiefly to the Hudson River resorts—the Highlands, the Catskills, Saratoga Springs, Lake George, Trenton Falls, Niagara—as well as Nahant and Newport. World traveler that he was by then, Curtis disclosed the shopworn character of some of the older resorts including the Catskills. There, for example, he took a jaundiced view of the entrepreneur who turned the narrow cascade of Kaaterskill Falls on and off for a price.[39] For our purposes here, three features above all seem significant about *Lotus-Eating*. The first, of course, is the allusion to Tennyson's poem in the title. The second is the contrarian, anti-urban strain that surfaces throughout the text, beginning in an early paragraph of Chapter 1:

I saw the steamer, crowded with passengers, hurrying away from the city. For none more than the Americans make it a principle to desert the city, and none less than the Americans know how to dispense with it. So we compromise by taking the city with us, and the country gently laughs us to scorn.[40]

The third significant feature of *Lotus-Eating* is that a Hudson River School painter, John Frederick Kensett, should have supplied the illustrations for the book (fig. 85). The artist and the author were fast friends by this time.[41] Some of the illustrations precede Kensett's earliest paintings of subjects for which he became most beloved and which he truly seemed to make his own: Lake George and, even more so, Newport (fig. 86).

Especially in the first of his two chapters on Newport, Curtis's complaint about Americans at leisure became something of a rant. Newport, he recalled, had been a "synonyme of repose" for the scattered southern summerers that had once frequented it, at a time, a generation earlier, when New Yorkers preferred the inland mineral spa of Saratoga Springs. "But," bemoaned Curtis, "[New York] looked suddenly seaward, and a floodtide of fashion rose along Narragansett Bay, and overflowed Newport . . . crushing into a month in the country that which crowds six months in

Fig. 85. J. W. Orr after John F. Kensett, *The Cliff Walk, Newport*. Wood engraving. George William Curtis, *Lotus-Eating: A Summer Book* (New York: Harper and Brothers, 1852), 192. Photograph: General Research Division, The New York Public Library, Astor, Lenox and Tilden Foundations.

a beautiful mirage. To reach those pleasant places is the aim of all our endeavors. A man would be rich, that he may have a fine house hung with pictures and adorned with sculptures. Even the greatest drudge pays the homage to his nature, of, at least, saying that. In youth it seems that we could reach out our hands and ourselves unlock the doors. But those golden gates

Fig. 86. John F. Kensett, *Beacon Rock, Newport Harbor*, 1857. Oil on canvas, 22 ½ x 36 in. National Gallery of Art, Washington, DC. Gift of Frederick Sturges, Jr. (1953.1.1). Image © 2005 Board of Trustees, National Gallery of Art, Washington, DC.

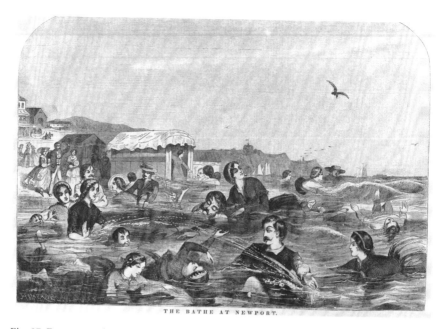

THE BATHE AT NEWPORT.

Fig. 87. Engraver unknown, after Winslow Homer, *The Bathe at Newport*, 1858. Wood engraving. *Harper's Weekly*, September 4, 1858, 568. Photograph: The Metropolitan Museum of Art, New York. The Irene Lewisohn Costume Reference Library.

the town."[42] Thus had Newport become, in Curtis's reckoning, the summer witness of some of the worst traits of the city-dweller:

> We Americans are workers by the nature of the case, or sons of laborers, who spend foolishly what they wisely won. And, therefore, New York, as the social representative of the country, has more than the task of Sisyphus ... It aims, and hopes, and struggles, and despairs, to make wealth stand for wit, wisdom, and beauty. In vain it seeks to create society by dancing, dressing, and dining ... Wealth will socially befriend a man at Newport and Saratoga, better than any similar spot in the world, and that is the severest censure that could be passed upon those places.
>
>
>
> It is very well to carry the country to the city, but is very ill to bring the city to the country. The influence of the city is always to be resisted ... The city, in its technical social sense, is always ludicrous, and if it were possible, insulting in the country...

Fig. 88. Sanford R. Gifford, *A Twilight in the Catskills*, 1861. Oil on canvas, 25 x 54 in. Private collection.

> We must leave in the city, then, as far as possible, the social fictions of the city.[43]

To be fair, in *Lotus-Eating* Curtis had many fine things to say about Newport. Yet, he could elicit them, he reported, only in "the meditative, autumnal air" of September. That was when "Fashion, the Diana of the Summer Solstice, is dethroned; that golden statue is shivered, and its fragments cast back into the furnace of the city, to be fused again and moulded; and out of the whirring dust and din the loiterer [i.e., the author] emerges" by the sea and imbibes what Curtis characterized as "the Italian air" of Newport.[44] "These are Mediterranean days," he mused. "They have the luxurious languor of the South."[45] Now the author was lotus-eating again.

Kensett's Newport paintings (fig. 86) project a Canaletto-like, Mediterranean light and clarity—a sanity—claimed by Curtis for the locale after the crowds had left. Not that they, like many of Gifford's Catskill scenes, are autumn pictures, but that most of them are virtually deserted: Kensett places us so far out in the still expanse of Narragansett Bay that we could never know of the fashionable crowd of which Curtis complains, and which may be identifiable, for example, with the raucous young water-sporters whom Winslow Homer gives us in his contemporaneous illustration (fig. 87). In Kensett's *Beacon Rock, Newport Harbor*, we are actually looking toward the port, with the redoubt of Fort Adams on the left. But though we look into a harbor, toward the city, we see little of its social or commercial life, and the prospect offers virtually the infinitude

Fig. 89. Frederic E. Church, *Twilight in the Wilderness*, 1860. Oil on canvas, 40 x 64 in. The Cleveland Museum of Art. Purchase, Mr. and Mrs. William H. Marlatt Fund (1965.233). Photograph: © The Cleveland Museum of Art.

and serenity of the ocean horizon. The latter inspired these words from Bayard Taylor in 1859, which seem to embellish upon Curtis's earlier:

> At sea, you look on the life from which you have emerged, as one looks from a mountaintop upon his native town. It is astonishing how fast your prejudices relax after the land has sunk—how great the insignificances in which you have been involved, disappear, as if they had never been, and every interest of real value starts into sudden distinctness ...[46]

Ocean horizons and mountaintop vistas: Taylor could be describing a Kensett, on the one hand, and a Gifford on the other. Perhaps these relatively featureless blue plains or vaporous voids that either artist preferred—indeed, which are evoked merely when their names are uttered—were as much mental refuges as actual landscapes to them and their patrons, the genteel class of affluent New Yorkers who read Curtis's and Taylor's books and followed them at home and abroad to seek a respite from the pressures of modern workaday and social existence. Then, following Curtis's invocation to "carry the country to the city," they purchased Kensett's and Gifford's paintings for their winter parlors. But is the

Fig. 90. Sanford R. Gifford, *Hunter Mountain, Twilight,* 1866. Oil on canvas, 30 ⅜ x 54 ⅛ in. Daniel J. Terra Collection (1999.57). Photograph: Terra Foundation for American Art, Chicago / Art Resource, NY.

landscape therein America, Europe, Asia—or Nirvana? Much has been made in the scholarship of the Transcendentalist overtones of the "luminist" landscape[47]—a plausible connection between literary and pictorial culture that would seem strengthened by Curtis's early internship with the Brook Farm community and the sentiments expressed in works such as *Lotus-Eating.* But it seems to me that what these landscapes answered was less an intellectual need than an emotional one in a nation not only fast-changing, but headed towards civil war.

For all their correspondences of tenor and expression, Kensett and Gifford are scarcely identical. Earlier I noted the Canaletto-like, Mediterranean clarity of Kensett's coastal views. Gifford's Catskills were often concertedly exotic, closer than Kensett's to the intoxicated or enchanted spirit implied in Curtis's *Lotus-Eaters* title and to the sun-dazzled lyricism of his *Nile Notes.* Benson had it right: Gifford's Catskill pictures *are* Oriental in spirit, and were so long before the artist ever visited the East. If it was not the actual experience of the East that informed them, then it was the distillation of Turner's Italianate aesthetic of the sun that did. Gifford quieted the master's turbulent brushwork or evaporated his watery pigmentation but retained his blinding luminosity, and endowed even the Catskills with a still, potentially mind-bending desert heat. Surely the literary climate sampled here would have encouraged such a vision. Whatever the case, Gifford's paintings are terrestrial vessels of aerial dust

whose occasional focal points of light in the distance—so painstakingly applied by the artist—attract the viewer to focus momentarily, only to leave him or her by turns gazing, then daydreaming. For Gifford's patrons, what a way in winter to lose oneself in the country—or surely somewhere not in the city.

I return one last time to Benson, where the question of the expression of Gifford's landscapes began. When that critic invoked Tennyson's "The Lotos-Eaters" to characterize the spirit of Gifford's pictures up to that time, he was in fact establishing a foil against which to contrast the true subject of his review, the painting that he considered to be the artist's latest and most impressive, *A Twilight in the Catskills* (1861; fig. 88; pl. XVII), recently rediscovered. Benson thought that the painting "reveals power that had not been thought of as belonging to S. R. Gifford."[48] To be sure, *A Twilight in the Catskills* stands out from all the other paintings that we have seen and even those that succeed it chronologically. It seems, in its infernal starkness, the farthest thing from the "lotos-eating" landscapes that we, as Benson did, take to be the essential Gifford. In the first place, the painting is the earliest and boldest of Gifford's major twilight pictures, his reflexive answer, with a Catskill subject, to Frederic Church's *Twilight in the Wilderness* (fig. 89), with its Maine setting, of the previous year, 1860. Other subjects in this mode are *A Winter Twilight* of 1862 (Indiana University Museum of Art, Bloomington), *Twilight in the Adirondacks* of 1864 (Adirondack Museum, Blue Mountain Lake, New York), and *Hunter Mountain, Twilight* (fig. 90; pl. XVIII) of 1866. But *A Twilight in the Catskills* stands out even from all of those for a quality—in a unique instance for Gifford—of *terribilità* (the most sublime aesthetic territory, into which even the comparable *Hunter Mountain* does not quite venture): a molten-looking stream running over a ledge bounded by burned or withered trees, the ember-like clouds and oven-like glow of the sunset itself, and the angry gloom of the Clove that moved another critic justly to term the picture "lowering, strange, almost awful."[49] Even more than Church's *Twilight in the Wilderness* it seems, in the context of its times, to manifest threat and alarm at the impending conflict between the Union and the ever growing number of seceding Confederate states, which were to ignite the Civil War that very spring. Just after Gifford finished this painting and sent it to the National Academy annual in May, he joined the Seventh Regiment of The New York National Guard (fig. 91) and served parts of the next three years in Washington, DC and Maryland. In 1860 Gifford was also losing his brother Charles to mental illness; Charles killed himself with an overdose of chlordal, prescribed for his depression, just as

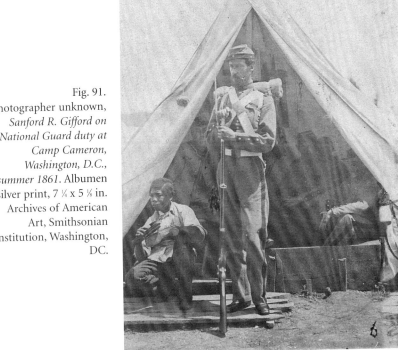

Fig. 91.
Photographer unknown,
*Sanford R. Gifford on
National Guard duty at
Camp Cameron,
Washington, D.C.,
summer 1861.* Albumen
silver print, 7 ¼ x 5 ⅛ in.
Archives of American
Art, Smithsonian
Institution, Washington,
DC.

Gifford was joining up. Elsewhere, I have made a case for interpreting *Hunter Mountain, Twilight* in light of the nation's simultaneous relief, exhaustion, and disillusionment at war's end.[50] I suspect that the strength of that interpretation, along with the fact that Gifford marked both the advent and the aftermath of the War with major pictures of his beloved Catskills at twilight, tends to support the biographical and cultural interpretation of the newly discovered *A Twilight in the Catskills.*

With reference to the present inquiry, however, it may be significant that *A Twilight in the Catskills* was Gifford's first major painting of the Clove. It is that stygian picture of the place that sets the dreamscape of 1862 (fig. 77; pl. XV) into relief, not, as Benson would have had us believe, the other way around. For *A Gorge in the Mountains* is surely a refuge from worldly care and a warring world, not merely for us, or for Gifford's critics, patrons, and friends, but for himself. He voiced exactly that sentiment in a letter to friends from his post at Fort Federal Hill in Baltimore in the summer before he painted the picture. Thanking them for letters describing their tours in the mountains, he admitted:

[Your] lively descriptions of the goings-on … in the Catskills was almost like being there myself—they made me somehow think that I have a right to be there … climbing with you among the cloves … but when under the hallucination I go to the gate of the Fort and am rudely roused from my dreams by the sentry sharply bringing his musket to "arms port"! and an abrupt "Halt"!…I find myself obliged to right about, and limit my walk to the round of the parapet, or mingle again with the busy-idle crowd of the quarters.[51]

Not only *A Gorge in the Mountains,* but Gifford's many drawings and oil sketches and studies of the Clove from this time testify to the artist's fulfillment of his dream—or perhaps only the unquenchable yearning to realize it—surely the reluctance ever to leave it.

Notes

1. For the most recent scholarship on both Gifford's vision and its application to the Catskill Mountains, see Franklin Kelly, "Nature Distilled: Gifford's Vision of Landscape," and Kevin J. Avery, "Gifford and the Catskills," in Kevin J. Avery and Franklin Kelly, eds., *Hudson River School Visions: The Landscapes of Sanford R. Gifford* (New York: The Metropolitan Museum of Art, 2003), 3–24; 25–51.
2. Barbara Novak, *American Painting of the Nineteenth Century: Realism, Idealism, and the American Experience* (New York: Praeger, 1969), esp. 92–104; and Barbara Novak, *Nature and Culture: American Landscape and Painting, 1825–1875* (New York: Oxford University Press, 1980), 28–31.
3. The principal source for Gifford's life and career remains Ila S. Weiss, *Poetic Landscape: The Art and Experience of Sanford R. Gifford* (Newark, DE: University of Delaware Press, 1987), the artist's early life is described on pp. 46–68; see also Avery and Kelly, *Hudson River School Visions,* 25, 30–32.
4. "Address by W. Whittredge," *Gifford Memorial Meeting of the Century, Friday Evening, November 19th, 1880, Century Rooms* (New York: The Century Association, 1880), 34: "Below him [from the summit of Mount Merino] on the opposite side of the [Hudson] river lay the village of Catskill, its roofs and windows glistening in the sun. There was one house standing in that village which was in full view, around which we may believe there was a halo of light that morning, which lighted up the path which [Gifford] was to follow. This was the house and studio of *THOMAS COLE,* the father of a long line of American landscape painters."
5. "Address by W. Whittredge," 34.
6. Weiss, *Poetic Landscape,* 49–50; Avery and Kelly, *Hudson River School Visions,* 28–33.
7. "Obituary," *The Crayon* 6, no. 4 (April 1859): 132, quoted in Avery and Kelly, *Hudson River School Visions,* 28.
8. Weiss, *Poetic Landscape,* 51; Avery and Kelly, *Hudson River School Visions,* 32, 33, fig. 25.
9. Kenneth J. Myers, *The Catskills: Painters, Writers, and Tourists in the Mountains, 1820–1895* (Yonkers: The Hudson River Museum, 1988), 37–51.
10. Leatherstocking's descriptions are quoted and discussed in Myers, *The Catskills,* 35.

11. Between 1825 and 1827, Cole painted five pictures of Kaaterskill Falls. Four are illustrated and all are discussed in Ellwood C. Parry III, *The Art of Thomas Cole: Ambition and Imagination* (Newark, DE: University of Delaware Press, 1988), 24, 27, 32–34, 36, 41–44, 47.

12. *The Scenery of the Catskill Mountains as Described by Irving, Cooper, Bryant, Willis Gaylord Clark, N. P. Willis, Miss Martineau, Tyrone Power, Parke Benjamin, Thomas Cole and other Eminent Writers* (New York: D. Fanshaw, 1846). On Beach and his improvements to the Catskill Mountain House, see Myers, *The Catskills*, 66–68.

13. "Travels at Home. From the *New-York Tribune* of July 12, 1860," quoted in *The Scenery of the Catskill Mountains as Described by Irving, Cooper, Bryant, Willis Gaylord Clark, N. P. Willis, Miss Martineau, Tyrone Power, Parke Benjamin, Thomas Cole, Bayard Taylor, and other Eminent Writers* (New York: D. Fanshaw, 1860), 42; and in Bayard Taylor, *At Home and Abroad: A Sketch-Book of Life, Scenery and Men*, second series (New York: G. P. Putnam, 1862), 325.

14. Gerald L. Carr illustrates this painting as *New England Landscape* in *Frederic Edwin Church: In Search of the Promised Land* (New York: Berry-Hill Galleries, 2000), pl. 6, 190. It is discussed briefly on 49–50.

15. *The Continental Monthly*, June 5, 1864: 686–687.

16. *Scenery of the Catskill Mountains* (1860), 43; Taylor, *At Home and Abroad*, 328–329.

17. The work has been recently re-titled thanks to Gerald Carr's discovery of the original name in the earliest known review of the picture dating from its first exhibition, in Gifford's studio, in December 1862. See Gerald L. Carr, "Sanford Robinson Gifford's *A Gorge in the Mountains* Revived," *The Metropolitan Museum of Art Journal* 38 (2003): 213–230.

18. The formulation of *A Gorge in the Mountains* is detailed in Avery and Kelly, *Hudson River School Visions*, 130–139.

19. The formulation of *Lake Nemi* and Gifford's debt to Turner therein is described in Avery and Kelly, *Hudson River School Visions*, 103–104. The artist's recollection of looking at his brother's prints is quoted in ibid., 27, and the print presumably after Turner's watercolor of Lake Nemi, at some time in the collection of Ruskin, is discussed and illustrated in ibid., 103–104.

20. Quoted in Avery and Kelly, *Hudson River School Visions*, 11.

21. L[ucia] D. P[ychowska], "Sketches of American Life and Scenery. II—The Catskill Mountains," *The Continental Monthly* (March 1864), quoted in Avery and Kelly, *Hudson River School Visions*, 139.

22. Carr, "*A Gorge in the Mountains*," 217–221; Avery and Kelly, *Hudson River School Visions*, 4, 14.

23. "Proteus" [Eugene Benson], "Art. Concerning Two Great and Representative Works," *New-York Commercial Advertiser*, December 27, 1862, quoted in Avery and Kelly, *Hudson River School Visions*, 138–139.

24. "Proteus" [Eugene Benson], "Our Artists. II.," *New-York Commercial Advertiser*, October 17, 1861, quoted in Avery and Kelly, *Hudson River School Visions*, 14.

25. Avery and Kelly, *Hudson River School Visions*, 14.

26. For Duncanson's *Land of the Lotus Eaters*, see Joseph D. Ketner, *The Emergence of the African-American Artist: Robert S. Duncanson, 1821–1872* (Columbia, MO and London: University of Missouri Press, 1993), 90–93, 112–113, 152–155. William Trost Richards also painted the subject in 1860. For this picture (now unlocated), see Linda S. Ferber, *William Trost Richards (1833–1905): American Landscape and Marine*

Painter (PhD diss., Columbia University, 1980; New York: Garland Publishing Company, 1980), 36–38.

27. John Croker, "Poems by Alfred Tennyson," *Quarterly Review* 44 (April–July 1833), quoted in Michael Thorn, *Tennyson* (New York: Little, Brown and Company, 1992), 106.

28. Thorn, *Tennyson*, 96–97. Even contemporary critics perceived this trait, such as the one in *Chambers Edinburgh Journal* in 1845, quoted on p. 146, n. 29.

29. Unidentified critic in *Chamber's Edinburgh Journal* n.s. IV (1845), quoted in Edgar F. Shannon, *Tennyson and the Reviewers: A Study of his Literary Reputation and the Influence of Critics upon his Poetry, 1827–1851* (Cambridge: Harvard University Press, 1952), 88.

30. Richard H. Horne, *A New Spirit of the Age* (1847), quoted in Shannon, *Tennyson and the Reviewers*, 88.

31. Christopher Ricks, *Tennyson*, 2nd ed. (Houndsmills, Basingstoke, Hampshire, and London: Macmillan Press Limited, 1989), 115; and Clyde de L. Ryals, *Theme and Symbol in Tennyson's Poems to 1850* (Philadelphia: University of Pennsylvania Press, 1964), 96.

32. For Taylor's opinion of Whitman, see Richard Cary, *The Genteel Circle: Bayard Taylor and his New York Friends* (Ithaca: Cornell University Press, 1952), 18. For Taylor's cautionary opinion of the effect on American poets of Tennyson's verse, see John Olin Edison, *Tennyson in America: His Reputation and Influence from 1827 to 1858* (Athens: The University of Georgia Press, 1943), 118.

33. Quoted in Paul C. Wermuth, *Bayard Taylor* (New York: Twayne Publishers, n.d., c. 1973), 61.

34. The publisher was Harper and Brothers. Curtis and many Americans used the Latin spelling "lotus," whereas Tennyson and many British contemporaries used the Greek "lotos."

35. Gordon Milne, *George William Curtis and the Genteel Tradition* (Bloomington: University of Indiana Press, 1956), 231ff. Weiss, *Poetic Landscape*, describes Gifford's links with the literary circle including Taylor, Stoddard, Stedman, Aldrich, and George Henry Boker in her chapter, "Poetry: A Circle of Friends," 21–45. Curtis's connections were more tangential, though he and Taylor knew each other as travel lecturers and sometimes corresponded, as described in Milne, *George William Curtis*, 87, 116, 123, 137.

36. George William Curtis, *Nile Notes of a Howadji* (New York: Harper and Brothers, 1851); George William Curtis, *The Howadji in Syria* (New York: Harper and Brothers, 1852).

37. John Esten Cooke, "A Handful of Autumn Leaves: from the Lowlands of Virginia," *Southern Literary Messenger* 18 (December 1852): 714; "George W. Curtis," *National Magazine* 4 (January 1854): 28, cited in Edison, *Tennyson in America*, 242, n. 129.

38. Curtis, *Nile Notes of a Howadji*, 237.

39. George William Curtis, *Lotus-Eating: A Summer Book* (New York: Harper & Brothers, 1852), 47: ". . . the [proprietor] of the Fall . . . drives a trade with both his spirits and his water. In fact, if your romantic nerves can stand the steady truth, the Catskill Fall is *turned on* to accommodate poets and parties of pleasure."

40. Curtis, *Lotus-Eating*, 12–13.

41. Milne, *George William Curtis*, 36–38, 58, 81.

42. Curtis, *Lotus-Eating*, 166.

43. Curtis, *Lotus-Eating*, 173–174, 176, 187.

44. Curtis, *Lotus-Eating*, 183–184.

45. Curtis, *Lotus-Eating*, 179.

46. Quoted from Taylor's first series of *At Home and Abroad* (1859) in Wermuth, *Bayard Taylor*, 60.

47. Novak, *American Painting of the Nineteenth Century*, esp. 55, 110–111, 116–117. The most recent and comprehensive criticism of the literature of luminism is J. Gray Sweeney, "Inventing Luminism: 'Labels are the Dickens'," *Oxford Art Journal* 26, no. 2 (2003): 93–120.

48. "Proteus" [Eugene Benson], "Our Artists," *New-York Commercial Advertiser*, 17 October 1861, Archives of American Art, microfilm reel D33, frame 133.

49. George William Sheldon, "How One Landscape-Painter Paints," *The Art-Journal* (New York), n.s. 3 (September 1877): 285.

50. Avery and Kelly, *Hudson River School Visions*, 42–45.

51. Letter from Sanford Robinson Gifford, Mount Clare Station, B. & O. R. R., Baltimore, July 27, 1862, to "My dear friends at Nestledown" (Tom and Candace Wheeler and family), in Gifford Family Records and Letters, vol. 1 (typescripts of missing originals), collection: Family of the Artist.

Bibliography

Adamson, Jeremy, Elizabeth McKinsey, Alfred Runte, and John F. Sears, eds. *Niagara: Two Centuries of Changing Attitudes, 1697–1901.* Washington, DC: The Corcoran Gallery of Art, 1985.

Alison, Archibald. *Essays on the Nature and Principles of Taste.* 1790. New York: Carvill, 1830.

"The Altar." *The Knickerbocker* 36 (December 1850): 534.

Avery, Kevin J. *American Paradise: The World of the Hudson River School.* New York: Metropolitan Museum of Art, 1987.

———. "The Panorama and Its Manifestation in American Landscape Painting, 1795–1870." PhD diss., Columbia University, 1995.

———. "Gifford and the Catskills." In *Hudson River School Visions: The Landscapes of Sanford R. Gifford.* Edited by Kevin J. Avery and Franklin Kelly, 25–51. New York: The Metropolitan Museum of Art, 2003.

Avery, Kevin J., and Franklin Kelly, eds. *Hudson River School Visions: The Landscapes of Sanford R. Gifford.* New York: The Metropolitan Museum of Art, 2003.

Baird, Robert. *State and Prospects of Religion in America.* New York: Robert Carter, 1856.

Barnhill, Georgia B. "Illustrations of the Adirondacks in the Popular Press." In *Adirondack Prints and Printmakers.* Edited by Caroline Mastin Welsh, 45–68. New York: The Adirondack Museum, 1998.

Beach, Charles L., comp. *Scenery of the Catskill Mountains as described by Irving, Cooper, Bryant, Willis Gaylord Clark, N. P. Willis, Miss Martineau, Tyrone Power, Park Benjamin, Thomas Cole, and Other Eminent Writers.* New York: D. Fanshaw, 1843.

Beecher, Henry Ward. *Life Thoughts, Gathered from the Extemporaneous Discourses of Henry Ward Beecher.* 1858. New York: Sheldon, 1860.

———. *New Star Papers; or Views and Experiences of Religious Subjects.* New York: Derling and Jackson, 1859.

Bell, Adrienne Baxter. *George Inness and the Visionary Landscape*. New York: National Academy of Design, 2003.

Benson, Eugene [Proteus, pseud.]. "Our Artists." *New-York Commercial Advertiser*, October 17, 1861.

———. "Our Artists. II." *New-York Commercial Advertiser*, October 17, 1861.

———. "Art. Concerning Two Great and Representative Works." *New-York Commercial Advertiser*, December 27, 1862.

Bentham, Jeremy. "Panopticon or The Inspection-House." In *The Works of Jeremy Bentham*. 11 vols. Edited by John Bowring, 4:39–172. Edinburgh: William Tait, 1843.

Blumin, Stuart M. *The Emergence of the Middle Class*. New York: Cambridge University Press, 1989.

Boime, Albert. *The Magisterial Gaze: Manifest Destiny and American Landscape Painting*. Washington, DC: Smithsonian Institution Press, 1991.

Born, Wolfgang. *American Landscape Painting: An Interpretation*. New Haven: Yale University Press, 1948.

———. "The Panoramic Landscape as an Art Form." *Art in America* 36, no. 1 (January 1948): 4–5.

Bowen, Eli. *The Pictorial Sketch-Book of Pennsylvania. Or, Its Scenery, Internal Improvement, Resources and Agriculture, Popularly Described*. Philadelphia: Willis P. Hazard, 1852.

Brodhead, Luke Wills. *The Delaware Water Gap: Its Scenery, the Legends and Early History*. Philadelphia: Sherman, 1870.

Brown, Dona. *Inventing New England: Regional Tourism in the Nineteenth Century*. Washington, DC: Smithsonian Institution Press, 1995.

Bruce, Robert. *The Lincoln Highway in Pennsylvania*. Washington, DC: National Highways Association, 1920.

Bruce, Wallace. *The Hudson River by Daylight*. 1873. New York: Gaylord Watson, 1876.

———, ed. *Along the Hudson with Washington Irving*. Poughkeepsie, NY: A.V. Haight, 1913.

Bruhn, Thomas P. *The American Print: Originality and Experimentation.* Storrs, CT: William Benton Museum of Art, 1993.

Buckingham, James Silk. *America, Historical, Statistical, and Descriptive.* 3 vols. London: Fisher, Son & Co, 1841.

Bunyan, John. *The Holy War.* 1682.

Bushman, Richard L. *The Refinement of America: Persons, Houses, Cities.* New York: Alfred A. Knopf, 1992.

Bushnell, Horace. *Nature and the Supernatural.* New York: Charles Scribner, 1858.

Caldwell, John, Oswaldo Rodriguez Roque et al. *American Paintings in the Metropolitan Museum of Art.* New York: The Metropolitan Museum of Art in association with Princeton University Press, 1994.

Carbonell, John. "Anthony Imbert: New York's Pioneer Lithographer." In *Prints and Printmakers of New York State 1825–1940.* Edited by David Tatham, 11–41. Syracuse: Syracuse University Press, 1986.

Carr, Gerald L. *Frederic Edwin Church: In Search of the Promised Land.* New York: Berry-Hill Galleries, 2000.

———. "Sanford Robinson Gifford's *A Gorge in the Mountain* Revived." *The Metropolitan Museum of Art Journal* 38 (2003): 213–230.

Cary, Richard. *The Genteel Circle: Bayard Taylor and his New York Friends.* Ithaca: Cornell University Press, 1952.

Carter, Edward C., III, John C. Van Horne, and Charles E. Brownwell, eds. *Latrobe's View of America, 1795–1820: Selections from the Watercolors and Sketches.* New Haven: Yale University Press, 1985.

Chamber's Edinburgh Journal. n.s. 4 (1845).

Cikovsky, Nicolai, Jr. "'The Ravages of the Axe': The Meaning of the Tree Stump in Nineteenth-Century American Art." *Art Bulletin* 61 (December 1979): 611–626.

Clark, Willis Gaylord. "Extract from the 'Ollapodiana' Papers of Willis Gaylord Clark." In *Scenery of the Catskill Mountains as described by Irving, Cooper, Bryant, Willis Gaylord Clark, N. P. Willis, Miss Martineau, Tyrone Power, Park Benjamin, Thomas Cole, and Other Eminent Writers.* Compiled by Charles L. Beach, 14. New York: D. Fanshaw, 1843.

Clement, Bernard. *The Panorama.* Translated by Anne-Marie Glasheen. London: Reaktion Books, 1999.

Cohn, Sherrye. *Arthur Dove: Nature as Symbol.* Ann Arbor: UMI Research Press, 1985.

Cole, Thomas. Papers. New York State Library, Albany, New York.

———."Emma Moreton, A West Indian Tale." *Saturday Evening Post,* May 14, 1825.

———. "Essay on American Scenery." 1835. In *American Art 1700–1960: Sources and Documents.* Edited by John W. McCoubrey, 98–110. Englewood Cliffs, NJ: Prentice Hall, 1965.

———. "Lecture on American Scenery: Delivered Before the Catskill Lyceum, April 1, 1841." *Northern Light* 1 (May 1841): 25–26.

The Continental Monthly (June 5, 1864): 686–687.

Cooke, John Esten. "A Handful of Autumn Leaves: from the Lowlands of Virginia." *Southern Literary Messenger* 18 (December 1852): 713–719.

Cooper, James Fenimore. *The Pioneers; Or, The Sources of the Susquehanna.* 1823. New York: Penguin Books, 1988.

———. *Home as Found.* 1838. New York: Capricorn Books, 1961.

———. *The Pathfinder.* 1840. New York: New American Library, 1961.

———. "American and European Scenery Compared." In *The Home Book of the Picturesque: Or, American Scenery, Art, and Literature,* 51–69. New York: George P. Putnam, 1852.

Cromley, Elizabeth. "A Room With a View." In *Resorts of the Catskills.* Edited by John S. Margolies and Alf Evers, 5–30. New York: St. Martin's Press for the Architectural League of New York, 1979.

"George W. Curtis." *National Magazine* 4 (January 1854): 28.

Curtis, George William. *Nile Notes of a Howadji.* New York: Harper and Brothers, 1851, 1856.

———. *Lotus-Eating: A Summer Book.* New York: Harper & Brothers, 1852.

———. *The Howadji in Syria.* New York: Harper and Brothers, 1852.

Danly, Susan, and Leo Marx, eds. *The Railroad in American Art:*

Representations of Technological Change. Cambridge: MIT Press, 1988.

Diamant, Lincoln. *Chaining the Hudson: The Fight for the River in the American Revolution.* New York: Citadel Press, 1989.

Doezema, Marianne. *Changing Prospects: The View From Mount Holyoke.* South Hadley, MA: Mount Holyoke College Art Museum; Ithaca, NY: Cornell University Press, 2002.

Downing, Andrew Jackson. "American Highland Scenery. Beacon Hill." *New-York Mirror* 12 (March 14, 1835): 293–294.

———. "The Dans-Kamer. A Reverie in the Highlands." *New-York Mirror* 13 (October 10, 1835): 117–118.

———. *A Treatise on the Theory and Practice of Landscape Gardening, Adapted to North America....* New York: Wiley & Putnam, 1841.

———. "On The Moral Influence of Good Houses." *Horticulturist* 2 (February 1848): 345–347.

———. "A Visit to Montgomery Place." In *Rural Essays. By A. J. Downing. Edited, with a memoir of the author, by George William Curtis; and a letter to his friends, by Fredrika Bremer,* 192. New York: George P. Putnam, 1853.

Drago, Harry Sinclair. *Canal Days in America: the History and Romance of Old Towpaths and Waterways.* New York: Clarkson N. Potter, Inc., 1972.

Dunlap, William. *The History of the Rise and Progress of the Arts of Design in the United States.* 3 vols. 1834. Boston: C.E. Goodspeed & Co., 1918.

Dunwell, Frances F. *The Hudson River Highlands.* New York: Columbia University Press, 1991.

Durand, Asher B. Papers. New York Public Library.

———. "Letters on Landscape Painting: Letter II." *The Crayon* 1 (January 1855): 34.

Durand, John. *Life and Times of A. B. Durand.* New York: Charles Scribner's Sons, 1894.

Dwight, Theodore. *Sketches of Scenery and Manners in the United States.*

New York: A. T. Goodrich, 1829.

Dwight, Timothy. *Travels in New England and New York.* 4 vols. 1822. Edited by Barbara Miller Solomon. Cambridge: Belknap Press of Harvard University Press, 1969.

Edison, John Olin. *Tennyson in America: His Reputation and Influence from 1827 to 1858.* Athens: The University of Georgia Press, 1943.

Emerson, Edward Waldo, and Waldo Emerson Forbes, eds. *Journals of Ralph Waldo Emerson.* Boston: Houghton Mifflin, 1910.

Evans, Robin. "Bentham's Panopticon, An Incident in the Social History of Architecture." *Architectural Association Quarterly* 3, no. 2 (April-July 1971): 21–37.

Evers, Alf. *The Catskills: From Wilderness to Woodstock.* 1972. Rev. ed. Woodstock, NY: Overlook Press, 1982.

Ewins, Neil. "'Supplying the Present Wants of Our Yankee Cousins…,': Staffordshire Ceramics and the American Market." *Journal of Ceramic History* 15 (1997): 105–127.

Fabricant, Carole. "The Aesthetics and Politics of Landscape in the Eighteenth Century." In *Studies in Eighteenth-Century British Art and Aesthetics.* Edited by Ralph Cohen, 49–81. Berkeley: University of California Press, 1985.

Faris, John T. *Old Trails and Roads in Penn's Land.* Philadelphia: J. B. Lippincott Co., 1927.

Felker, Tracie. "First Impressions: Thomas Cole's Drawings of His 1825 Trip Up the Hudson River." *American Art Journal* 24, nos. 1/2 (1992): 60–93.

Ferber, Linda S. *William Trost Richards (1833-1905): American Landscape and Marine Painter.* PhD diss., Columbia University, 1980; New York: Garland Publishing Company, 1980.

Ferguson, Alfred R., and Jean Ferguson Carr, eds. *The Essays of Ralph Waldo Emerson.* Cambridge: Harvard University Press, 1987.

"The Fine Arts. Exhibition at the National Academy." *Literary World* 1 (May 15, 1847): 347–348.

Flint, Janet. "The American Painter-Lithographer." In *Art & Commerce: American Prints of the Nineteenth Century,* conference proceedings,

126–142. Boston: Museum of Fine Arts, distributed by the University Press of Virginia, 1975.

Foucault, Michel. *Discipline and Punish*. Translated by Alan Sheridan. New York: Vintage Books, 1979.

———. "The Eye of Power." In *Power/Knowledge, Selected Interviews and Other Writings 1972–1977*. Edited by Colin Gordon and translated by Colin Gordon, Leo Marshall, John Mepham, and Kate Soper, 146–165. New York: Pantheon Books, 1980.

Fowler, John. *Journal of a Tour in the State of New York, in the Year 1830*. London: Whittaker, Treacher, and Arnot, 1831.

Frederick, John T. *The Darkened Sky: Nineteenth Century American Novelists and Religion*. South Bend: University of Notre Dame Press, 1969.

Furniss, David A., Richard J. Wagner, and Judith Wagner. *Adams Ceramics, Staffordshire Potters and Pots, 1779–1998*. Atglen, PA: Schiffer Publishing, 1999.

George Walter Vincent Smith Art Museum. *Arcadian Vales: Views of the Connecticut River Valley*. Springfield: Springfield Library and Museums Association, 1981.

Gifford, Sanford R. "Gifford Family Records and Letters." Typescript of unlocated original letter, transcribed by Alice Carter Gifford. 3 vols. Edited by Robert Wilkinson, Edith Wilkinson, and Eleanor Peckham. Collection Sanford Gifford, M.D., Cambridge, MA.

Gilpin, William. *Observations on the River Wye, and Several Parts of South Wales, &c. relative chiefly to Picturesque Beauty: Made in the Year 1770*. 5th ed. London: T. Cadell Junior and W. Davies, 1800.

Glassie, Henry. "Reevaluation of a Thomas Cole Painting." *Museum Studies* 8 (1976): 96–108.

———. "Thomas Cole and Niagara Falls." *The New-York Historical Society Quarterly* 2 (April 1974): 89–111.

Gombrich, Ernst. *Art and Illusion: A Study in the Psychology of Pictorial Representation*. New York: Pantheon Books, 1960.

———. "Art History and Psychology in Vienna Fifty Years Ago." *Art Journal* 44, no. 2 (Summer 1984): 162–164.

Gould, Stephen Jay. "Church, Humboldt, and Darwin: The Tension and Harmony of Science and Art." In *The Paintings of Frederic Edwin Church*. Edited by Franklin Kelly, 94–107. Washington, DC: National Gallery of Art, 1989.

Graci, David. *Mt. Holyoke, An Enduring Prospect, History of New England's Most Historic Mountain*. Holyoke: Calem Publishing Co., 1985.

Hall, Basil. *Forty Etchings, From Sketches Made with the Camera Lucida, in North America in 1827 and 1828*. Edinburgh: Cadell & Co.; London: Simpkin, Marshall, and Man, Boys & Graves, 1829.

Hall, Ray. *Women in the Labor Force: A Case Study of the Potteries in the Nineteenth Century*. London: Queen Mary College, University of London, 1986.

Handy, Robert T. *A Christian America*. New York: Oxford University Press, 1971.

———, ed. *Religion in the American Experience*. Columbia: University of South Carolina Press, 1972.

Hill, John, with engravings after watercolors by William G. Wall. *Hudson River Port Folio*. 1821–1825. New York: G. & C. & H. Carvill, 1828.

Hinton, John Howard. *The History and Topography of the United States*. 2 vols. London: I. T. Hinton & Simpkin & Marshall, 1830–1832. Engravings by Fenner Sears & Co.

Historic Hudson Valley. *Visions of Washington Irving: Selected Works from the Collections of Historic Hudson Valley*. Tarrytown, NY: Historic Hudson Valley, 1991.

Hitchcock, Orra White. *Report on the Geology, Mineralogy, Botany, and Zoology of Massachusetts*. Amherst: Press of J. S. and C. Adams, 1833.

Holley, O. L. *The Picturesque Tourist; Being A Guide through the Northern and Eastern States and Canada*. New York: J. Disturnell, 1844.

Horne, Richard H., ed. *A New Spirit of the Age*. 2 vols. New York: Harper and Brothers, 1844.

Howat, John K. et al. *American Paradise: The World of the Hudson River School*. New York: The Metropolitan Museum of Art, 1987.

Hyde, Ralph. *Panoramania!* London: Trefoil, 1988.

The Hudson Illustrated with Pen and Pencil. New York: T. W. Strong, 1852.

Hudson River, and the Hudson River Railroad, with a complete map, and wood cut views of the principal objects of interest upon the line. New York: W. C. Locke; Boston: Bradbury & Guild, 1851.

Hudson, Winthrop S. *Religion in America.* New York: Scribner's and Sons, 1973.

Huntington, David. *The Landscapes of Frederic Edwin Church: Vision of An American Era.* New York: George Braziller, 1966.

Irving, Pierre M. *Life and Letters of Washington Irving.* 4 vols. New York: Putnam, 1862–1864.

Irving, Washington. *A History of New York, From the Beginning of the World to the End of the Dutch Dynasty ... by Diedrich Knickerbocker.* 1809. Philadelphia: J. B. Lippincott & Co., 1871.

——. *The Sketch-Book of Geoffrey Crayon, Gent.* 1819–1820. New York: New American Library, 1961.

—— [Geoffrey Crayon, pseud.], ed. *A Book of the Hudson, Collected from the Various Works of Diedrich Knickerbocker.* New York: G. P. Putnam, 1849.

——. "The Catskill Mountains." In *A Landscape Book, by American Artists and American Authors: Sixteen Engravings on Steel from Paintings by Cole, Church, Cropsey, Durand, Gignoux, Kensett, Miller, Richards, Smillie, Talbot, Weir,* 22–29. New York: G. P. Putnam, 1868.

Kelly, Franklin. *Frederic Edwin Church and the National Landscape.* Washington, DC: Smithsonian Institution Press, 1988.

——, ed. *The Paintings of Frederic Edwin Church.* Washington, DC: National Gallery of Art, 1989.

——. "Nature Distilled: Gifford's Vision of Landscape." In *Hudson River School Visions: The Landscapes of Sanford R. Gifford.* Edited by Kevin J. Avery and Franklin Kelly, 3–24. New York: The Metropolitan Museum of Art, 2003.

Ketner, Joseph D. *The Emergence of the African-American Artist: Robert S. Duncanson, 1821–1872.* Columbia: University of Missouri Press, 1993.

Keyes, Donald D. et al. *The White Mountains: Place and Perceptions.* Durham, NH: University Art Galleries, University of New Hampshire, 1980.

Krannert Art Museum. *At Home and Abroad in Staffordshire.* Champaign, IL: Krannert Art Museum, 1988.

Larsen, Ellouise Baker. *American Historical Views on Staffordshire China.* 1935. New York: Dover Publications, 1975.

————. "William Adams." *Magazine Antiques* 4 (October 1939): 170–173.

Lawall, David. *Asher Brown Durand: His Art and Art Theory Relative to His Times.* New York: Garland, 1977.

Leith, John H., ed. *Creeds of the Churches: A Reader's Christian Doctrine from the Bible to the Present.* Rev. ed. Richmond: John Knox Press, 1973.

Levasseur, Auguste. *Lafayette in America in 1824 and 1825; Or, Journal of a Voyage to the United States.* 2 vols. Translated by John D. Godman. Philadelphia: Carey and Lea, 1829.

Lossing, Benson John. *The Pictorial Field-Book of the American Revolution; Or, Illustrations, by Pen and Pencil, of the History, Biography, Scenery, Relics, and Traditions of the War for Independence.* 2 vols. New York: Harper & Brothers, 1850.

Martin, Ann Smart. "Makers, Buyers, and Users: Consumerism as a Material Culture Framework." *Winterthur Portfolio* 28, no. 2/3 (1993): 141–157.

————. "Magical, Mythical, Practical, and Sublime: The Meanings and Uses of Ceramics in America." In *Ceramics in America.* Edited by Robert Hunter, 28–46. Milwaukee: Chipstone Foundation, 2001.

Martineau, Harriet. *Retrospect of Western Travel.* 3 vols. 1838. New York: Greenwood Press, 1969.

Marx, Leo. *The Machine in the Garden: Technology and the Pastoral Ideal in America.* New York: Oxford University Press, 1965.

May, Henry E. *The Enlightenment in America.* New York: Oxford University Press, 1978.

McCoubrey, John W., ed. *American Art 1700–1960: Sources and*

Documents. Englewood Cliffs, NJ: Prentice Hall, 1965.

McKinsey, Elizabeth. *Niagara Falls: Icon of the American Sublime.* Cambridge and New York: Cambridge University Press, 1985.

McNulty, Bard, ed. *The Correspondence of Thomas Cole and Daniel Wadsworth.* Hartford: The Connecticut Historical Society, 1983.

Miller, Char. *Gifford Pinchot and the Making of Modern Environmentalism.* Washington, DC: Island Press, 2001.

Miller, George L. "A Revised Set of CC Index Values for Classification and Economic Scaling of English Ceramics from 1787 to 1880." *Historical Archaeology* 25, no. 1 (1991): 1–25.

————, Ann Smart Martin, and Nancy S. Dickinson. "Changing Consumption Patterns: English Ceramics and the American Market from 1770 to 1840." In *Everyday Life in the Early Republic.* Edited by Catherine E. Hutchins, 219–248. Winterthur, DE: Winterthur Museum,1994.

Miller, Perry. "The Location of American Religious Freedom." From *Religion and Freedom in American Thought.* 1954. Reprinted in *Nature's Nation,* 150–162. Cambridge: Harvard University Press, 1967.

————. "The Romantic Dilemma in American Nationalism and the Concept of Nature." *Harvard Theological Review.* 1955. Reprinted in *Nature's Nation,* 197–207. Cambridge: Harvard University Press, 1967.

Milne, Gordon. *George William Curtis and the Genteel Tradition.* Bloomington: University of Indiana Press, 1956.

Morris, Norval, and David J. Rothman, eds. *The Oxford History of the Prison.* New York: Oxford University Press, 1995.

Morris, George Pope. "Woodman, Spare That Tree." In *Poems, Lyrical and Idyllic.* Compiled by Edmund Clarence Stedman, 64–65. New York: Charles Scribner, 1860.

Myers, Kenneth J. *The Catskills: Painters, Writers, and Tourists in the Mountains, 1820–1895.* Yonkers, NY: Hudson River Museum of Westchester, 1988.

————. "Selling the Sublime: The Catskills and the Social

Construction of Landscape Experience in the United States, 1776–1876." PhD diss., Yale University, 1990.

———. "On the Cultural Construction of Landscape Experience: Contact to 1830." In *American Iconology: New Approaches to Nineteenth-Century Art and Literature.* Edited by David C. Miller, 58–79; 306–310. New Haven: Yale University Press, 1993.

———. "Art and Commerce in Jacksonian America: The Steamboat *Albany* Collection." *Art Bulletin* 81 (September 2000): 503–528.

The New York State Tourist. Descriptive of the Scenery of the Hudson, Mohawk, & St. Lawrence Rivers. New York: A. T. Goodrich, 1842.

Nevius, Blake. *Cooper's Landscapes, An Essay on the Picturesque Vision.* Berkeley: University of California Press, 1976.

[Noah, Mordecai?] "Annual Exhibition of the Academy of National Design [sic]." *[New York] Evening Star, for the Country*, May 10, 1836, 1.

Noble, Louis Legrand. *The Life and Works of Thomas Cole*, edited by Elliot S. Vesell. Cambridge: The Belknap Press, 1964.

Novak, Barbara. *American Painting of the Nineteenth Century: Realism, Idealism, and the American Experience.* New York: Praeger, 1969.

———. *Nature and Culture: American Landscape and Painting, 1825–1875.* New York: Oxford University Press, 1980.

———. "The Nationalist Garden and the Holy Book." *Art in America* 60 (January–February 1972): 46–57. Reprinted in *Nature and Culture: American Landscape and Painting, 1825–1875,* 3–17. New York: Oxford University Press, 1980.

"Obituary [for Henry Ary]." *The Crayon* 6, no. 4 (April 1859): 132.

O'Brien, Raymond. *American Sublime: Landscape and Scenery of the Lower Hudson Valley.* New York: Columbia University Press, 1981.

Oettermann, Stephan. *The Panorama: History of a Mass Medium.* Translated by Deborah Lucas Schneider. New York: Zone Books, 1997. First published 1980.

Parry, Ellwood C., III. "Landscape Theatre in America." *Art in America* 59, no. 6. (November 1971): 52–61.

————. "Recent Discoveries in the Art of Thomas Cole." *Magazine Antiques* 120, no. 5 (November 1981): 1156–1165.

————. "Thomas Cole's Early Career: 1818–1829." In *Views and Vision.* Edited by Edward J. Nygren and Bruce Robertson, 161–187. Washington, DC: The Corcoran Gallery of Art, 1986.

————. *The Art of Thomas Cole: Ambition and Imagination.* Newark, DE: University of Delaware, 1988.

————."Thomas Cole's Early Drawings: In Search of a Signature Style." In Detroit Institute of Arts, "A Special Issue: the Drawings of Thomas Cole." *Bulletin of the Detroit Institute of Arts* 66, no. 1 (1990): 7–18.

P[ychowska], L[ucia] D. "Sketches of American Life and Scenery. II—The Catskill Mountains." *The Continental Monthly* 5, no. 3 (March 1864): 270–273.

Pierson, George Wilson. *Tocqueville in America.* 1938. Baltimore: Johns Hopkins University Press, 1996.

Richardson, Judith. *Possessions: The History and Uses of Haunting in the Hudson Valley.* Cambridge: Harvard University Press, 2003.

Prown, Jules David. *Art as Evidence—Writings on Art and Material Culture.* New Haven: Yale University Press, 2001.

Ricks, Christopher. *Tennyson.* 2nd ed. Houndsmills, Basingstoke, Hampshire, and London: Macmillan Press Limited, 1989.

[Richards, T. Addison]. "Sunnyside." *Harper's Monthly* 14 (December 1856): 1–21.

Robertson, Bruce. "Venit, Vidit, Depinxit: The Military Artist in America." In *Views and Visions.* Edited by Edward J. Nygren and Bruce Robertson, 83–103. Washington, DC: The Corcoran Gallery of Art, 1986.

Rodman, William M. "Nature and the Church." *The Knickerbocker* 36 (December 1850): 535.

Rockwell, Rev. Charles. *The Catskill Mountains and the Region Around. Their Beauty, Legends, and History. With sketches in prose and verse, by Cooper, Irving, Bryant, Cole, and Others.* New York: Taintor Brothers, 1867.

Roque, Oswaldo Rodriguez. "The Exaltation of American Landscape Painting." In *American Paradise: The World of the Hudson River School*, edited by Kevin J. Avery, 21–48. New York: Metropolitan Museum of Art, 1987.

Ryals, Clyde de L. *Theme and Symbol in Tennyson's Poems to 1850*. Philadelphia: University of Pennsylvania Press, 1964.

Schapiro, Meyer. "Style." 1953. Reprinted in *Theory and Philosophy of Art*. 51–102. New York: George Braziller, 1994.

Schuyler, David. "The Sanctified Landscape: The Hudson River Valley, 1820 to 1850." In *Landscape in America*. Edited by George F. Thompson, 93–109. Austin: University of Texas Press, 1995.

Seaver, Esther Isabel. *Thomas Cole 1801–1848: One Hundred Years Later*. Hartford: Wadsworth Atheneum, 1949.

Sears, John F. *Sacred Places: American Tourist Attractions in the Nineteenth Century*. 1989. Amherst, MA: University of Massachusetts Press, 1998.

Shank, William H. *Indian Trails to Super Highway*. York, PA: American Canal and Transportation Center, 1988.

Shannon, Edgar F. *Tennyson and the Reviewers: A Study of His Literary Reputation and the Influence of Critics upon his Poetry, 1827–1851*. Cambridge: Harvard University Press, 1952.

Sheldon, George William. "How One Landscape-Painter Paints." *The Art-Journal*, n.s. 3 (September 1877): 284–285.

Siegel, Nancy. "Painted Image, Inspirational Text: Thomas Cole and the Influence of John Bunyan." In Mark Andrew White, ed., *Image and Text: American Creativity and the Relationship between Writing and the Visual Arts*, 15–26. Wichita: The Edwin A. Ulrich Museum of Art, 2000.

———. *Along the Juniata: Thomas Cole and the Dissemination of American Landscape Imagery*. Huntingdon, PA: Juniata College Museum of Art in association with University of Washington Press, 2003.

Silliman, Benjamin. *Remarks Made, On a Short Tour, Between Hartford and Quebec in the Autumn of 1819*. New Haven: S. Converse, 1820.

Sketches of the North River. New York: W. H. Collyer, 1838.

Smith, Sidney. "Review of Adam Seybert, *Statistical Annals of the United States of America* (1818)." *Edinburgh Review* 33 (January 1820): 69–80.

Smith, David. "Publications of John Bunyan's Work In America." *Bulletin of the New York Public Library* 66 (December 1962): 630–652.

Snyder, Jeffrey B. *Historical Staffordshire: American Patriots and Views.* Atglen, PA: Schiffer Publishing, 1995.

Sweeney, J. Gray. "Inventing Luminism: 'Labels are the Dickens.'" *Oxford Art Journal* 26, no. 2 (2003): 93–120.

Swett, J. "The Miner's Sabbath." *The Knickerbocker* 44 (July 1854): 19.

Taintor, Charles Newhall. *The Hudson River Route. New York to Albany, Saratoga Springs, Lake George, Lake Champlain, Adirondacks and Montreal.* New York: Taintor Brothers, 1869.

Taylor, Bayard. *At Home and Abroad: A Sketch-Book of Life, Scenery and Men.* 2nd ser. New York: G. P. Putnam, 1862.

Thompson, Ralph. *American Literary Annuals & Gift Books 1825–1865.* New York: H.W. Wilson Co., 1936.

Thoreau, Henry David. "Walking." *Atlantic Monthly* 9 (June 1862): 657–674.

Tichi, Cecilia. *New World, New Earth: Environmental Reform in American Literature from the Puritans through Whitman.* New Haven: Yale University Press, 1979.

Trollope, Frances. *Domestic Manners of the Americans.* 1832. Edited by Donald Smalley. New York: Vintage Books, 1960.

Turner, James. *The Politics of Landscape.* Oxford: Basil Blackwell, 1979.

_____. "*Landscape* and the Art Prospective in England, 1584–1660." *Journal of the Warburg and Courtauld Institutes* 42 (1979): 290–293.

Tymn, Marshall, ed. *Thomas Cole's Poetry.* York, PA: Liberty Cap Books, 1972.

———, ed. *Thomas Cole: The Collected Essays and Prose Sketches.* St. Paul, MN: The John Colet Press, 1980.

Van Zandt, Roland. *The Catskill Mountain House.* 1966. Hensonville, NY: Black Dome Press, 1991.

Wall, Diana di Zerega. "Family Dinners and Social Teas: Ceramics and Domestic Rituals." In *Everyday Life in the Early Republic.* Edited by Catherine E. Hutchins, 249–284. Winterthur, DE: Winterthur Museum, 1994.

Wallace, Richard W. *Salvator Rosa in America.* Wellesley, MA: Wellesley College Museum, Jewett Arts Center, 1979.

Wallach, Alan. "The Ideal American Artist and the Dissenting Tradition: A Study of Thomas Cole's Popular Reputation." PhD diss., Columbia University, 1973.

————. "Making a Picture of the View from Mount Holyoke." In *American Iconology: New Approaches to Nineteenth Century Art and Literature.* Edited by David Miller, 80–91, 310–312. New Haven: Yale University Press, 1993.

————. "Thomas Cole: Landscape and the Course of American Empire." In *Thomas Cole: Landscape into History.* Edited by William H. Truettner and Alan Wallach, 23–111. Washington, DC: National Museum of American Art; New Haven: Yale University Press, 1994.

————. "Wadsworth's Tower: An Episode in the History of American Landscape Vision." *American Art* 10, no. 3 (Fall 1996): 8–27.

————. "Thomas Cole's *River in the Catskills* as Antipastoral." *Art Bulletin* 84, no. 2 (June 2002): 334–350.

Weiss, Ila S. *Poetic Landscape: The Art and Experience of Sanford R. Gifford.* Newark, DE: University of Delaware Press, 1987.

Wermuth, Paul C. *Bayard Taylor.* New York: Twayne Publishers, n.d., c. 1973.

Willis, Nathaniel Parker with illustrations by William H. Bartlett. *American Scenery; Or, Land, Lake, and River Illustrations of Transatlantic Nature.* 2 vols. London: George Virtue, 1840. Reprint, Barre, MA: Imprint Society, 1971.

Whittredge, Worthington. "Address by W. Whittredge." In *Gifford Memorial Meeting of the Century, Friday Evening, November 19th, 1880, Century Rooms,* 34. New York: The Century Association, 1880.

Wölfflin, Heinrich. *Principles of Art History.* 1915. Translated by M. D. Hottinger. New York: Dover Publications, 1950.

Notes on the Contributors

KEVIN J. AVERY is Associate Curator in the Department of American Paintings and Sculpture at The Metropolitan Museum of Art and Adjunct Professor in the Art Department of Hunter College, City University of New York. He received his PhD from Columbia University. Recently he organized the exhibition and prepared the catalogue *Treasures from Olana: Landscapes by Frederic Edwin Church* (2005). He was the organizer, with Franklin Kelly, of *Hudson River School Visions: The Landscapes of Sanford R. Gifford* (2003). Avery is also co-editor and co-author of the catalogue of the Gifford exhibition. He edited and co-authored *American Drawings and Watercolors in The Metropolitan Museum of Art, Volume I* (2002). Other exhibitions and catalogues that he has written or to which he has contributed essays are *Art and the Empire City: New York, 1825–1861* (2000), *American Tonalism* (1997), and *Church's Great Picture: The Heart of the Andes* (1993).

MATTHEW BAIGELL is Distinguished Professor Emeritus of Art History at Rutgers University. He received his PhD from the University of Pennsylvania. He is the author of many books and articles on nineteenth- and twentieth-century American Art including: *Artist and Identity in Twentieth-Century America* (2001); co-editor, *Complex Identities: Jewish Consciousness and Modern Art* (2001); co-author, *Peeling Potatoes, Painting Pictures: Women Artists in Post-Soviet Russia, Estonia, and Latvia* (2001); "American Art Around 1960 and the Loss of Self," *Art Criticism* (1998); "Barnett Newman's Stripe Paintings and Kaballah: A Jewish Take," *American Art* 8 (Spring 1994); *Albert Bierstadt* (1988); *A Concise History of American Painting and Sculpture* (1984); *Thomas Cole* (1981); and *Dictionary of American Art* (1979). His *American Artists, Jewish Images,* a study of fourteen artists, will appear in 2006. *A History of Jewish American Art* and his co-edited *Antisemitism and Assimilation: Jewish Dimensions in Modern Art* will appear in 2007.

PHILLIP EARENFIGHT is Director of The Trout Gallery and Associate Professor of Art History at Dickinson College. He received his PhD from Rutgers University. He organized *Visualizing a Mission: Artifacts and Imagery of the Carlisle Indian School, 1879–1918* (2004) and is planning an

exhibition of ledger drawings associated with the Carlisle Indian School in conjunction with the Beinecke Library, Yale University. He co-organized *Grace Hartigan: Painting Art History* (2003) and edited the exhibition catalogue. He specializes in the art and architecture of late medieval Florence and his publications include "Mnemonics, Catechism, and *The Allegory of Divine Misericordia*: How a Trecento Florentine Confraternity Instructed its Members in Christian Theology through Image and Text," *Journal of Religious History* 28 (2004) and "Duccio's *Maestà* Passion Cycle and Medieval Manuscript Illuminations," *Source* 12 (Spring 1994). Currently, he is writing a monograph on the art and architecture of the Misericordia in Florence.

DAVID SCHUYLER is Arthur and Katherine Shadek Professor of the Humanities and Professor of American Studies at Franklin & Marshall College. He received his PhD in History from Columbia University, where his dissertation was awarded the Richard B. Morris Prize. He is the author of *A City Transformed: Redevelopment, Race, and Suburbanization in Lancaster, Pennsylvania, 1940–1980* (2002), *Apostle of Taste: Andrew Jackson Downing 1815–1852* (1996), and *The New Urban Landscape: The Redefinition of City Form in Nineteenth-Century America* (1986), co-editor of *From Garden City to Green City: The Legacy of Ebenezer Howard* (2002), and co-editor of three volumes of *The Frederick Law Olmsted Papers*, the most recent of which is *The Years of Olmsted, Vaux & Company, 1865–1874* (1992), as well as author of more than twenty articles in books and professional journals. He is Associate Editor of the *Journal of Planning History*, is an advisory editor of the *Creating the North American Landscape* series at The Johns Hopkins University Press, and is a member of the editorial board of the *Olmsted Papers* publication project.

NANCY SIEGEL is Director of the Juniata College Museum of Art and Assistant Professor of Art History at Juniata College. She received her PhD from Rutgers University. She organized the exhibition and authored the catalogue for *Along the Juniata: Thomas Cole and the Dissemination of American Landscape Imagery* (2003) in addition to *The Morans: The Artistry of a Nineteenth-Century Family of Painter-Etchers* (2001). Recent publications include: "'I never had so difficult a picture to paint': Albert Bierstadt's White Mountains Scenery and *The Emerald Pool*," *Nineteenth-Century Art Worldwide* (September 2005), "An Oil Sketch by Thomas Cole of the Ruins of Kenilworth Castle," *The Burlington Magazine* (September 2002), and co-author, "Municipal Parks in New York City: Olmsted, Riis,

and the Transformation of the Urban Landscape, 1858–1897," in *Transformations of Urban and Suburban Landscapes* (2002). She is currently at work on *An Acquired Taste: Patriotic Imagery in the Home and the Shaping of a National Culinary Culture* and will co-curate an international exhibition on the Moran family in 2009.

ALAN WALLACH is Ralph H. Wark Professor of Art and Art History and Professor of American Studies at the College of William and Mary. He received his PhD from Columbia University. He is the author of *Exhibiting Contradiction: Essays on the Art Museum in the United States* (1998) and was co-curator of the exhibition *Thomas Cole: Landscape into History,* and co-author of the accompanying catalogue (1994). His writings have appeared in a wide range of periodicals and anthologies. Early in his career he was the author of "Thomas Cole and the Aristocracy," *Arts Magazine* 56 (1981, reprinted 1998), and co-author of "The Museum of Modern Art as Late Capitalist Ritual: An Iconographic Analysis," *Marxist Perspectives* I (Winter 1978, reprinted 2004), and "The Universal Survey Museum," *Art History* (1980, reprinted 2004). Recent publications include "Thomas Cole's 'River in the Catskills,' as Antipastoral," *Art Bulletin* 84 (2002), and "The Norman Rockwell Museum and the Representation of Social Conflict" in Patricia Johnston, ed., *Between High and Low: Representing Social Conflict in American Visual Culture* (2005). His current scholarly concerns include American art museums and the history of landscape vision in the United States in the period 1800–1880. He was an elected member of the board of directors of the College Art Association (1995–2000) and was a member of the Board of Managing Editors of *American Quarterly* (2000–2003).

Index